A MiDDLE-EARTH TRAVELER

SKETCHES FROM BAG END TO MORDOR

John Howe

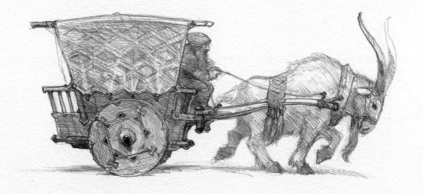

Houghton Mifflin Harcourt

Boston · New York

2018

First U.S. edition

Copyright © 2018 by John Howe

For information about permission to reproduce selections from this book, write to trade.permissions@hmhco.com or to Permissions, Houghton Mifflin Harcourt Publishing Company, 3 Park Avenue, 19th Floor, New York, New York 10016.

hmhco.com

Library of Congress Cataloging-in-Publication Data is available.

ISBN 978-1-328-55751-3

Printed and bound by RR Donnelley APS, China

HC 10 9 8 7 6 5 4 3 2 1

First published in Great Britain by HarperCollins*Publishers* 2018

℗® and TOLKIEN® are registered trade marks of The Tolkien Estate Limited

Quotations from *The Hobbit* by J.R.R. Tolkien © The Tolkien Estate Limited 1937, 1951, 1966, 1978, 1995; quotations from *The Lord of the Rings* by J.R.R. Tolkien © The Tolkien Estate Limited 1954, 1955, 1966

All sketches produced specifically during the development of *The Lord of the Rings* and *The Hobbit* film trilogies are reproduced courtesy of New Line Productions, Inc. and Warner Bros. Entertainment Inc.

CONTENTS

INTRODUCTION

There are many maps of Middle-earth. They were drawn, at least the very first ones, by its creator, J.R.R. Tolkien, who felt the need to map out the roads and paths taken by his characters. Essentially, these are maps as they were made during the Golden Age of Exploration, pieced together from the accounts of voyagers. They mix great precision and a certain vagueness, as if Tolkien was working from detailed reports of his characters, as well as sketching out rumours and tales heard second-hand. Some roads are well travelled, the cities they reach and the country they traverse clearly described. Other lands are less familiar, the roads lost and even forgotten, receding into the mists of legend and the stuff of fireside tales.

J.R.R. Tolkien drew maps full of terra incognita, with borders of far-distant lands, from which few travellers come. Distances so precisely measured close to home ("home", for Tolkien, is of course the Shire) become estimates and guesses as the wanderer proceeds. It is easy to imagine the author himself in Rivendell, compiling notes and lists and sketches based on the accounts of travellers. His maps have none of the God's-eye all-knowingness of many fantasy maps, where every detail is carefully crafted in preparation; his are, in fact, the reverse. They are, with his elaborate and elegant drawings, the natural product of his storytelling when the limits of words are reached. They are witness to the evocative power of his stories, through the rich looking-glass of his imagination.

Naturally, there is a clear trace of Tolkien's own wanderings in those maps. Much has been made of his walking tour in Switzerland in 1911, at the age of nineteen. The Alps likely provided many useful memories; it is possible to stand in a spot near Lauterbrunnen and make out the exact cliffs Tolkien depicted in his illustration of Rivendell. The Jungfrau may have inspired Celebdil, where Gandalf battled with the Balrog, and the Lonely Mountain from *The Hobbit* may be the Matterhorn in disguise. As for the emblematic Lake-town, it is assuredly based on Tolkien's encounter with the Swiss Lake Dwellers, a subject very much in vogue at the time (and itself another fiction, but more of that later).

The sense of reality, of personal experience, pervades much of Middle-earth, so much so that we are tempted to seek out a real place for every locality he describes. Such over-rationalization, though, would be to sell Tolkien far too short, and ignore the breadth and depth of his imagination: sometimes playful, occasionally spontaneous and above all, deeply rooted in philology. Tolkien's imaginary world cannot simply be pinned on top of any wishful map.

Much of his geography is deeply symbolic. The Anduin is not the Danube, the Volga or the Rhine transposed, but the spirit is the same: the continent-traversing river that ends only when it reaches the sea. In a different sense, the burned and scarred land of Mordor is perhaps a geographical transposing of the spiritual distress suffered during the First World War. Conversely, the Elven realms may be prelapsarian remnants of Paradise on Earth, the remains of the kingdom

of the time before time. (Tolkien skirts the theme of immortality, only evoking world-weariness in passing: the world immobile, yet inexorably fading.)

Nearly half a century after the publication of *The Lord of the Rings* (and sixty-five years after *The Hobbit* first took the reader to Middle-earth), the film trilogy added yet another layer to the geography of the novels. Another tale told through traveller's eyes, the film geography bears only a piecemeal resemblance (thoroughly documented in the film location books) to the real New Zealand. The films capture a spiritual and symbolic New Zealand seen through the lens of fiction, freeing them from simple topography and transforming the landscape into a vehicle for storytelling.

Having spent years in Middle-earth, I realize I have proceeded along the same paths. The sum of images inspired by this experience that I have come to create cannot be placed in any one category; while some are based on precise localities, others are the product of chance and juxtaposition. To my mind there are four layers to the strata of imagining Middle-earth: the stories themselves; the descriptions and details they provide; the places and events that inspired the author; and the locations chosen in New Zealand for the two film trilogies. Overlaying all this, and in places sandwiched between, is my personal experience, the chance encounters with landscape and light, the places that simply feel right and can become part of the picture. (Curiously, the North America of my youth is not part of this: the Rockies are not the Misty Mountains, the Grey Havens are nowhere in the Pacific Northwest.) Some places, like Switzerland, fall into two categories. In the end, they all become inextricably woven into the mindscape of Middle-earth.

Naturally, this is a geography of mind and spirit, guided by the stories, defined by chance and longing for the personal relationship to landscape, and beyond that, to the sublime. How many times have I looked north from atop the ramparts of Gundabad, wishing I could find an excuse to go wandering in the kingdom of the Witch king of Angmar. I recall the excitement when the script of *The Hobbit* took us east to the Sea of Rhûn, or north to the Blasted Heath, where once were dragons, and my disappointment when script revisions demanded that we leave it unexplored. How I wished it were possible to reach the Iron Hills (you could just make them out from the tower of the town hall of Esgaroth). Most of all, I longed to have an excuse to explore the coast of Middle-earth (a desire I managed to partially satisfy with long hikes along the clifftops and shorelines of New Zealand).

So this book is my chance. I've packed sketchbooks and pencils and compiled lists of the places I've not yet been. I have every intention of drawing my way there — and back again — at last.

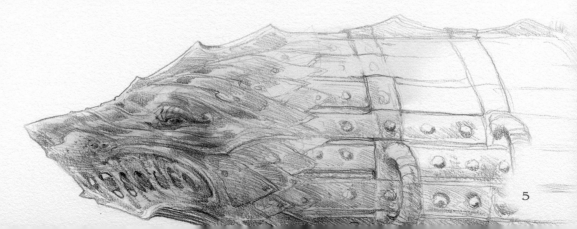

PROLOGUE
The Making of Middle-earth

SPLINTERED SYMPHONIES

Tolkien associates light and music, two vital symbols of life, with the creation of his universe.
While he sought much of his inspiration in history and philology, the Music of the Ainur is a truly
original concept, unknown in traditional creation myths. While the Ainur sang the polyphony of
creation, they did not create Music from nothing, but were given the themes. *"They shared in its making,
but only on the same terms as we make a work of art or story."* The creation of the very idea of music as a
force of life comes from Ilúvatar, and it is he who transforms the melodic vision into reality. The
Music the Ainur create is the Flame Imperishable (or the Secret Fire, of which Gandalf is a servant),
the very spark of life and truth, and the source of creativity; Tolkien considers the act of pure
creation to be the domain of God; sub-creation, or art, the realm of Man. But the music is flawed by
the dissonance of Melkor, and the creation of Middle-earth is a long history of strife and struggle.

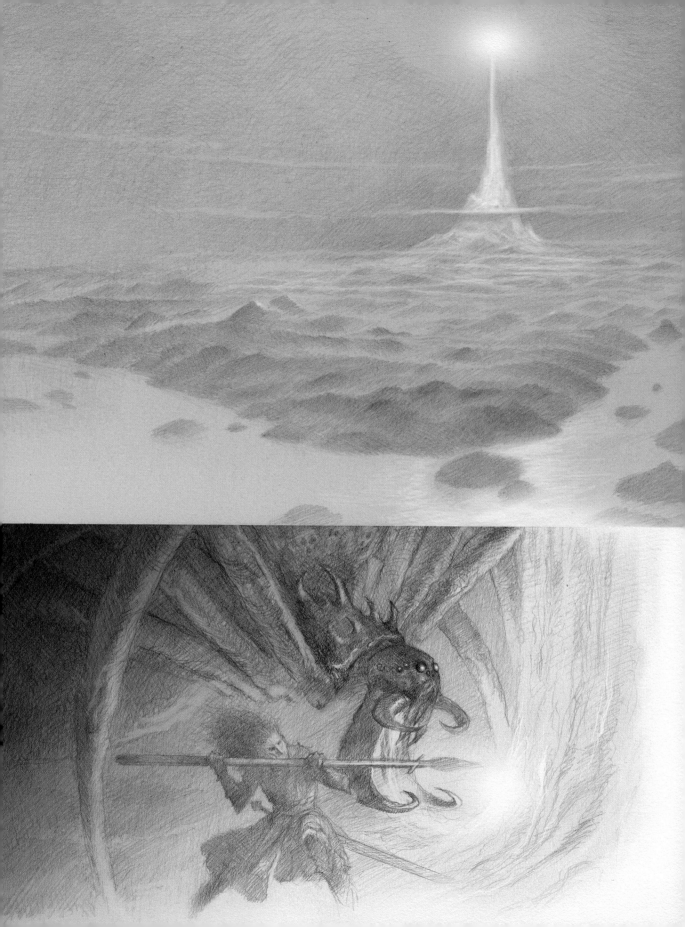

LAMPS AND TREES

Light is the one element that we cannot hold, but which is essential to life.
Impalpable as it is precious, Light is woven into every story of humankind, in
creation myths the world over, from the solar hero to the ever-renewed dawn and
the cycle of the seasons. Rather than draw his inspiration from the solar myths,
Tolkien chooses to place Light in the very laps of the gods of Middle-earth, first
in the form of the two lamps: sky-blue Illuin and high-gold Ormal, atop their high
pillars (Helkar, in the far north and Ringil in the south), and later in the shape
of the Two Trees: silver Telperion and golden Laurelin. Both Lamps and Trees are
destroyed by Melkor, until finally the Valar create the Moon and the Sun. Such a
complex origin of Light underlines Tolkien's notion of its precious nature; it is a
divine gift, very much in keeping with Prometheus' gift of fire to mankind, but a
tenuous and fragile gift; the light of pity and forgiveness is easily extinguished by
winds of adversity or avarice.

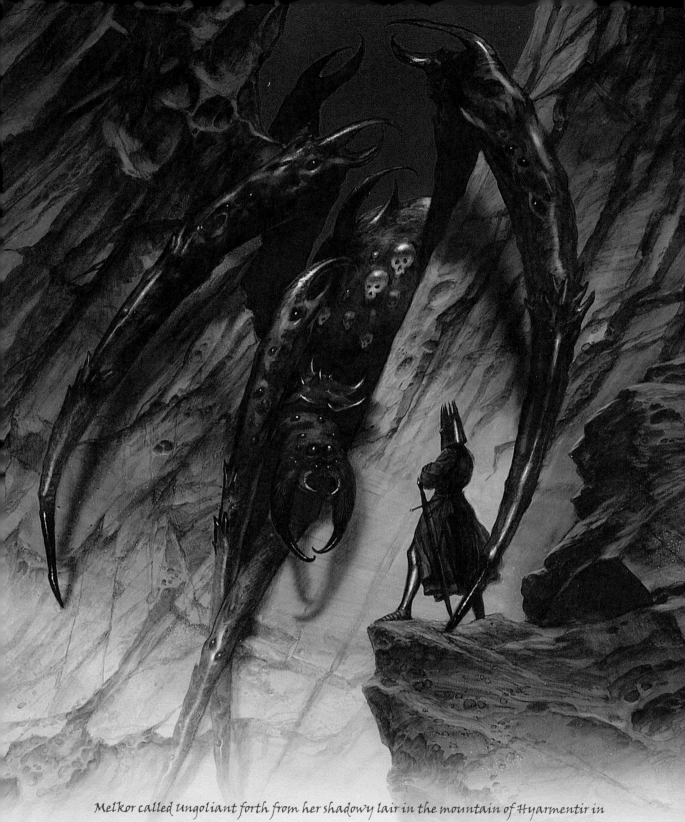

Melkor called Ungoliant forth from her shadowy lair in the mountain of Hyarmentir in
Aman, promising her vengeance on the Valar and the hunters of Oromë. The loathsome
creature accompanied him to Valinor, where he pierced the hearts of the Two Trees and
she greedily sucked up their bright sap-blood.

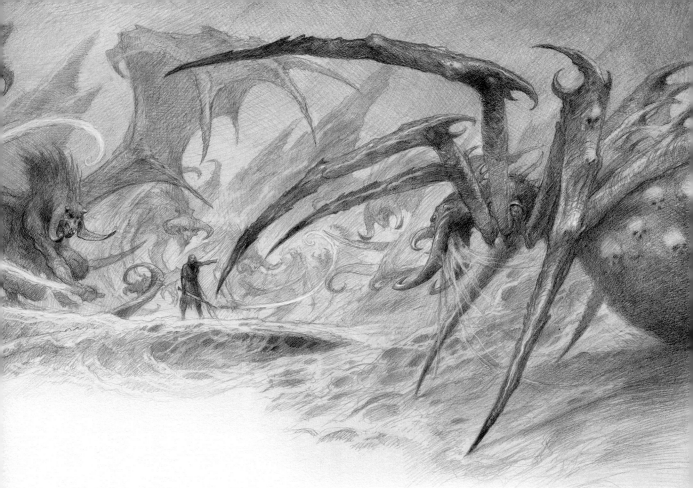

MELKOR AND UNGOLIANT

Ungoliant, a creature whose origins lie beyond notions of good and evil. While Melkor desires
domination and ultimate power, he is not ready to entirely destroy the world. Ungoliant, his ally
but not his servant, wishes nothing more than to extinguish the light, light that she simultaneously
loathes and hungers for. She drinks light in the manner of a spider-shaped black hole, drawing all
into her and still unsated. (This coupling of loathing and desire is a deeply uncomfortable notion,
small wonder that Tolkien embodies it in such a hateful form.) She longs for the original darkness,
the formless non-universe from which Eru Ilúvatar created the visible world. The "Unlight" of
Ungoliant is not simply darkness in the sense of the absence of light – it is akin to a rent in the
fabric of universe, a perceivable presence of an absence: the paradox of living darkness against
which no light can prevail.

When Melkor slays the Two Trees and Ungoliant consumes their light, more than simple
darkness comes. *"The Light failed, but the darkness that followed was more than loss of light. In that hour was
made a Darkness that seemed not lack but a thing with being of its own, for it was indeed made by malice out of Light."*
Tolkien chooses to postulate a Darkness that is a force of its own, a ditheist universe with two
opposing entities, each the antonym of the other, conferring palpable intent to Darkness' very
existence. Of this, Ungoliant is the physical embodiment. Ultimately, though, Tolkien makes his
feelings clear: victim of her own insatiable hunger, Ungoliant eventually devours herself.

ONE RING TO RULE THEM ALL

Magical rings play an often-crucial role in myth, legend and folklore, nor are rings of invisibility unknown. One of the more famous is Plato's cautionary tale of the Ring of Gyges, a peasant who discovers a magic ring in a bronze horse uncovered by an earthquake, then commits all manner of misdeeds while invisible. For Plato, who poses the question of whether invisibility would make a dishonest man out of the wearer, the ring is more a philosophical tool than a magical artefact. The Welsh hero Owein, in the tale of The Lady of the Fountain from the Mabinogion, receives a ring of invisibility from a maiden in a castle where he is imprisoned; the same tale is retold by Chrestien de Troyes in the story of Yvain. In Arthurian legend, both Perceval and Gareth benefit from magical rings that confer invincibility in battle. Wagner combines two magical objects into a ring forged by the dwarf Alberich from the Rhinegold. When it is taken by Odin, Alberich places a curse upon it. Odin gives the ring to the giants Fasolt and Fafnir, with dreadful consequences. Of any resemblance between Wagner's magical ring and his own creation, Tolkien tersely stated: "Both rings were round, and there the resemblance ceases." What is more likely is that Tolkien and Wagner were familiar with the same source: Andvarinaut, the famous Ring of the Niebelung from the Volsunga Saga and The Nibelungenlied.

The nine Men to whom Sauron gave rings, "kings, sorcerers, and warriors of old" were ensnared by him, becoming his servants, the Ringwraiths. The seven Dwarven kings used their rings to gather wealth, the rings augmenting their desire for gold and treasure. (In that, they resemble Draupnir, the golden arm-ring of Odin that could multiply itself to increase wealth.) Sauron recovered three; the others, according to Gandalf, were destroyed by dragons. Only the three Elven-rings, made in secret by the master Elven smith Celebrimbor, were not subject to Sauron's will. One was given to Gandalf by Círdan the Shipwright, the other two were worn by Galadriel and Elrond. They ultimately passed into the West with their bearers.

The One Ring was forged by Sauron alone, and in his hands would spell the end of the long struggle between the forces of light and dark in Middle-earth. While it represents ultimate power, it curiously has limits of its own. Those who were strong of will could resist it: Galadriel, Faramir, Gandalf and Aragorn all refused to wield the Ring. (Isildur possessed the Ring for two years, and though he refused to destroy it there is no mention of his wearing it on his finger.) Tom Bombadil escaped its influence entirely. He placed it on his finger and remained visible, even making it disappear by sleight-of-hand before returning it to Frodo. He could also see Frodo, even when he put it on and disappeared: "Take off your golden ring! Your hand's more fair without it." Both Bilbo and Frodo (as well as Sam, who carried it for a short time) resisted the power of the Ring, though Bilbo confessed he felt "stretched" by it. Both might well have succumbed, as did Gollum, who possessed the Ring for 478 years, and endured 77 more between losing it to Bilbo and falling with it into the Cracks of Doom.

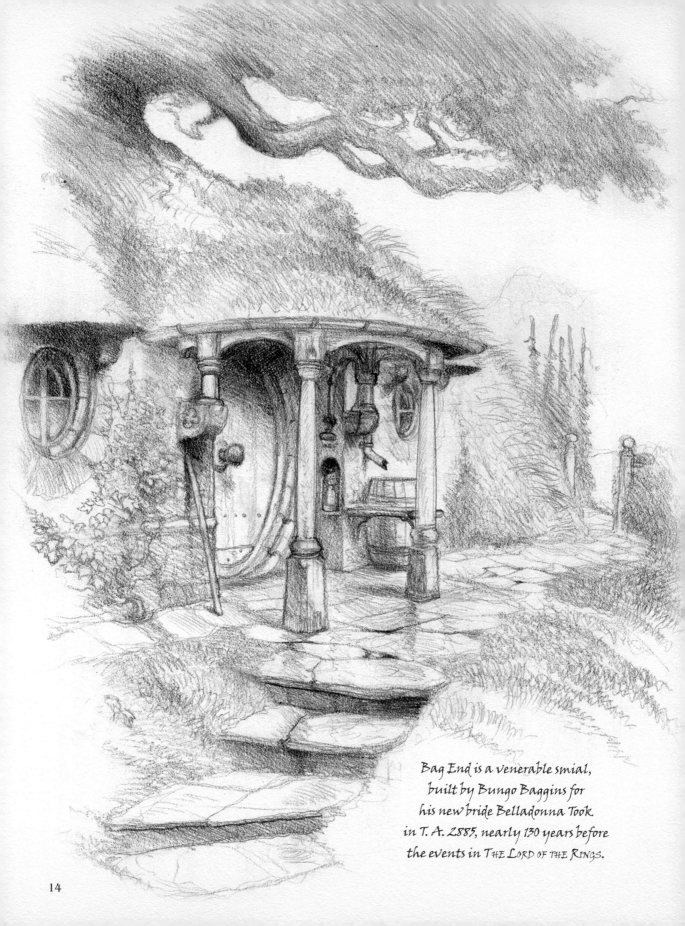

Bag End is a venerable smial,
built by Bungo Baggins for
his new bride Belladonna Took
in T. A. 2885, nearly 130 years before
the events in THE LORD OF THE RINGS.

14

ROUND DOORS & ROUNDED HILLS

The peaceable land of the Shire

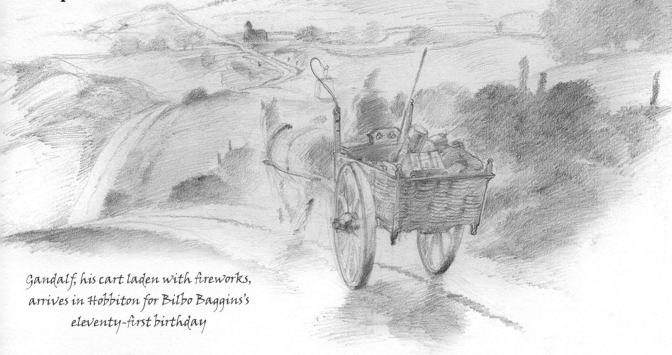

Gandalf, his cart laden with fireworks, arrives in Hobbiton for Bilbo Baggins's eleventy-first birthday

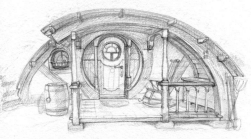

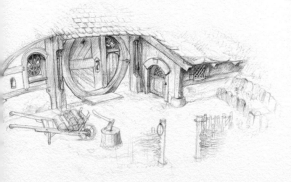

Fittingly, the momentous adventures in both *The Hobbit* and *The Lord of the Rings* begin in the green and peaceable Shire. While not a vast region, the Shire nevertheless measures forty leagues from north to south, and fifty wide, and is divided into four quarters, or farthings. The first Hobbits arrived from the vale of Anduin in 1601 of the Third Age, fleeing unrest east of the Misty Mountains and settled in the kingdom of Arthedain with the blessing of its lord, to whom they swore allegiance. When the Kingdom of Arnor fell, the Shire remained, largely forgotten by the outside world, discretely guarded by the Rangers, or Dúnedain, to the north. Dwarves and Elves might pass through, and Men, mostly from Bree, beyond the Brandywine to the east, but while Sauron gathered his strength and rumours of war floated on the wind, the Shire dreamt on.

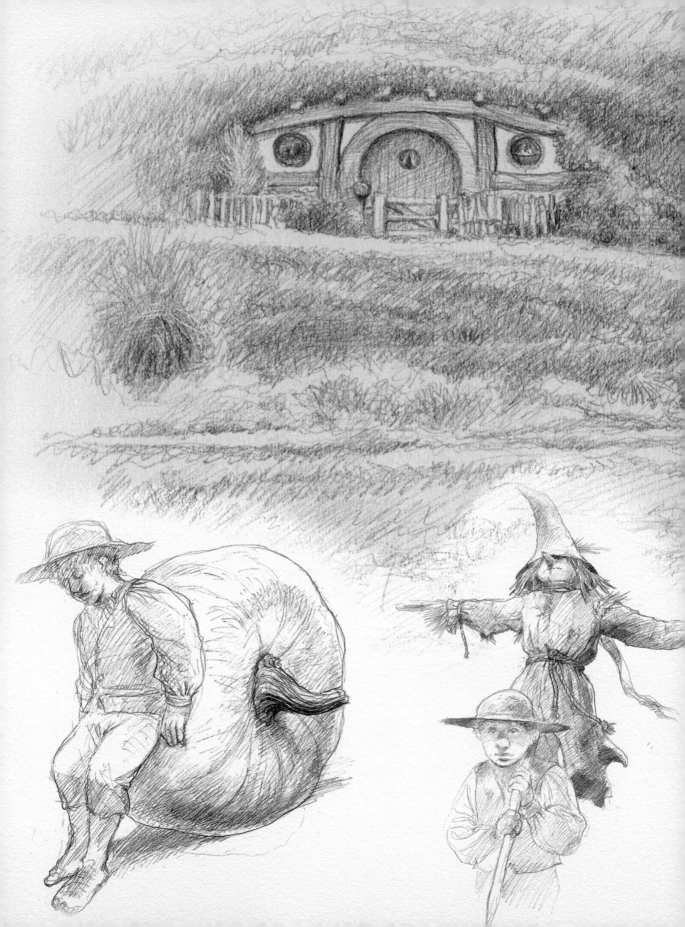

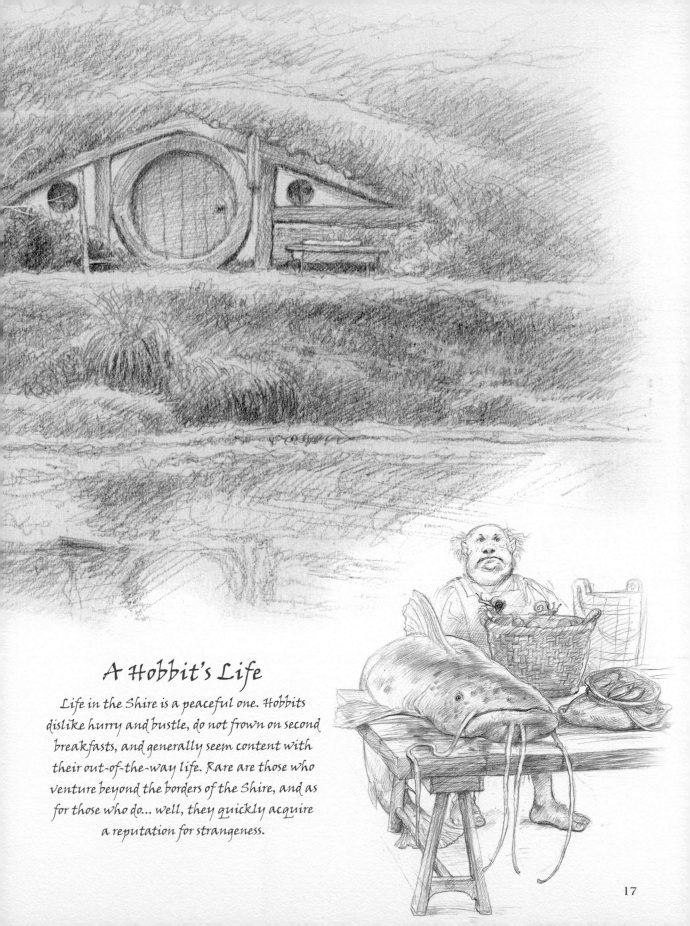

A Hobbit's Life

Life in the Shire is a peaceful one. Hobbits dislike hurry and bustle, do not frown on second breakfasts, and generally seem content with their out-of-the-way life. Rare are those who venture beyond the borders of the Shire, and as for those who do... well, they quickly acquire a reputation for strangeness.

17

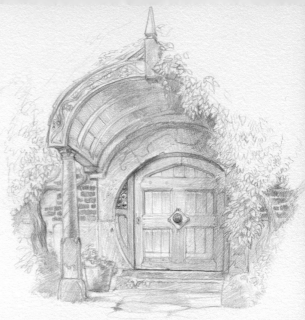

In A Hole in the Ground...

"In a hole in the ground there lived a hobbit. Not a nasty, dirty, wet hole, filled with the ends of worms and an oozy smell, nor yet a dry, bare, sandy hole with nothing in it to sit down on or to eat: it was a hobbit-hole, and that means comfort."

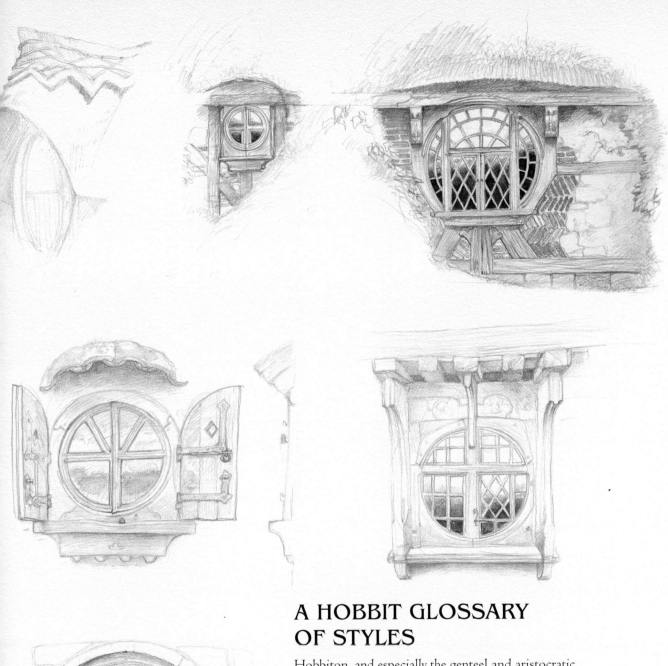

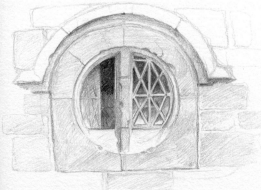

A HOBBIT GLOSSARY OF STYLES

Hobbiton, and especially the genteel and aristocratic Bag End, symbolize the Romantic past of England's rural life. A Victorian landscape, with rounded doors and windows, tucked away behind hedges and beneath grassy knolls. Like Pugin, who remodelled the archetypal English village, Tolkien transposed that same vision into Middle-earth. As readers, arriving in Hobbiton is like coming home to childhood: a comfortable cozy place with the wider world perhaps beckoning, but still beyond.

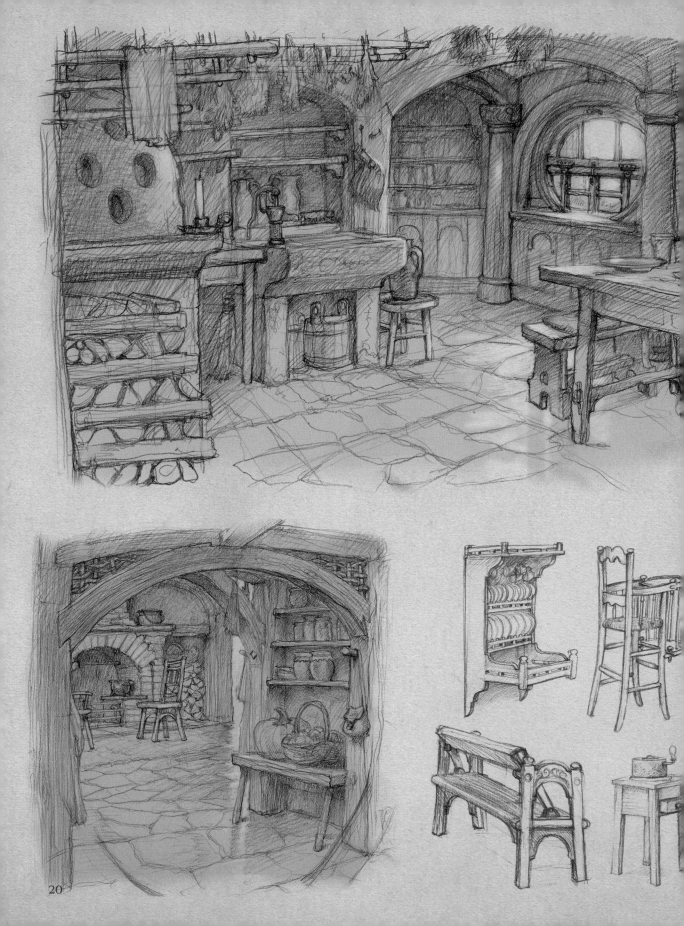

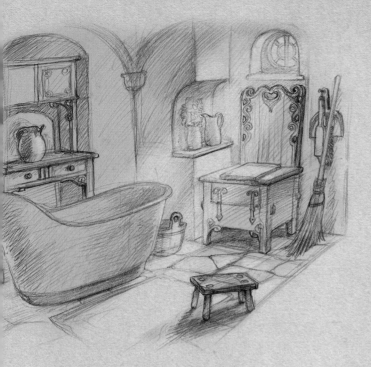

A MODEST HOBBIT DWELLING

Number Three Bagshot Row, the birthplace of Samwise Gamgee, was destroyed by Saruman after the War of the Ring, leaving only a gaping sand-pit. New Row (or, as the inhabitants of Bywater called it: Sharkey's End) replaced it, and became home once more to Samwise, gardener, companion of Frodo, Ring-bearer, warrior and husband of Rosie (née Cotton) and proud father of infant Elanor, first of many children. While modest, it nonetheless features a bath and a kitchen pump. Outside: an ample tool shed and, of course, a vast garden.

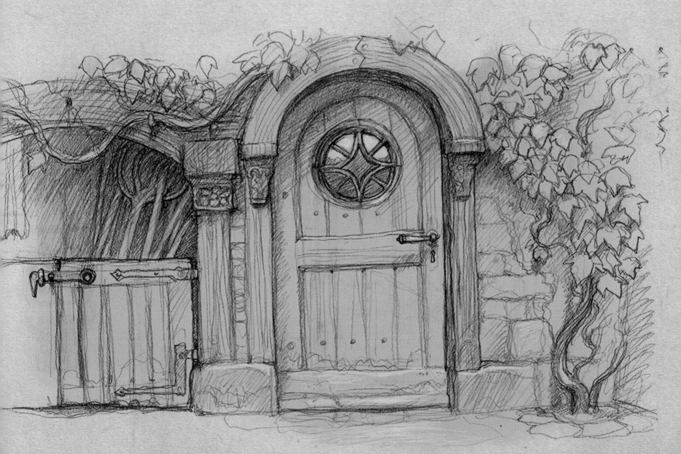

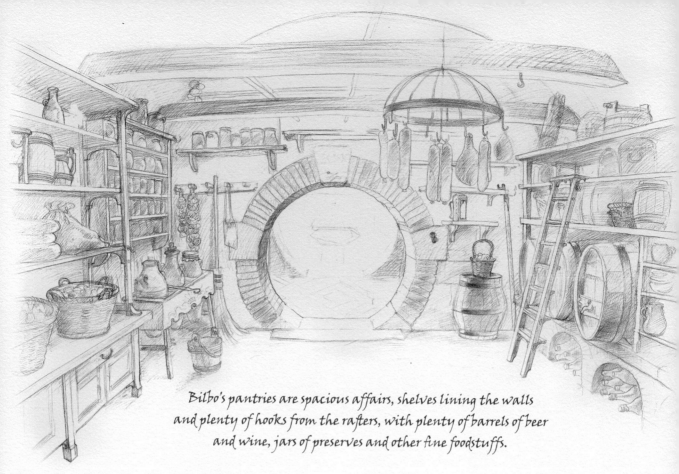

Bilbo's pantries are spacious affairs, shelves lining the walls
and plenty of hooks from the rafters, with plenty of barrels of beer
and wine, jars of preserves and other fine foodstuffs.

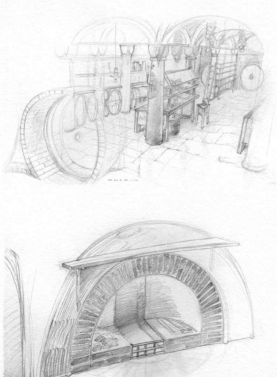

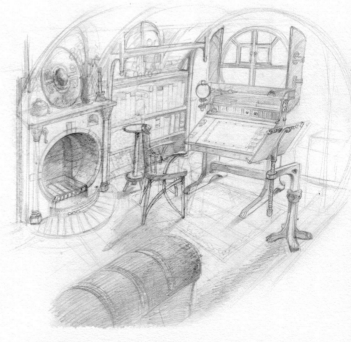

Bilbo Baggins' domicile is arguably the finest hole
in all Hobbiton and possibly in the Shire.

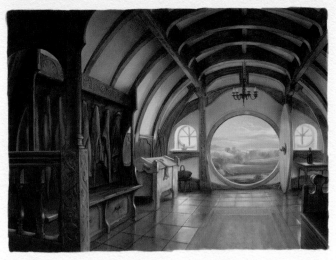

BAG END INSIDE AND OUT

"It had a perfectly round door like a porthole, painted green, with a shiny yellow brass knob in the exact middle. The door opened on to a tube-shaped hall like a tunnel: a very comfortable tunnel without smoke, with panelled walls, and floors tiled and carpeted, provided with polished chairs, and lots and lots of pegs for hats and coats - the hobbit was fond of visitors. The tunnel wound on and on, going fairly but not quite straight into the side of the hill – The Hill, as all the people for many miles round called it – and many little round doors opened out of it, first on one side and then on another. No going upstairs for the hobbit: bedrooms, bathrooms, cellars, pantries (lots of these), wardrobes (he had whole rooms devoted to clothes), kitchens, dining – rooms, all were on the same floor, and indeed on the same passage. The best rooms were all on the left – hand side (going in), for these were the only ones to have windows, deep – set round windows looking over his garden, and meadows beyond, sloping down to the river."

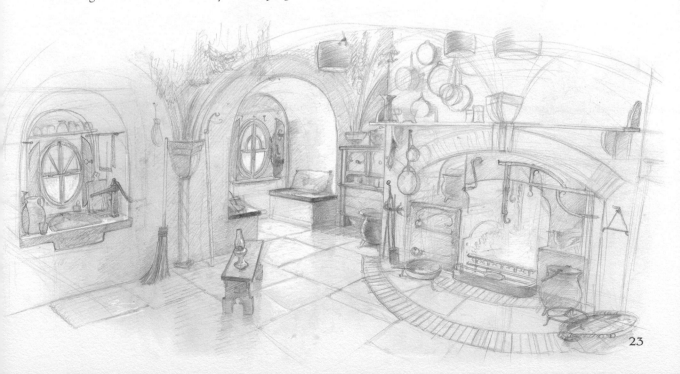

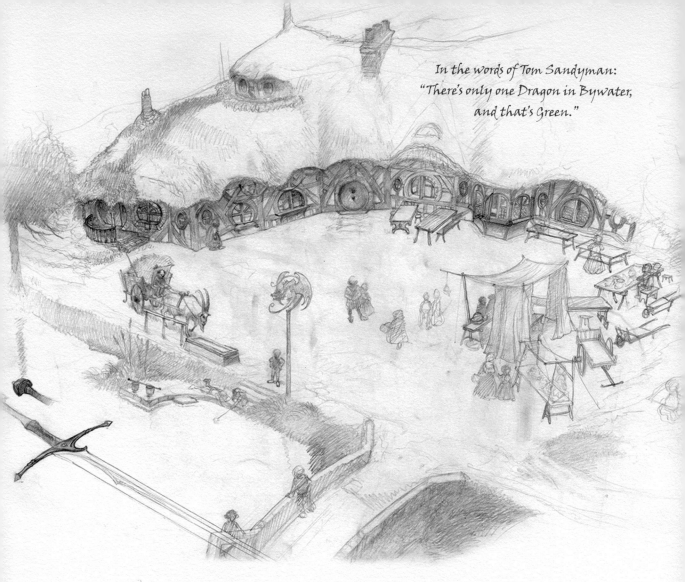

In the words of Tom Sandyman:
"There's only one Dragon in Bywater,
and that's Green."

The Green Dragon

The Shire's famous public house is found in the Westfarthing village of Bywater; the inn is on the Bywater road, about a mile from Bag End in Hobbiton. When the hobbits returned from the War of the Ring, they defeated Sharkey's ruffians at the Battle of Bywater.

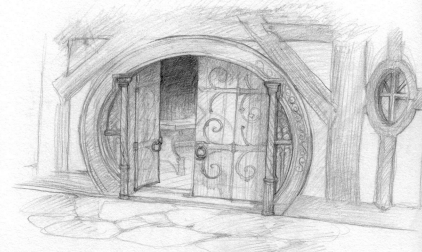

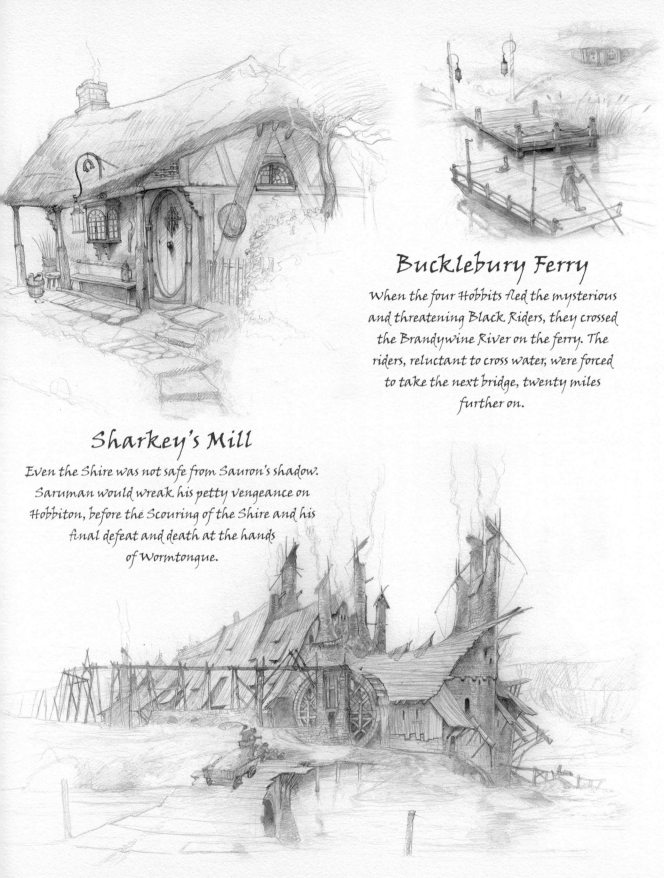

Bucklebury Ferry

When the four Hobbits fled the mysterious
and threatening Black Riders, they crossed
the Brandywine River on the ferry. The
riders, reluctant to cross water, were forced
to take the next bridge, twenty miles
further on.

Sharkey's Mill

Even the Shire was not safe from Sauron's shadow.
Saruman would wreak his petty vengeance on
Hobbiton, before the Scouring of the Shire and his
final defeat and death at the hands
of Wormtongue.

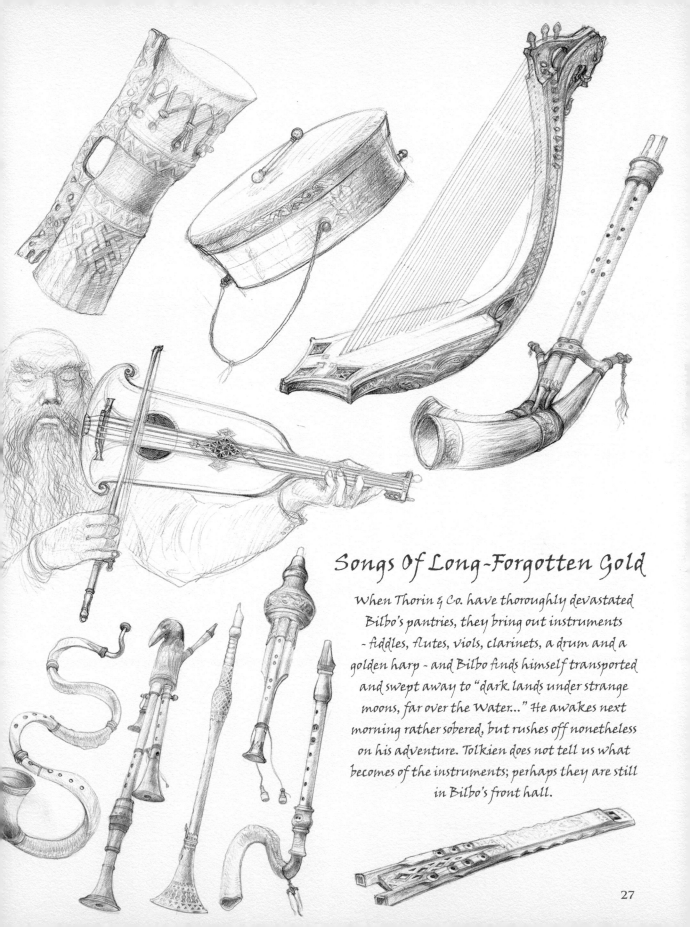

Songs Of Long-Forgotten Gold

When Thorin & Co. have thoroughly devastated
Bilbo's pantries, they bring out instruments
- fiddles, flutes, viols, clarinets, a drum and a
golden harp - and Bilbo finds himself transported
and swept away to "dark lands under strange
moons, far over the Water..." He awakes next
morning rather sobered, but rushes off nonetheless
on his adventure. Tolkien does not tell us what
becomes of the instruments; perhaps they are still
in Bilbo's front hall.

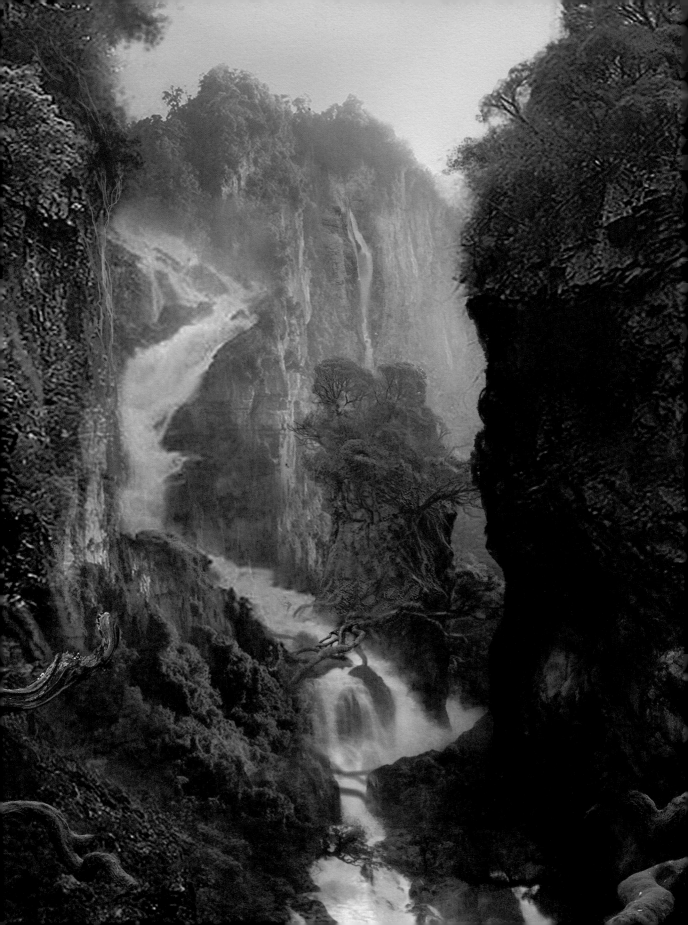

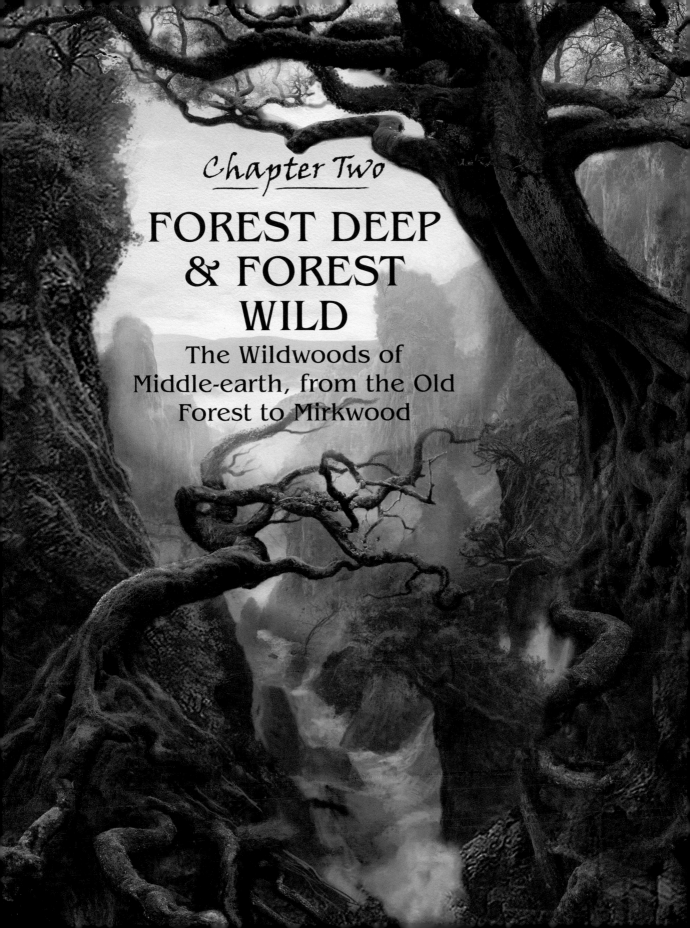

Chapter Two

FOREST DEEP & FOREST WILD

The Wildwoods of Middle-earth, from the Old Forest to Mirkwood

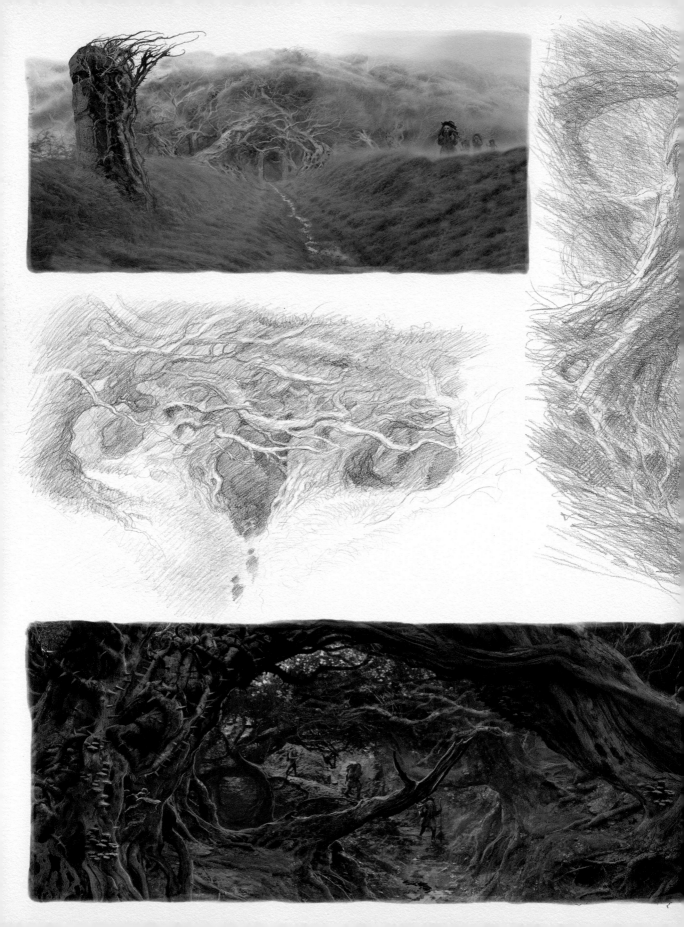

MIRKWOOD

According to Gandalf the Grey, the forest of Mirkwood was "the greatest forest in the Northern world," stretching four hundred miles from the Grey Mountains in the north to the Brown Lands bordering Rohan in the south. When Thorin and Company are unceremoniously abandoned by Gandalf at the Forest Gate, they set off resolutely along the Elf-path, not quite realizing that the eastern eaves of Mirkwood are over two hundred miles distant.

Tolkien did not invent Mirkwood, but distilled his version from "Myrkviðr", literally the "black forest" that appears first in Snorri Sturlusson's Poetic Edda. According to Tolkien, "black" is a pale echo of the original meaning: murky, irredeemably dark, and weighted with a sense of gloom.

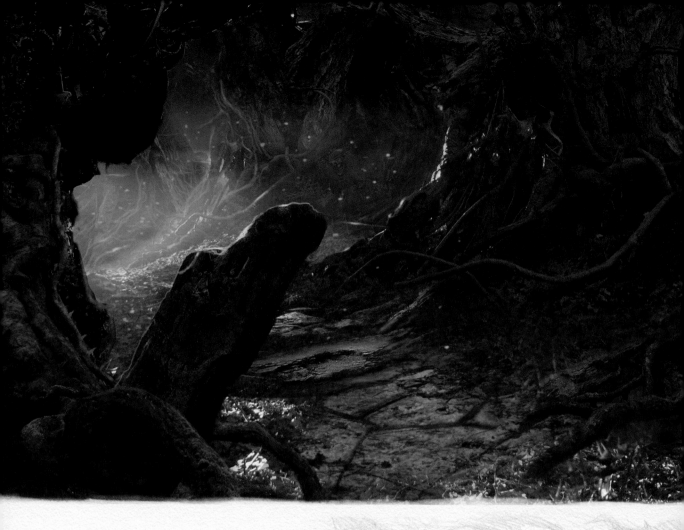

Gandalf left a stern warning for Thorin and
Company when they entered Mirkwood through
the Forest Gate. Under no circumstances were they
to stray from the Elf-path, if they hoped to emerge
safely on the Long Lake.

The Dwarves carried on for days in the dark forest,
crossing an enchanted black stream (into which Bombur
fell, sending him into a deep sleep) finally losing their way
completely and utterly.

And no wonder, for Mirkwood is vast and malevolently
alive, a great swathe of thick-boled ancient trees with
branches so densely intertwined that light cannot penetrate.
It is very nearly the doom of Thorin's quest.

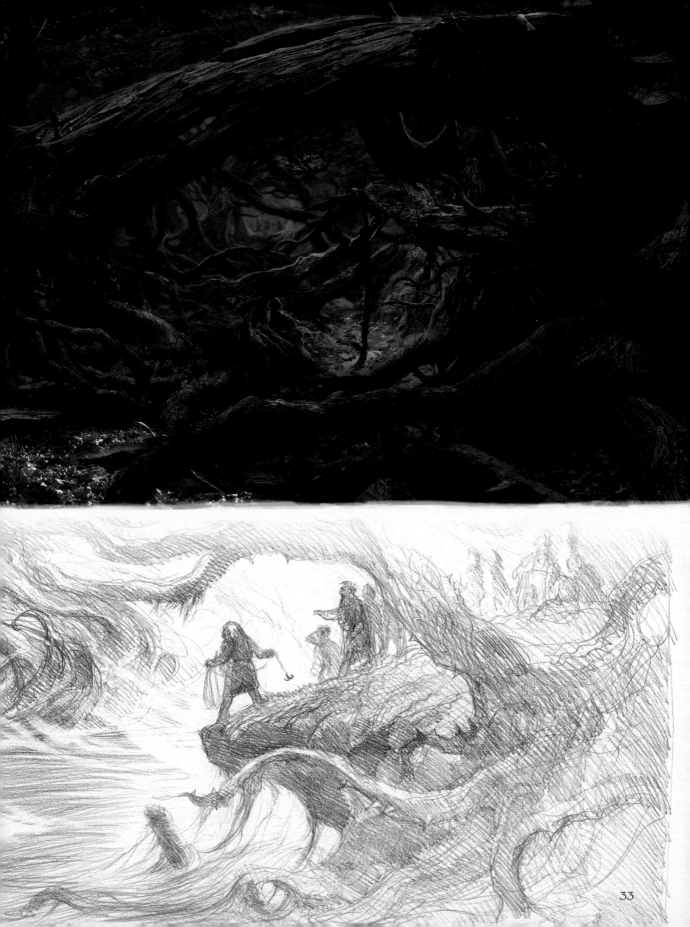

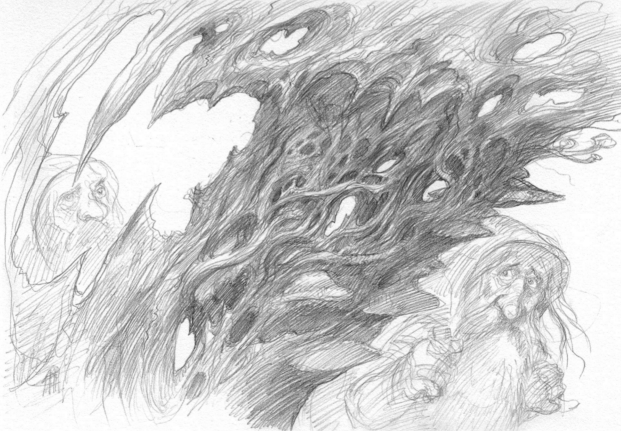

Under the influence of the Necromancer, the forest has become a place of dread, perilous for the unwary. Huge spiders, distant offspring of Shelob, nest in its trees, and but for the resourcefulness of an invisible burglar, they would have feasted on twelve Dwarves.

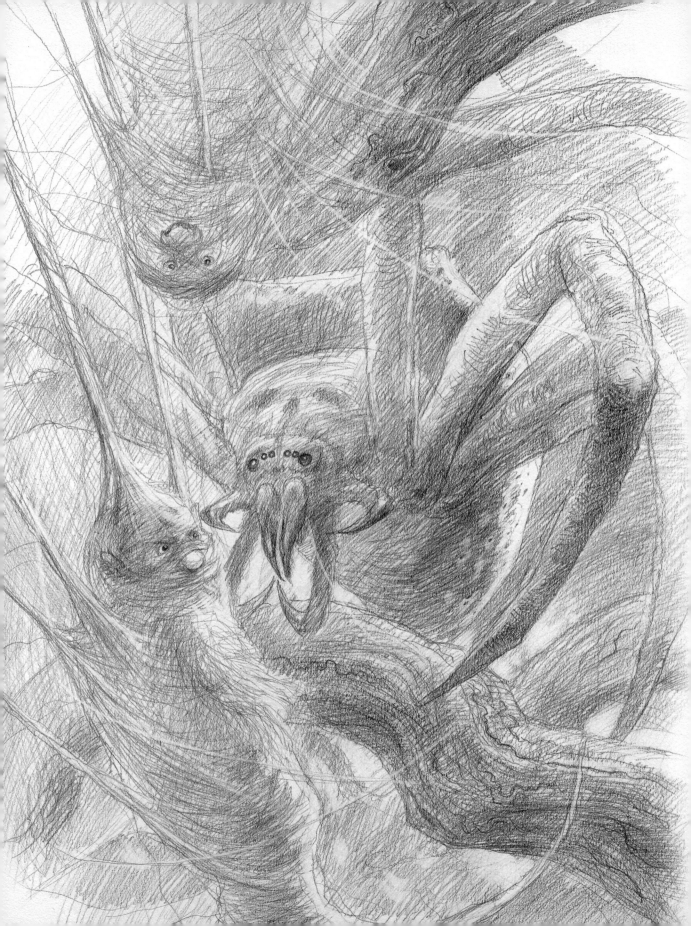

The High Hay forms the western edge of the Old Forest,
a dense hedge constantly tended by the Bucklanders.

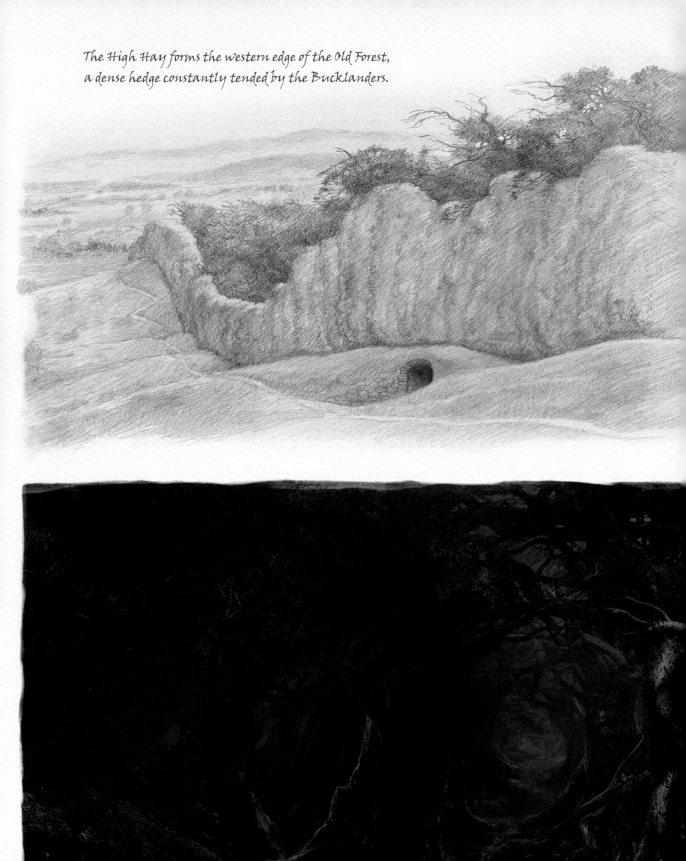

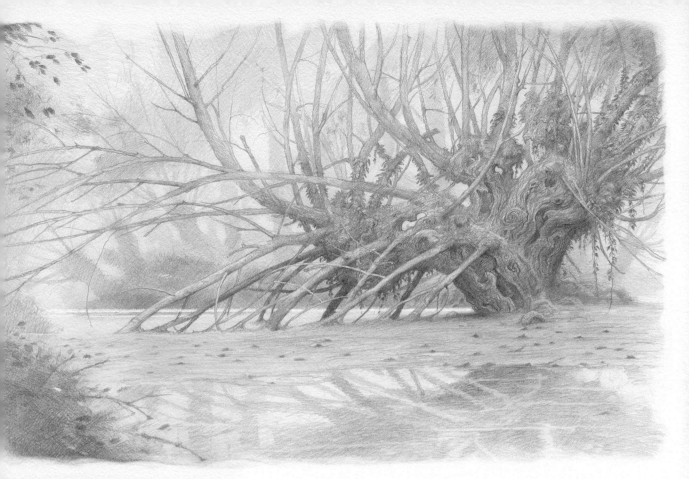

OLD MAN WILLOW

Of all the trees of the Old Forest, according to Tom Bombadil "none were more dangerous than the Great Willow; his heart was rotten, but his strength was green; and he was cunning, and a master of winds, and his song and thought ran through the woods on both sides of the river. His grey thirsty spirit drew power out of the earth and spread like fine root-threads in the ground, and invisible twig-fingers in the air, till it had under its dominion nearly all the trees of the Forest from the Hedge to the Downs."

Old Man Willow may have been a Huorn once, a malevolent spirit in tree-form. But for the timely arrival of Tom Bombadil, he would have put an end to four venturesome Hobbits.

Left: The Old Forest

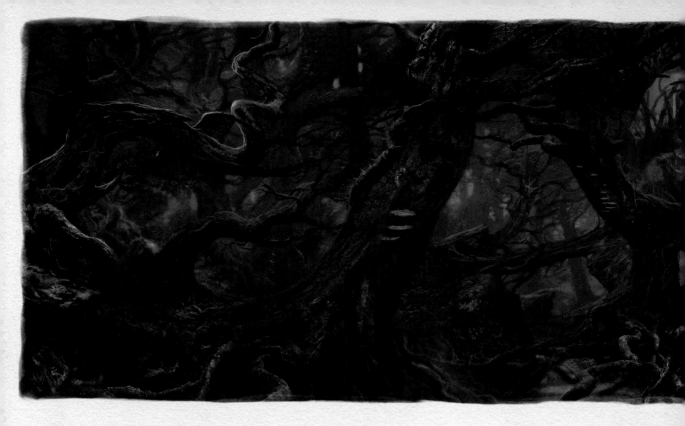

FANGORN AND THE HUORNS

Of the vast and ancient forest that once covered much of Eriador, little remains. It is now the domain of Treebeard, or Fangorn; bordered on the south by the land of Rohan, and the steep slopes of the Misty Mountains to the west. Fangorn has become dark over the years: the trees entwine their branches so thickly that little light reaches the forest floor. Even Legolas feels the subdued anger of Fangorn when Aragorn, Gimli and he enter the forest. The River Entwash flows down from the mountains, nearby is Wellinghall and the shallow cavern Treebeard calls his home.

When the Ents are roused to war, the Huorns follow, a moving forest coming under cover of darkness to block the mouth of Helm's Deep. When the fleeing Uruk army passes under its eaves, they are never seen again. Come morning, the Huorns have returned to Fangorn.

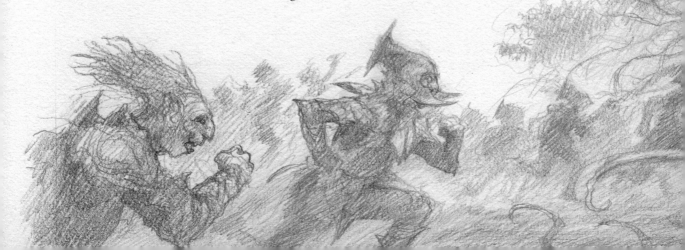

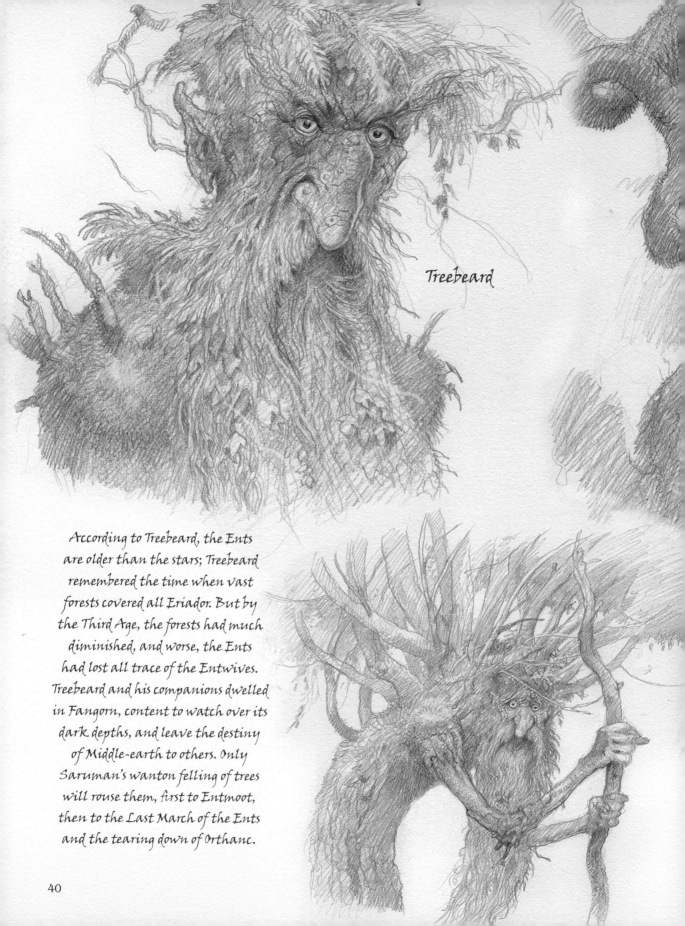

Treebeard

According to Treebeard, the Ents are older than the stars; Treebeard remembered the time when vast forests covered all Eriador. But by the Third Age, the forests had much diminished, and worse, the Ents had lost all trace of the Entwives. Treebeard and his companions dwelled in Fangorn, content to watch over its dark depths, and leave the destiny of Middle-earth to others. Only Saruman's wanton felling of trees will rouse them, first to Entmoot, then to the Last March of the Ents and the tearing down of Orthanc.

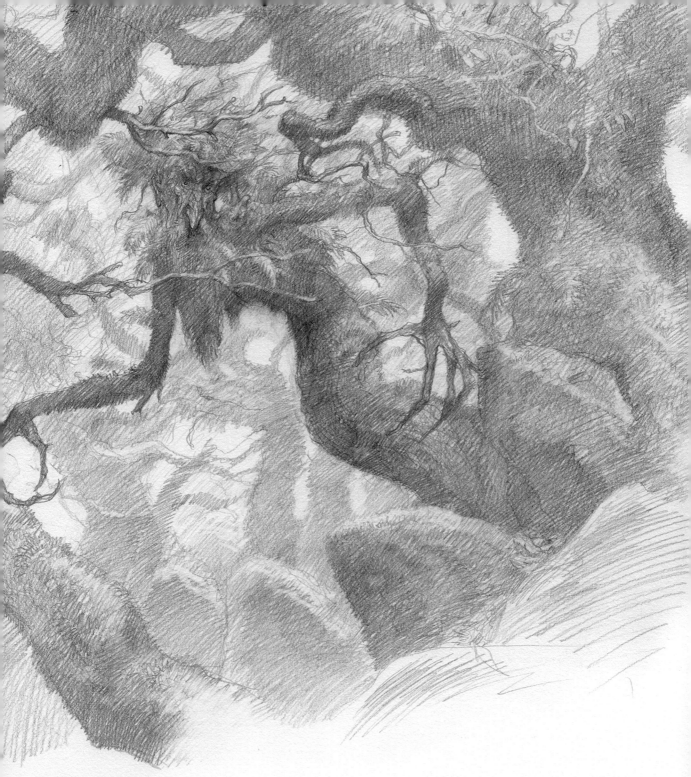

THE ENTS

Tolkien borrowed the term "Ent" from the Anglo-Saxon word for "giant". The Vala, or god, Yavanna implored Ilúvatar to create them when she perceived that Dwarves, with their sharp and sturdy weapons, were no friends of trees. The Ents are guardians, tree-shepherds; slow to anger, but relentless once they have decided to act.

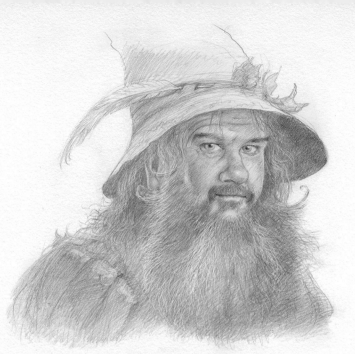

Tom Bombadil

*"Eldest, that's what I am... Tom remembers the
first raindrop and the first acorn... He knew
the dark under the stairs when it was fearless –
before the Dark Lord came from outside."*

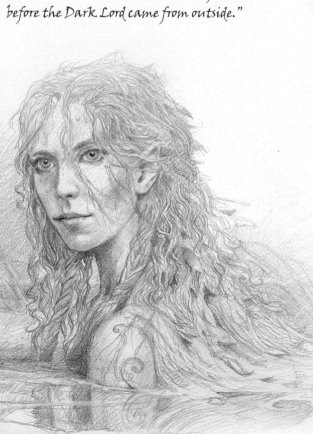

Bombadil met the "River-woman's
daughter" when he was gathering water
lilies by the River Withywindle. When
they first met, she dragged Tom into the
water, but he escaped and later returned
to capture her and make her his bride.
Goldberry is clearly a river spirit, akin to
the Slavic *rusalka* or the Norse *nix*.

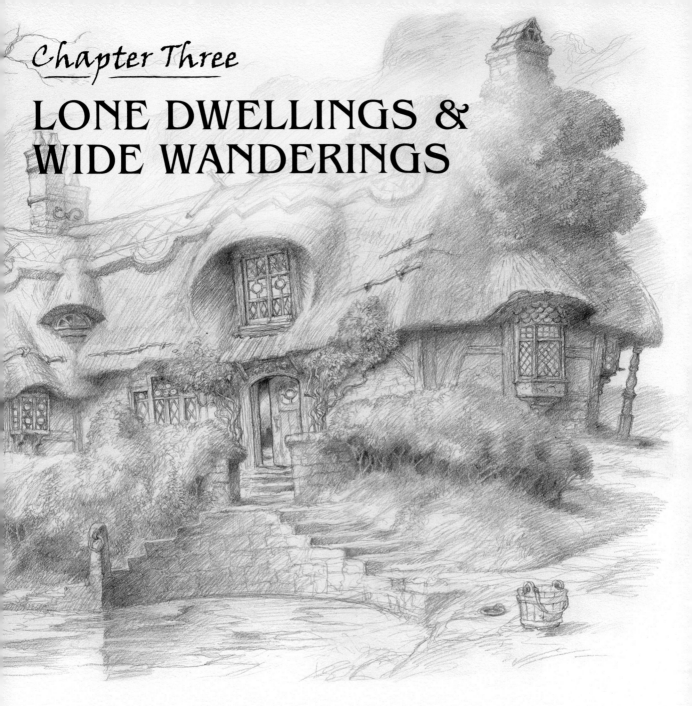

Chapter Three
LONE DWELLINGS & WIDE WANDERINGS

Even the Elves consider Tom Bombadil to be immortal. Elrond speaks of him thus: "But I had forgotten Bombadil, if indeed this is still the same that walked the woods and hills long ago, and even then he was older than old. That was not then his name. Iarwain Ben-adar we called him, oldest and fatherless. But many another name he has since been given by other folk: Forn by the Dwarves, Orald by Northern Men, and other names beside. He is a strange creature..."

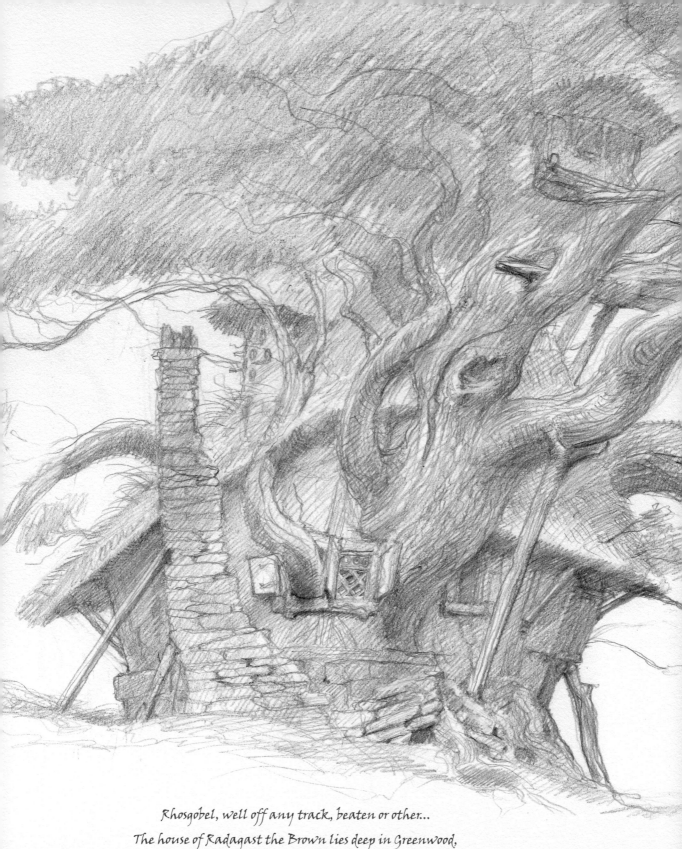

Rhosgobel, well off any track, beaten or other...
The house of Radagast the Brown lies deep in Greenwood,
though no one is certain where.

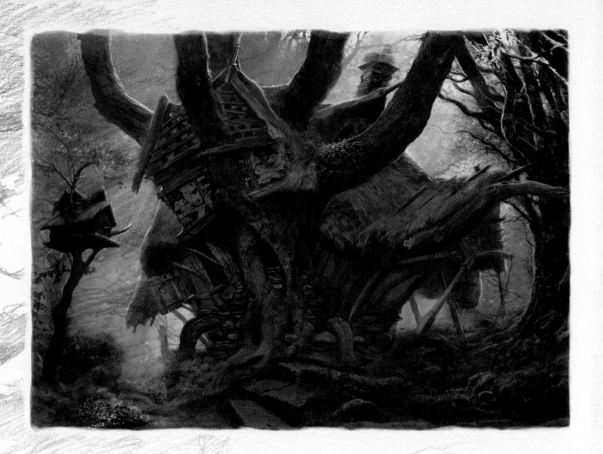

RHOSGOBEL

Tolkien tells us very little about Rhosgobel, Radagast's house. It lies somewhere near the southwest borders of Mirkwood, between the Carrock and the Old Forest Road and its name means "brown dwelling". Over time, Radagast's home has become a tree house, but one of a most unusual kind: a huge oak tree grows up through the middle of it, and is slowly prising the house apart; the crooked walls are propped up from all sides and roots invade every room.

We also know little of the resident, except that he could speak to beasts and birds (he was also friends with the great Eagles), little interested in power and the affairs of Men, and grandly irked Saruman in that regard. Perhaps his crumbling house, slowly returning to nature, symbolizes his retreat from the world, vanishing into the forest itself.

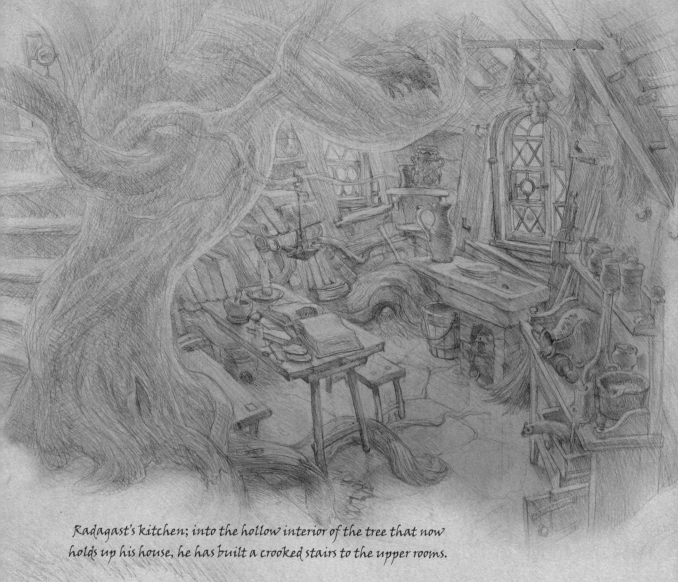

Radagast's kitchen; into the hollow interior of the tree that now holds up his house, he has built a crooked stairs to the upper rooms.

RADAGAST THE BROWN

In Gandalf's words: "Radagast is, of course, a worthy wizard, a master of shapes and changes of hue; and he has much lore of herbs and beasts, and birds are especially his friends."

Aiwendil, Radagast's original name, meant "bird-friend" in Quenya. The Noldor named him Radagast or "tender of beasts". His origin may be a borrowing from "Radigost", a Slavic harvest deity. Of his fate after the War of the Ring, Tolkien tells us nothing. Elven scouts sent to Rhosgobel found it empty.

Radagast's study, slowly returning to nature as the tree spreads through his house. His shelves are filled with things gathered during the course of his wanderings. Wild animals sleep there.

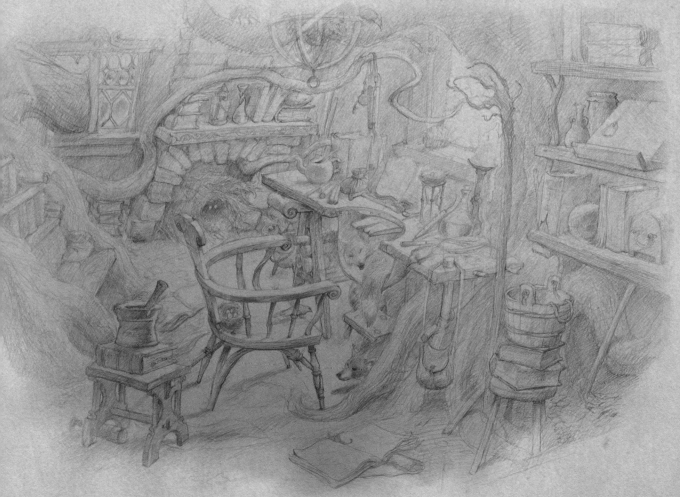

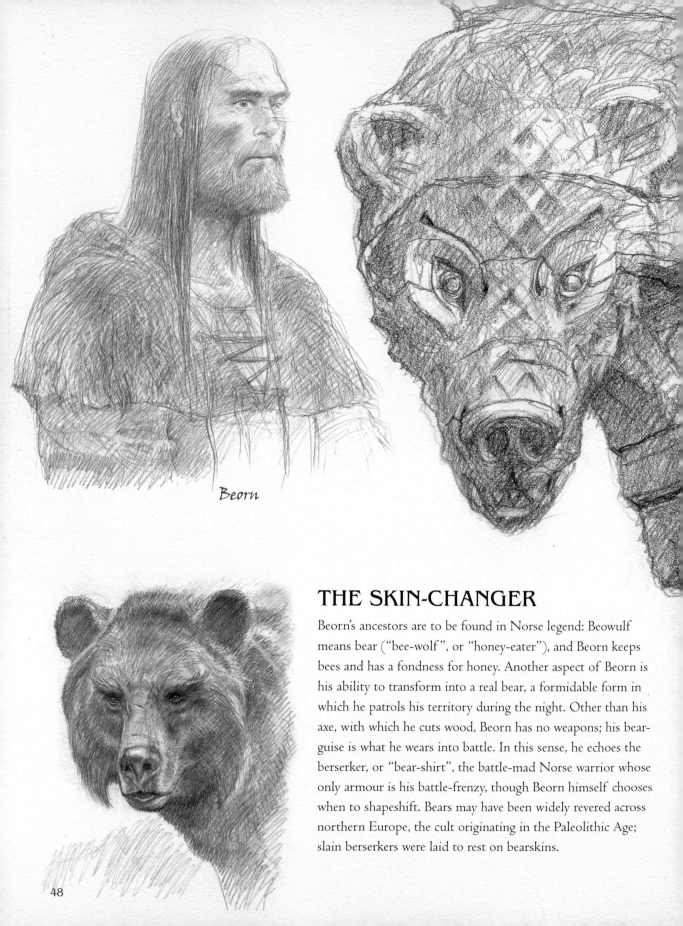

Beorn

THE SKIN-CHANGER

Beorn's ancestors are to be found in Norse legend: Beowulf means bear ("bee-wolf", or "honey-eater"), and Beorn keeps bees and has a fondness for honey. Another aspect of Beorn is his ability to transform into a real bear, a formidable form in which he patrols his territory during the night. Other than his axe, with which he cuts wood, Beorn has no weapons; his bear-guise is what he wears into battle. In this sense, he echoes the berserker, or "bear-shirt", the battle-mad Norse warrior whose only armour is his battle-frenzy, though Beorn himself chooses when to shapeshift. Bears may have been widely revered across northern Europe, the cult originating in the Paleolithic Age; slain berserkers were laid to rest on bearskins.

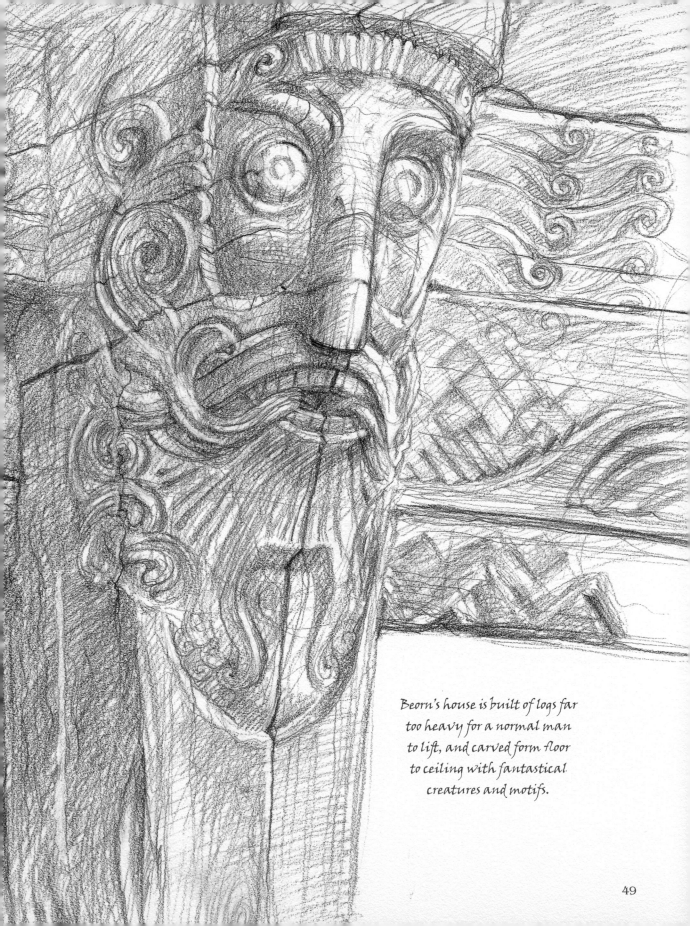

Beorn's house is built of logs far
too heavy for a normal man
to lift, and carved form floor
to ceiling with fantastical
creatures and motifs.

49

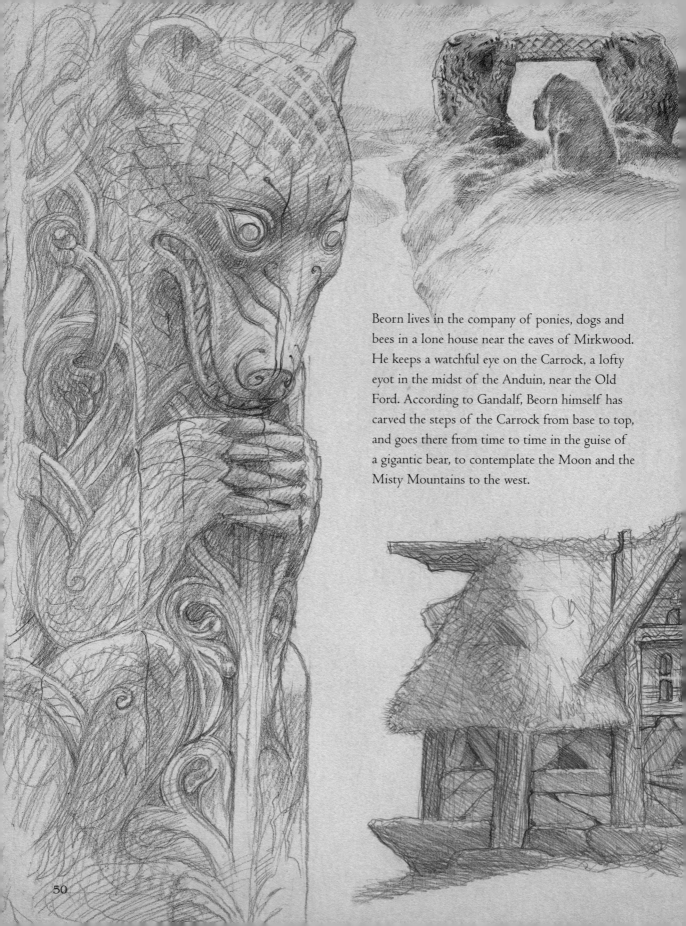

Beorn lives in the company of ponies, dogs and bees in a lone house near the eaves of Mirkwood. He keeps a watchful eye on the Carrock, a lofty eyot in the midst of the Anduin, near the Old Ford. According to Gandalf, Beorn himself has carved the steps of the Carrock from base to top, and goes there from time to time in the guise of a gigantic bear, to contemplate the Moon and the Misty Mountains to the west.

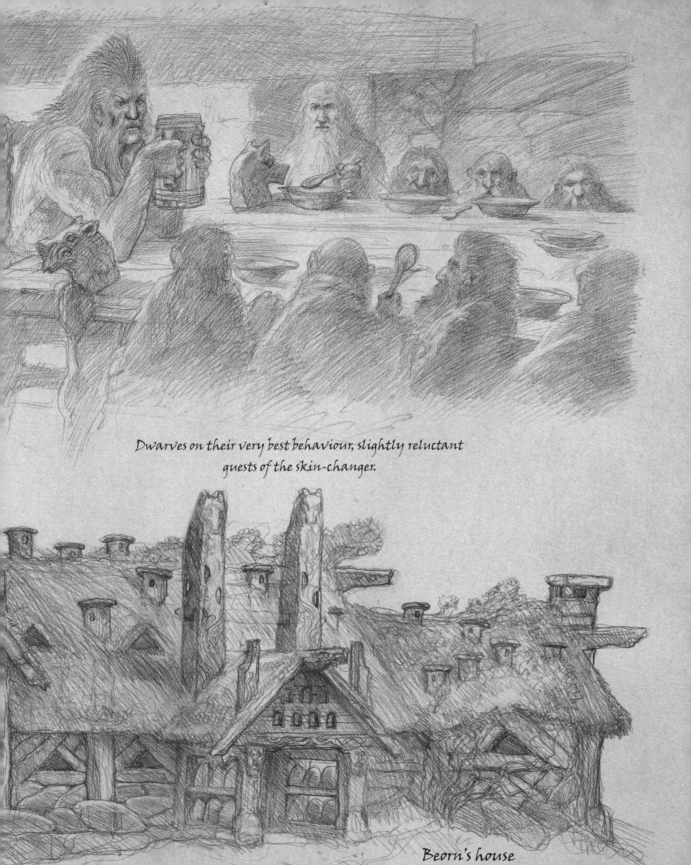

Dwarves on their very best behaviour, slightly reluctant guests of the skin-changer.

Beorn's house

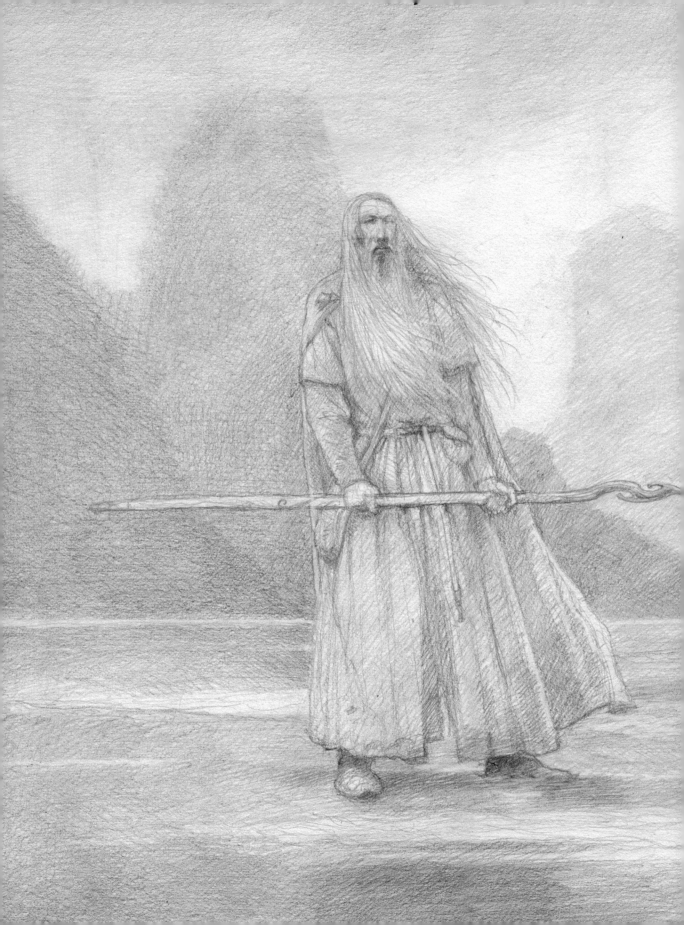

Not all who wander are lost...

THE ISTARI

The Istari were sent by Manwë from the Undying Lands when Sauron's presence was again perceived to be growing in Middle-earth. They were five in number: Saruman, Gandalf, Radagast, and the two Blue Wizards (named in some records as Alatar and Pallando), though each had many names. Though each had the outward appearance of old men, they were kin to the Valar, and greater than Elves, Dwarves or Men. Though forbidden by Manwë to use their power to conquer and dominate, Saruman defied this and was excluded from the Order.

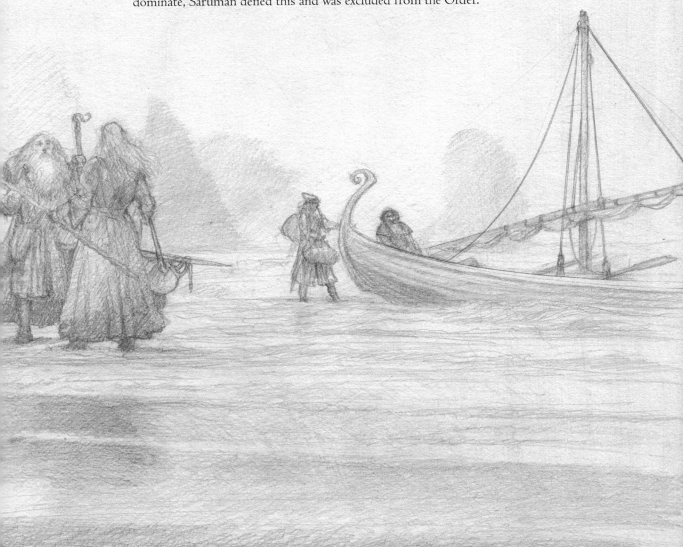

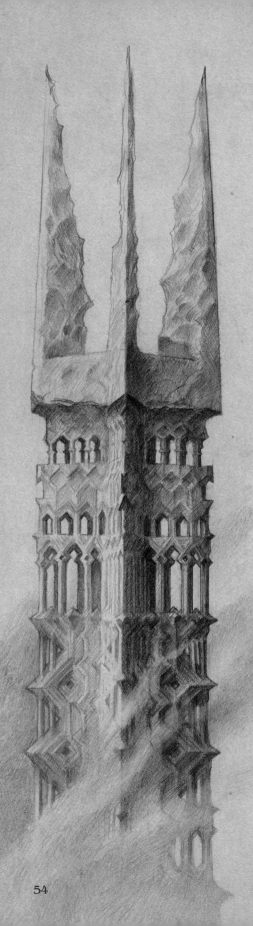

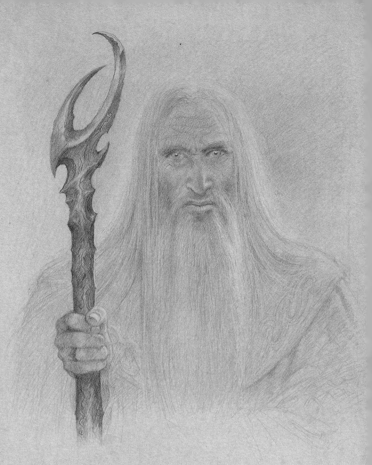

SARUMAN IN ORTHANC

"A peak and isle of rock it was, black and gleaming hard: four mighty piers of many-sided stone were welded into one, but near the summit they opened into gaping horns, their pinnacles sharp as the points of spears, keen-edged as knives. Between them was a narrow space, and there upon a floor of polished stone, written with strange signs, a man might stand five hundred feet above the plain."

Standing in the centre of the Ring of Isengard, Saruman's Tower of Orthanc was built by the Dúnedain, descendants of Elendil, at the time of the birth of the kingdoms of Arnor and Gondor. Green lawns and orchards filled the Ring, with paved avenues bordered by stone and copper pillars joined by great chains. A Palantír was kept in its upper chambers. Isengard was a strategic stronghold, keeping watch over the ford of the River Isen and the Gap of Rohan between the Misty Mountains to the north and the White Mountains to the south.

After the Long Winter of the year 2758 of the Third Age, Gondor was attacked by the Corsairs of Umbar, while Rohan was ravaged by the Dunlendings from the east, who occupied Isengard, though they were unable to enter the tower. Defeating the corsairs, Beren, Steward of Gondor, came to the aid of Rohan, and the Dunlendings were driven out of Isengard. When Saruman offered his services to Gondor as Warden of the Tower he was gratefully handed the Keys of Orthanc, which had been kept in Minas Tirith, by King Fréalaf of Rohan and the Steward Beren. The valley became known as Nan Curunír, or "Wizard's Vale". But Saruman's ambition was to locate the lost Ring of Power and use it to contest the will of Sauron. Daring to gaze into the Palantír to aid his search, his mind was snared by Sauron who corrupted him with visions of dominion over Middle-earth.

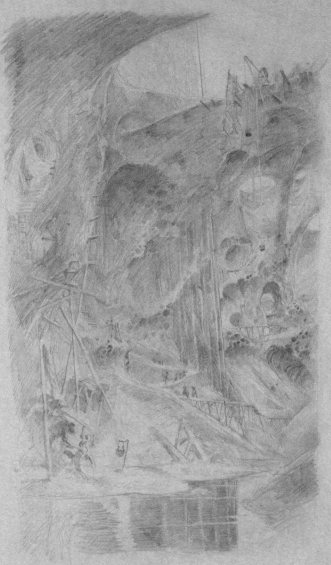

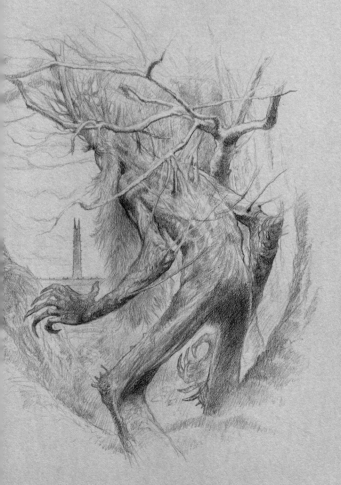

His mind turned to thoughts of steel and gears and furnaces. The orchards of Isengard were felled and great pits were filled with factories and forges of war. From Isengard, Saruman sent forth his army of Uruk-hai to destroy Rohan, but was in turn besieged by Treebeard and the Ents, who flooded the Ring and drowned the caverns, though they were powerless to damage the Tower itself.

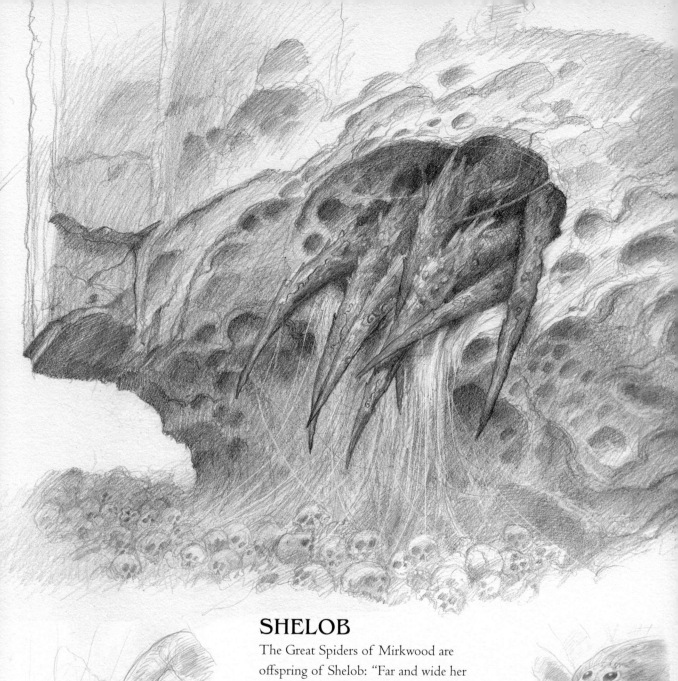

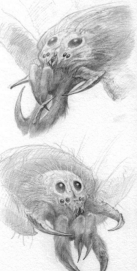

SHELOB

The Great Spiders of Mirkwood are offspring of Shelob: "Far and wide her lesser broods, bastards of the miserable mates, her own offspring, that she slew, spread from glen to glen, from the Ephel Dúath to the eastern hills, to Dol Guldur and the fastnesses of Mirkwood." The spiders speak in whispery voices that Bilbo can understand thanks to the Ring. Other remnants of the far-flung spawn of Shelob likely endure in the darkest corners of Middle-earth.

The way to Mordor. Frodo and Sam make their way to the tunnel-path which will lead them into Mordor

Shelob was the "last child of Ungoliant to trouble the unhappy world". Dwelling in Torech Ungol, the pass below Cirith Ungol, she devoured Orcs who strayed too close to the tunnels of her lair. Shelob stung Frodo and was about to carry him off when Sam stabbed her with the Elvish blade, Sting. Wounded, she fled shrieking in pain; her fate is unknown.

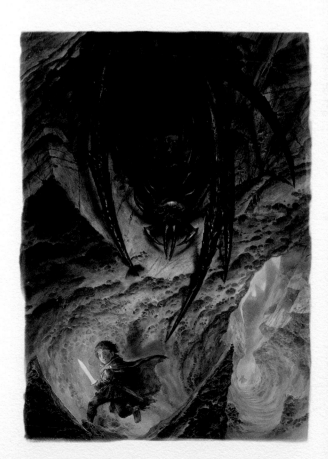

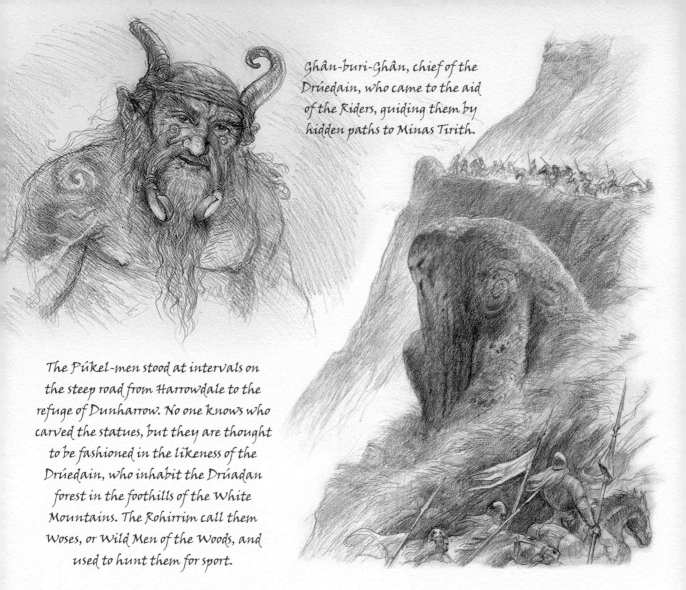

Ghân-buri-Ghân, chief of the
Drúedain, who came to the aid
of the Riders, guiding them by
hidden paths to Minas Tirith.

The Púkel-men stood at intervals on
the steep road from Harrowdale to the
refuge of Dunharrow. No one knows who
carved the statues, but they are thought
to be fashioned in the likeness of the
Drúedain, who inhabit the Drúadan
forest in the foothills of the White
Mountains. The Rohirrim call them
Woses, or Wild Men of the Woods, and
used to hunt them for sport.

There are many solitary beings in Middle-earth; dwelling apart or hidden, they have often become
the stuff of legend. The Barrow-wights, who haunt the Barrow-downs in Eriador, are close cousins
of the *draugr* that guarded Norse burial mounds. Tortured spirits, since the First Age they have
haunted the tombs of the Barrow-kings, whispering and crouching in the dark.

> "Cold be hand and heart and bone
> And cold be sleep under stone
> Never more to wake on stony bed
> Never, till the Sun falls and the Moon is dead.
> In the black wind the stars shall die
> And still be gold here let them lie
> Till the Dark Lord lifts his hand over dead sea and withered land."

Frodo and his companions very nearly die at their skeletal hands, saved – for a second time –
by Tom Bombadil's timely arrival.

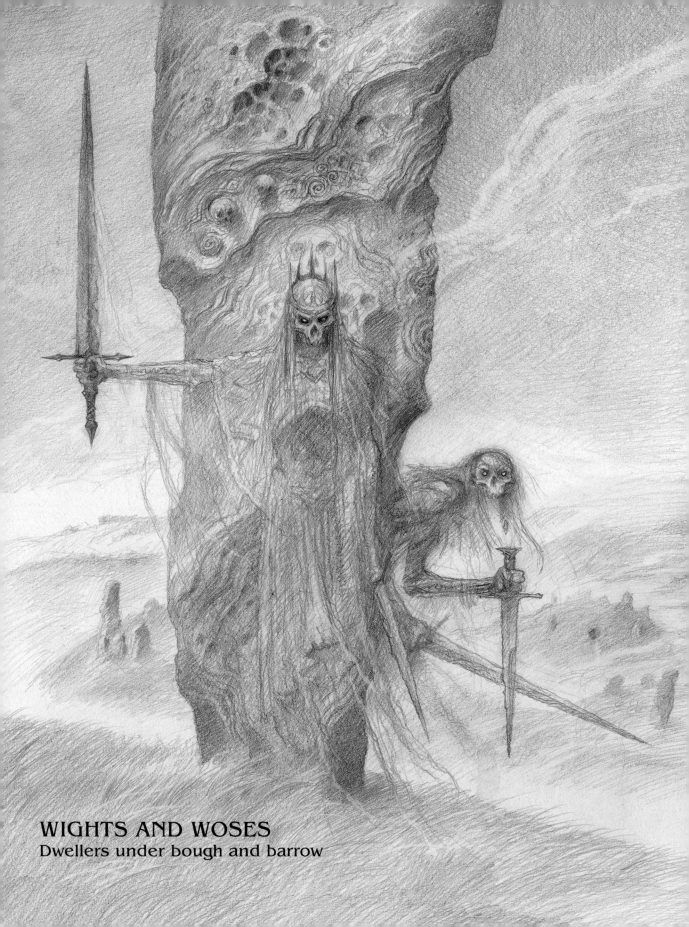

WIGHTS AND WOSES
Dwellers under bough and barrow

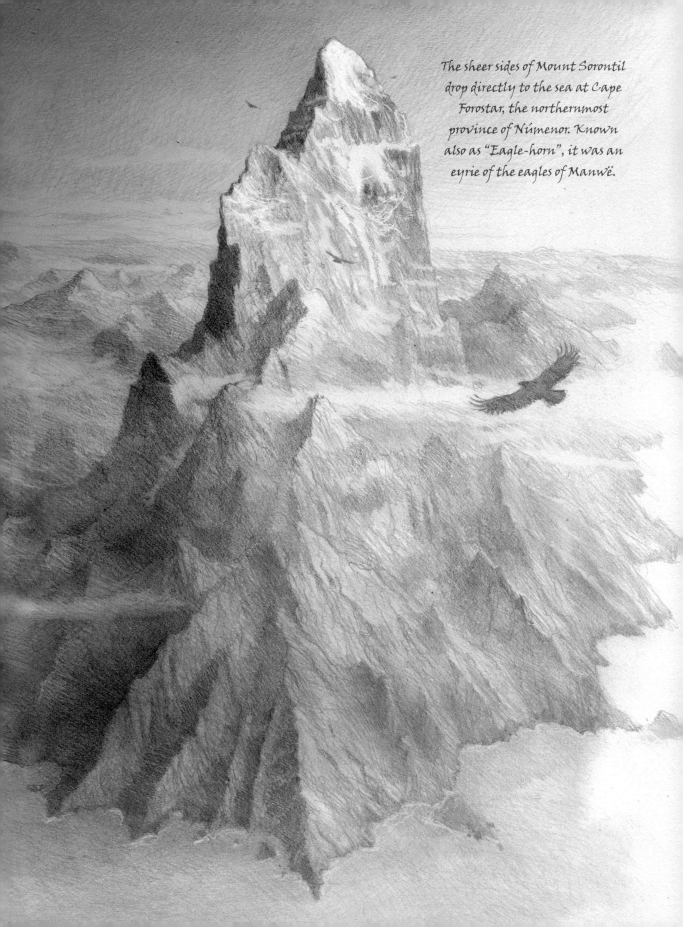

The sheer sides of Mount Sorontil
drop directly to the sea at Cape
Forostar, the northernmost
province of Númenor. Known
also as "Eagle-horn", it was an
eyrie of the eagles of Manwë.

Chapter Four

HIGH SNOWS & LOFTY AERIES
The Mountains of Middle-earth

Middle-earth is a world still young, with tangible traces of its creation and the great upheavals and strife between the Valar and Melkor. It is a land surveyed by gods; demigods still tread its paths in the First and Second Ages. Middle-earth is a land that has been broken many times. The chain of the Blue Mountains has been broken in two, sinking into the sea to create the Gulf of Lune. The oceans have been "bent" to remove Arda from Middle-earth. Islands and continents have been raised from beneath the seas.

Above these rugged and oft-tortured lands, the great Eagles ride the winds, choosing the highest peaks as their inaccessible aeries.

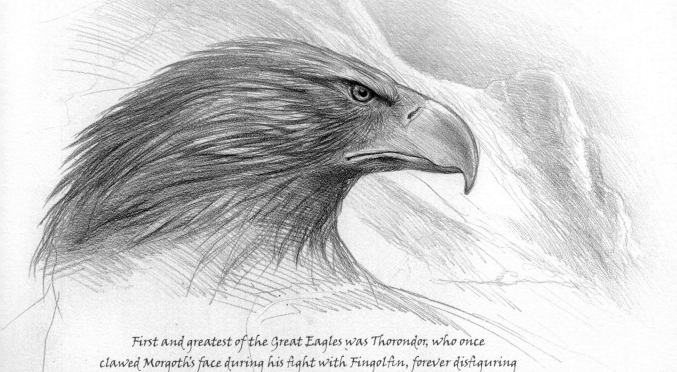

First and greatest of the Great Eagles was Thorondor, who once clawed Morgoth's face during his fight with Fingolfin, forever disfiguring the mighty Vala, and carrying the Elven-king's body to the mountain peaks of the Echoriath. He also fought alongside Eärendil during the Siege of Angband, aiding him in his slaying of the great dragon Ancalagon the Black

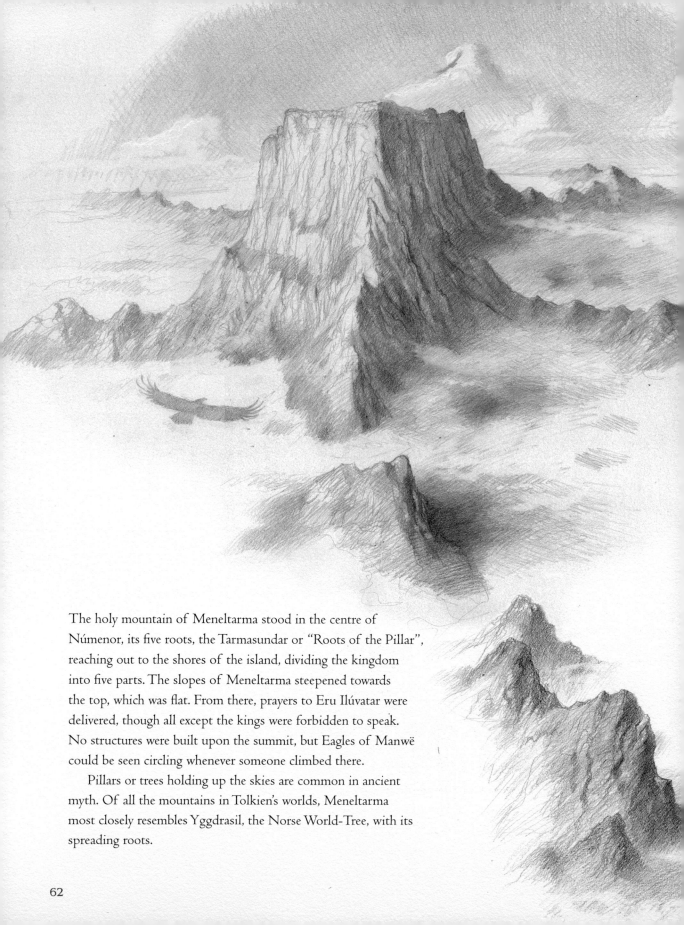

The holy mountain of Meneltarma stood in the centre of
Númenor, its five roots, the Tarmasundar or "Roots of the Pillar",
reaching out to the shores of the island, dividing the kingdom
into five parts. The slopes of Meneltarma steepened towards
the top, which was flat. From there, prayers to Eru Ilúvatar were
delivered, though all except the kings were forbidden to speak.
No structures were built upon the summit, but Eagles of Manwë
could be seen circling whenever someone climbed there.

Pillars or trees holding up the skies are common in ancient
myth. Of all the mountains in Tolkien's worlds, Meneltarma
most closely resembles Yggdrasil, the Norse World-Tree, with its
spreading roots.

THE EAGLES OF MANWË

The Eagles are said to have first inhabited Taniquetil in Arda, brought into being by Manwë himself. From there, they could be sent forth as the eyes of Manwë, to watch over the land.

For many years, the Eagles lived atop the triple peaks of Thangorodrim, until Morgoth established his power in Angband and they left for Crissaegrim, which became known as Cirith Thoronath or "Eagles' Cleft", because it was inaccessible from below.

A pair of Eagles had their home in the house of the King of Númenor, and Eagles kept watch over the sacred peak of Meneltarma. When Al-Pharazôn (corrupted in mind by Sauron) was preparing a great armada to make war upon the Valar, they sent storm-clouds in the form of Eagles to warn the Númenóreans. The warning went unheeded, and Númenor was destroyed.

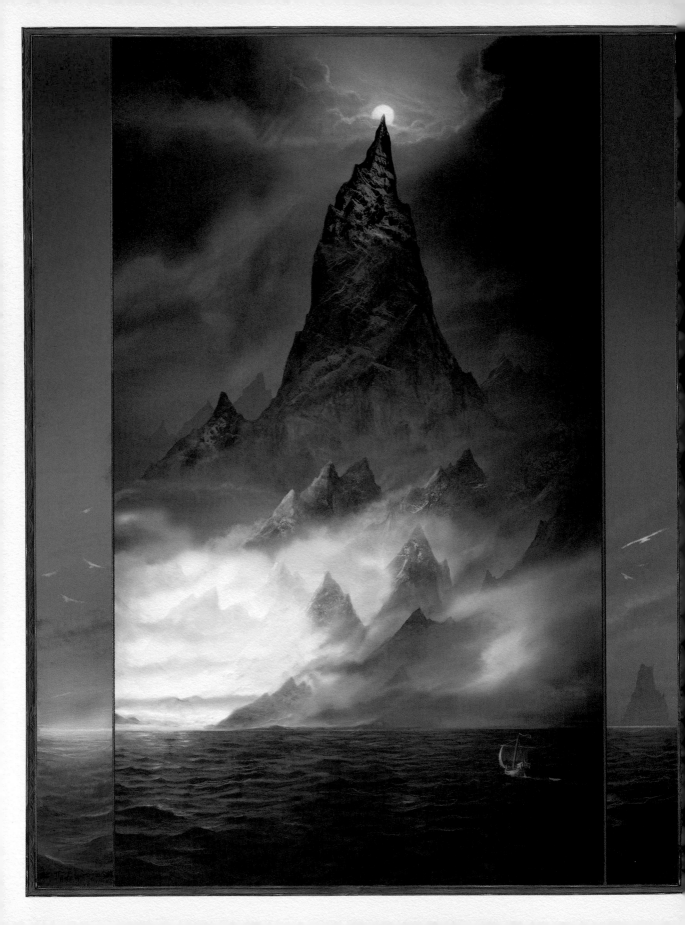

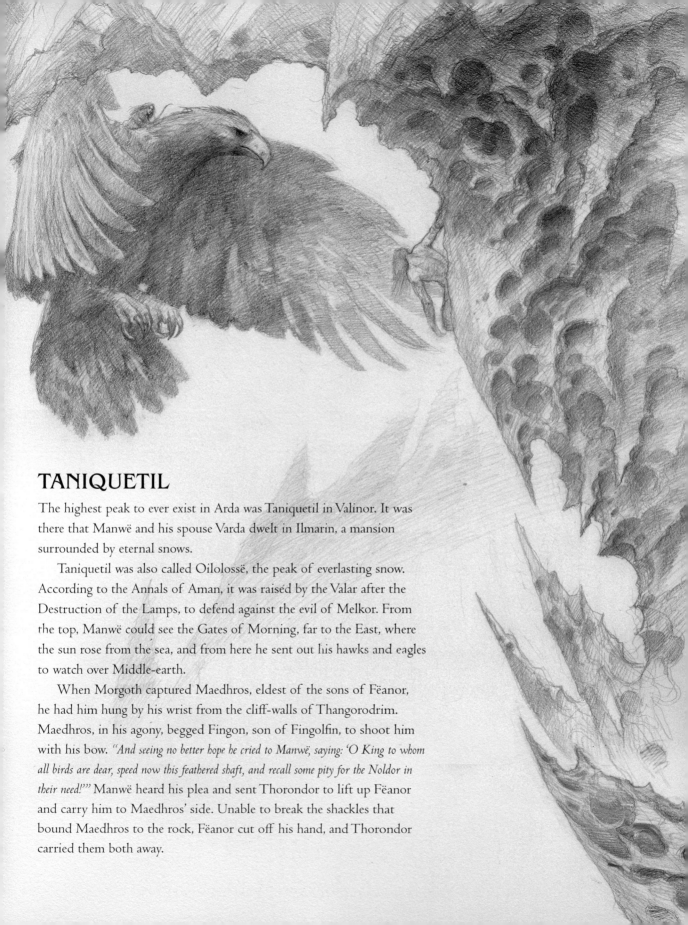

TANIQUETIL

The highest peak to ever exist in Arda was Taniquetil in Valinor. It was there that Manwë and his spouse Varda dwelt in Ilmarin, a mansion surrounded by eternal snows.

Taniquetil was also called Oilolossë, the peak of everlasting snow. According to the Annals of Aman, it was raised by the Valar after the Destruction of the Lamps, to defend against the evil of Melkor. From the top, Manwë could see the Gates of Morning, far to the East, where the sun rose from the sea, and from here he sent out his hawks and eagles to watch over Middle-earth.

When Morgoth captured Maedhros, eldest of the sons of Fëanor, he had him hung by his wrist from the cliff-walls of Thangorodrim. Maedhros, in his agony, begged Fingon, son of Fingolfin, to shoot him with his bow. *"And seeing no better hope he cried to Manwë, saying: 'O King to whom all birds are dear, speed now this feathered shaft, and recall some pity for the Noldor in their need!'"* Manwë heard his plea and sent Thorondor to lift up Fëanor and carry him to Maedhros' side. Unable to break the shackles that bound Maedhros to the rock, Fëanor cut off his hand, and Thorondor carried them both away.

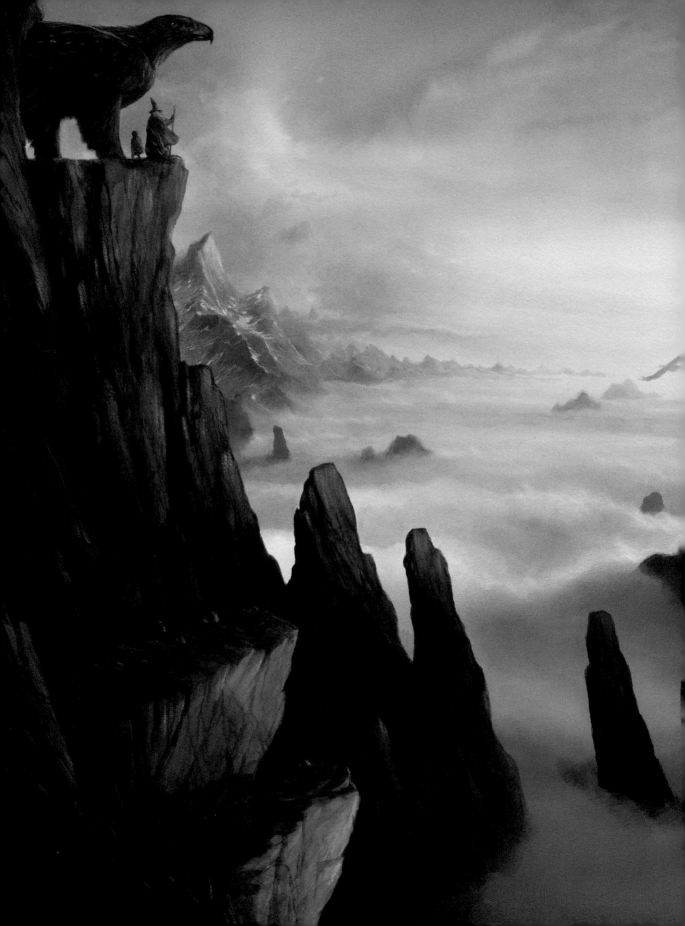

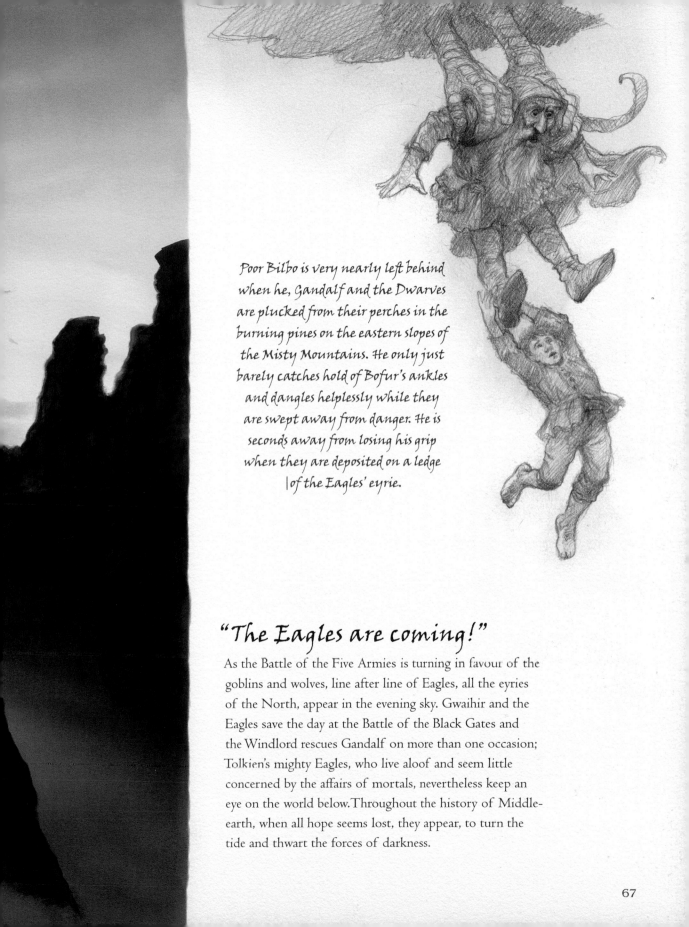

Poor Bilbo is very nearly left behind
when he, Gandalf and the Dwarves
are plucked from their perches in the
burning pines on the eastern slopes of
the Misty Mountains. He only just
barely catches hold of Bofur's ankles
and dangles helplessly while they
are swept away from danger. He is
seconds away from losing his grip
when they are deposited on a ledge
|of the Eagles' eyrie.

"The Eagles are coming!"

As the Battle of the Five Armies is turning in favour of the
goblins and wolves, line after line of Eagles, all the eyries
of the North, appear in the evening sky. Gwaihir and the
Eagles save the day at the Battle of the Black Gates and
the Windlord rescues Gandalf on more than one occasion;
Tolkien's mighty Eagles, who live aloof and seem little
concerned by the affairs of mortals, nevertheless keep an
eye on the world below. Throughout the history of Middle-
earth, when all hope seems lost, they appear, to turn the
tide and thwart the forces of darkness.

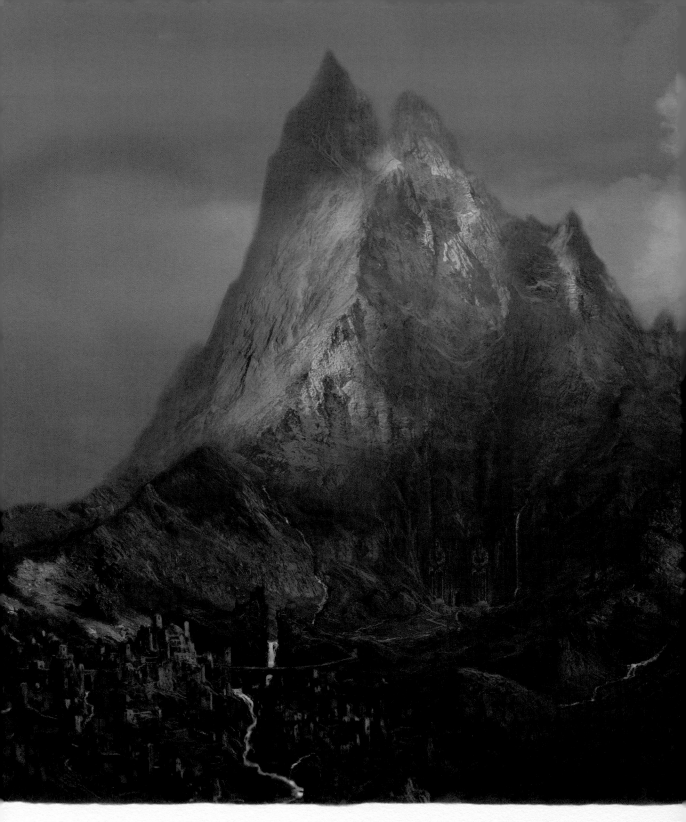

"There at last!" The Lonely Mountain, at the end of the Long Lake,
the final destination of Thorin's quest.

THE LONELY MOUNTAIN

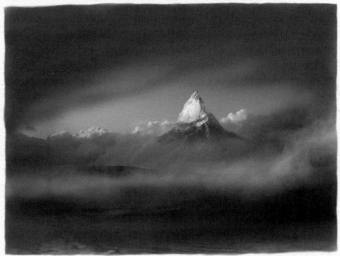

Tolkien's fondness for names allows him to build a dense history of Middle-earth with only a few words. At the time of *The Hobbit*, he was still exploring the world he had created, literally accompanying Bilbo on his adventures. Thus, for the Lonely Mountain, we have only the Sindarin name Erebor; but, given time, the solitary peak at the north end of the Long Lake, source of the River Running, would doubtless have gathered many more.

By creating names in each of the cultures of Middle-earth, Tolkien attaches to each a history seen through the eyes of those who first named it; comparing them to one another results in a fragmentary history of a convincing verisimilitude unattainable through simple description.

THE MISTY MOUNTAINS

Stretching fully nine hundred miles, from Carn Dûm near Mount Gundabad in the north to Dol Baran and the Gap of Rohan in the south, the unbroken chain of the Misty Mountains was upraised by Morgoth in the First Age to hinder the roaming of the Maiar huntsman Oromë. Durin, first of the Dwarves, awoke to the world under Gundabad, which later became a stronghold of the Witch-king of Angmar. Khazad-dûm, greatest of the Dwarven kingdoms, was founded by Durin under the peak of Celebdil, the Elven haven of Rivendell was to be found in its north-western foothills. Stone giants lived in the mountains, as Bilbo and his companions discovered.

The Misty Mountains had few passes. Most important of these were the High Pass above Rivendell and the Redhorn Pass, where the Fellowship of the Ring tried to cross before reluctantly entering the Mines of Moria. There were actually two alternative routes in the High Pass; the lower pass was more prone to being blocked by Orcs; hence most travellers used the higher pass, except during those rare interludes when the Orcs were suppressed.

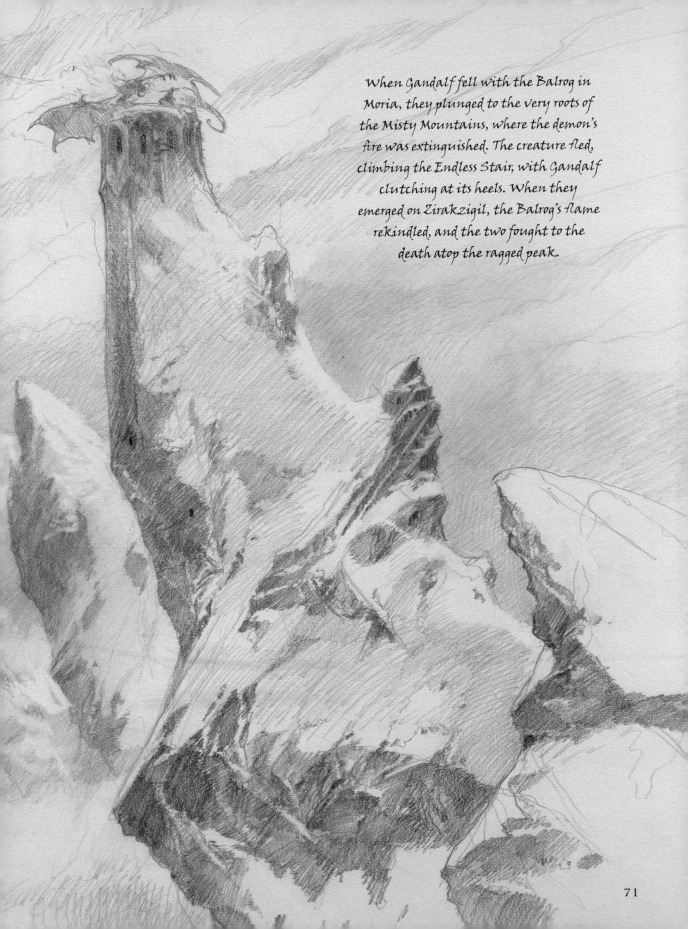

When Gandalf fell with the Balrog in
Moria, they plunged to the very roots of
the Misty Mountains, where the demon's
fire was extinguished. The creature fled,
climbing the Endless Stair, with Gandalf
clutching at its heels. When they
emerged on Zirakzigil, the Balrog's flame
rekindled, and the two fought to the
death atop the ragged peak.

71

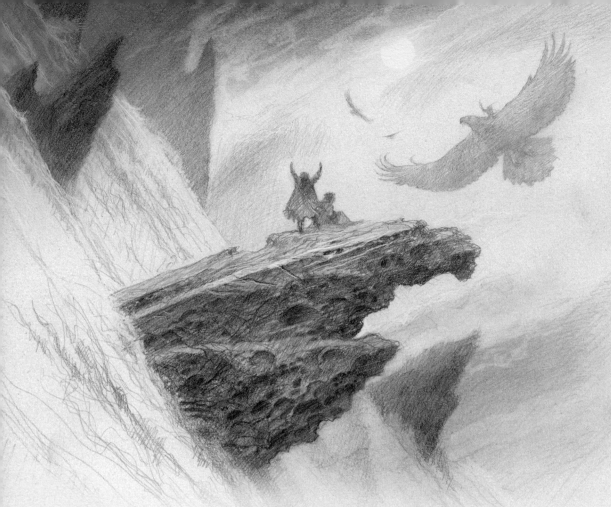

"Side by side they lay, and down swept Gwaihir, and down swept Landroval and Melendor the Swift, and in a dream, not knowing what fate had befallen them, the wanderers were lifted up and borne far away out of the darkness and the fire."

MOUNT DOOM

From the obsidian tower of Barad-dûr, Sauron's Road runs straight to Mount Doom on the Plains of Gorgoroth in the heart of Mordor, where it winds up the ragged flanks of the volcano before entering a tunnel near the summit. There, in the depths of the Mountain of Fire, is where the One Ring was forged, and there only can it be destroyed.

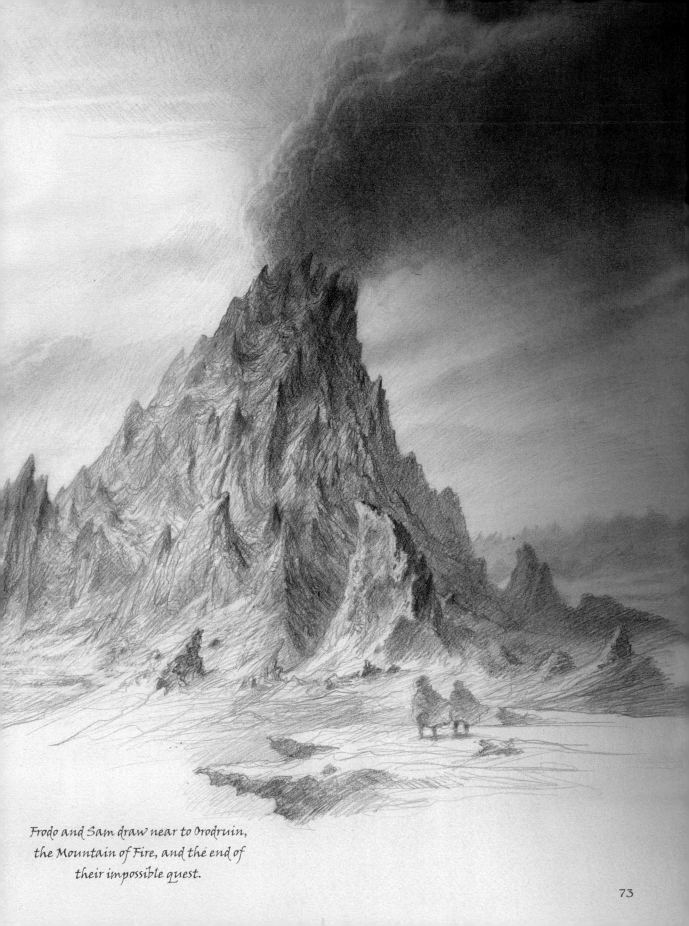

Frodo and Sam draw near to Orodruin,
the Mountain of Fire, and the end of
their impossible quest.

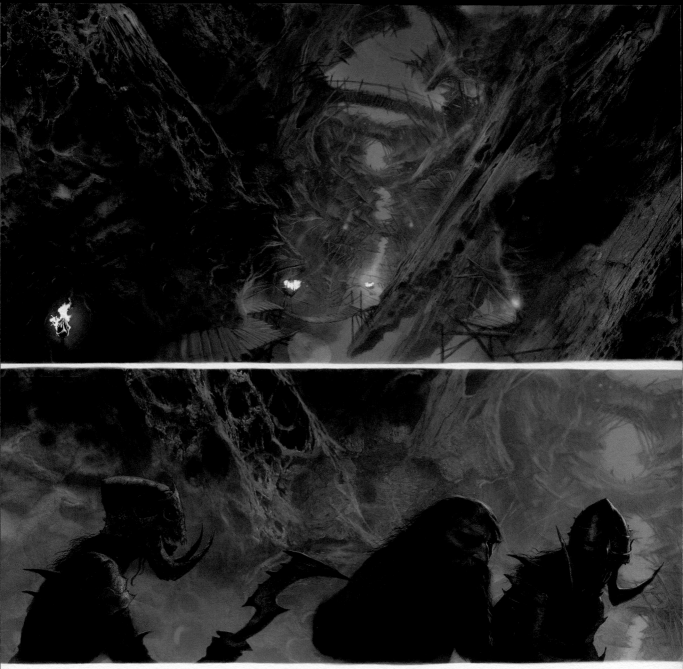

Chapter Five

GOBLIN CAVES

"And down down to Goblin-town..."

No sooner has the crack in the cave-floor trap snapped shut behind the Dwarves than they are pushed, pinched, shoved and sent stumbling down to Goblin-town to face the Great Goblin.

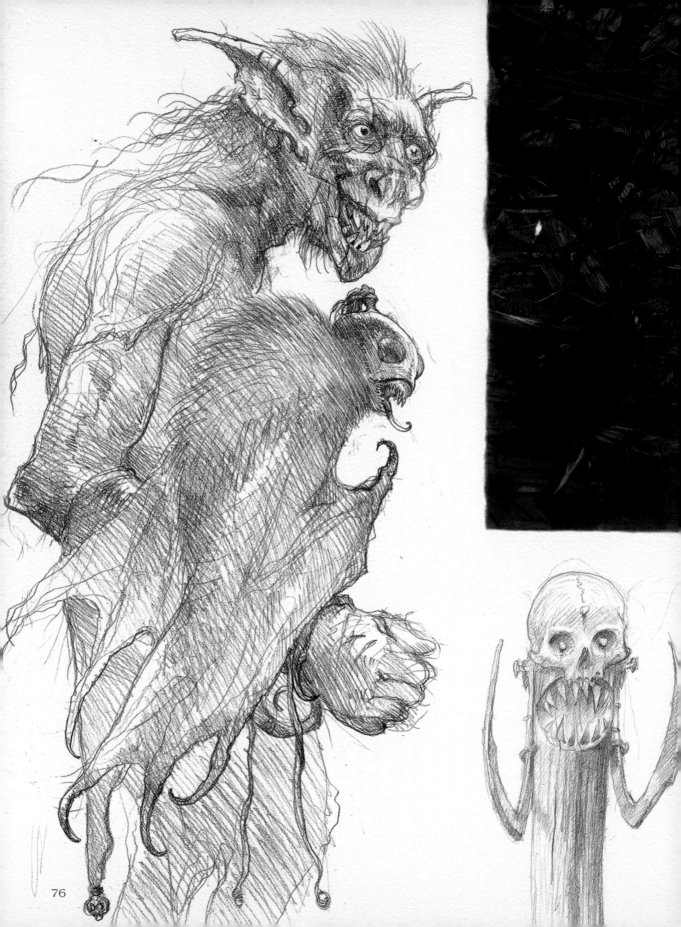

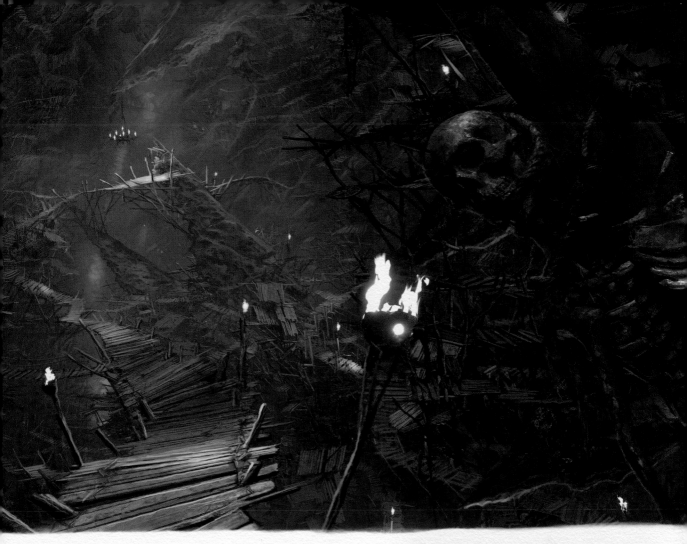

GOBLIN TOWN

Deep under the Misty Mountains live the goblins. Wedged into caverns aslant and possibly bottomless, their kingdom is an impossible maze of crooked walkways, ill-hung bridges and slippery platforms, the whole adorned with the spoils of their scavenging. And worse, they seem to be quite partial to Dwarf meat.

Thorin and Company are only saved by the timely intervention of Gandalf, who, in a flash of blinding light and a sweep of Glamdring, lops off the Great Goblin's head. As for their burglar, lost in the confusion, he is having an unexpected and fateful encounter on the shores of an underground lake far below.

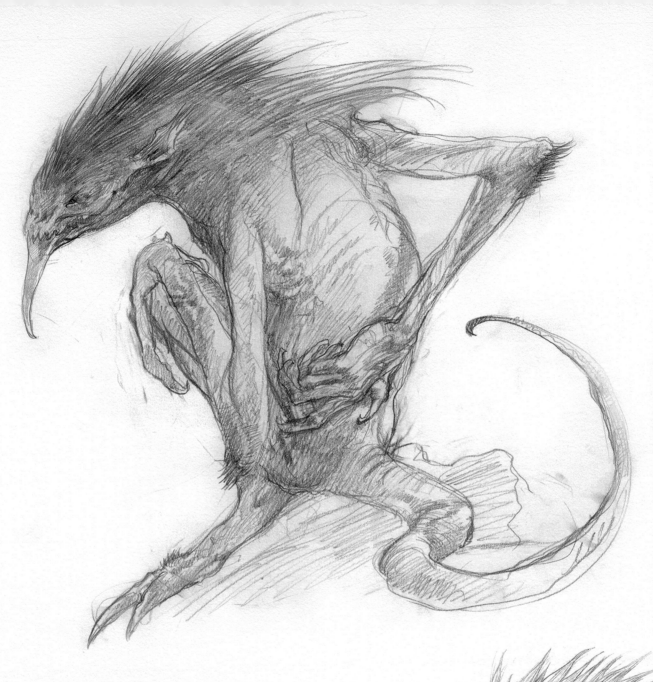

GOBLINS OF MORIA

After the Dwarves were driven from the Mines of Moria, and King
Durin V slain by a Balrog, Goblins infested the underground kingdom.
Thrór led a force to reclaim the mines, but was killed by the Goblin
leader Azog. The Dwarves eventually slew Azog, and his son Bolg died
in the Battle of the Five Armies. Balin and the Dwarves reclaimed
Moria, but were besieged and killed. When Gandalf led the Company
of the Ring through the same mines, they were assaulted by Goblins —
and something far more deadly, roused from the darkness far below.

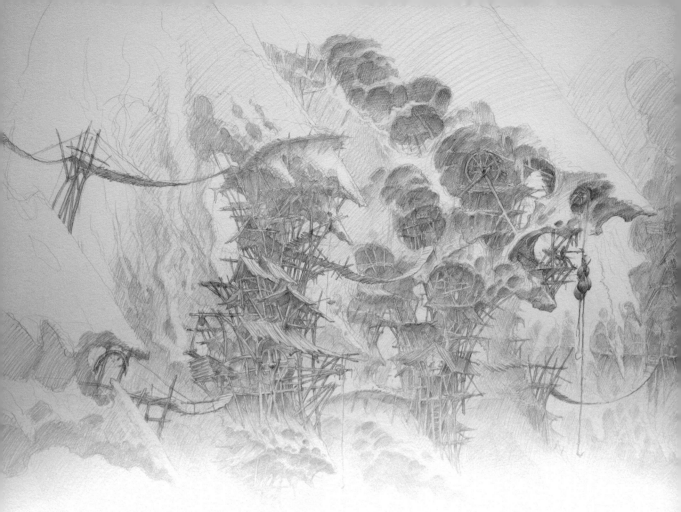

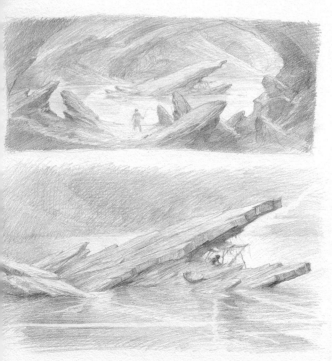

RIDDLES IN THE DARK

Impossible questions and riddle games are found throughout world folklore. The guessing game has been part of this since ancient times. Often the hero of the folk tale — the orphan, the younger son or the poor suitor — completes his quest not through strength or skill of arms, but through cleverness and kindness. Orpheus successfully and famously answers the question of the Theban sphinx and thus escapes destruction. Bilbo cheats (just a little) but escapes Gollum's clutches, redeeming himself for his unfair play by sparing the creature as he flees.

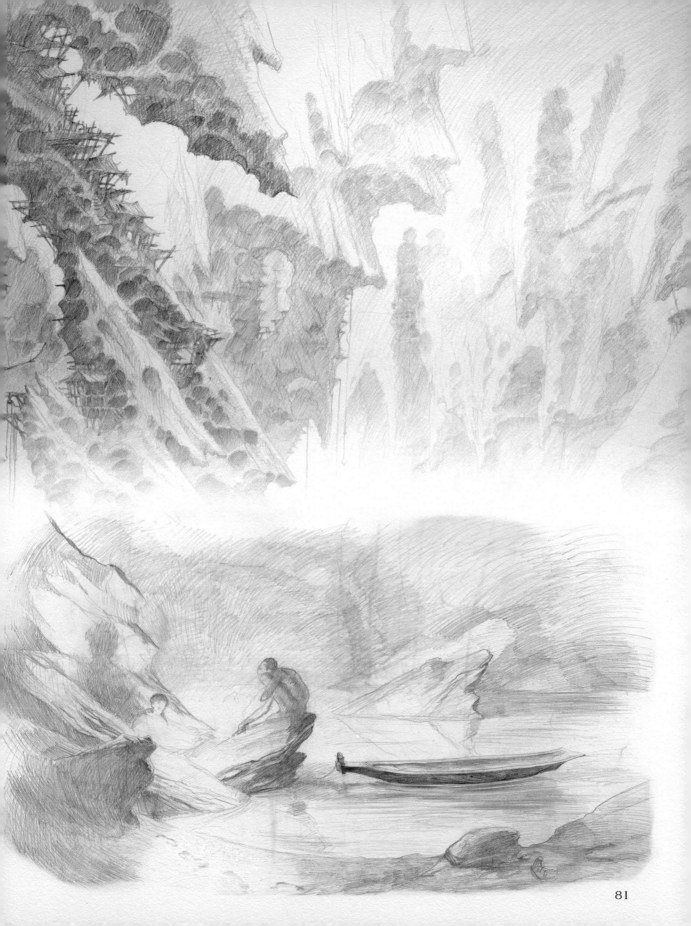

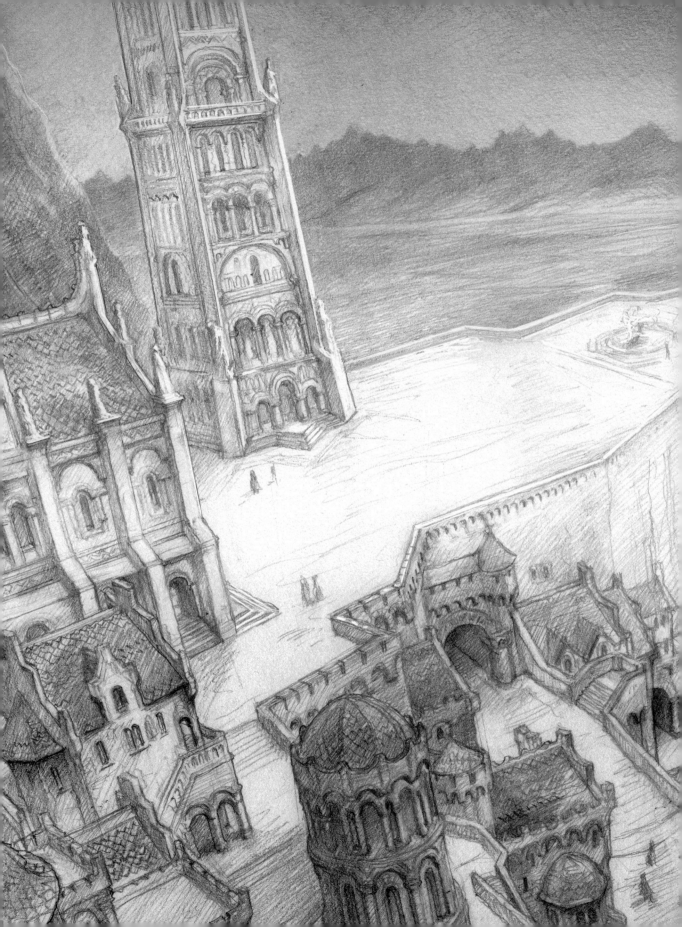

Chapter Six

CITIES OF MEN

MINAS TIRITH

Minas Tirith, the greatest city in Middle-earth, striking citadel and capital of the splendid Kingdom of Gondor, was built upon the outthrust knee of Mount Mindolluin. "For the fashion of Minas Tirith was such that it was built on seven levels, each delved into the hill, and about each was set a wall, and in each was a gate. But the gates were not set in a line: the Great Gate in the City wall was at the east point of the circuit, but the next faced half south, and the third half north, and so to and fro upwards; so the paved way that climbed toward the citadel turned this way and that and then that across the face of the hill." The outer wall was constructed of the same dark stone as Orthanc, pierced only by the great iron-bound gate, flanked by towers and bastions. From the Great Gate to the Anduin stretch the Pelennor fields, and beyond, the grim and jagged silhouette of the Ephel Dúath, border of the dark land of Mordor.

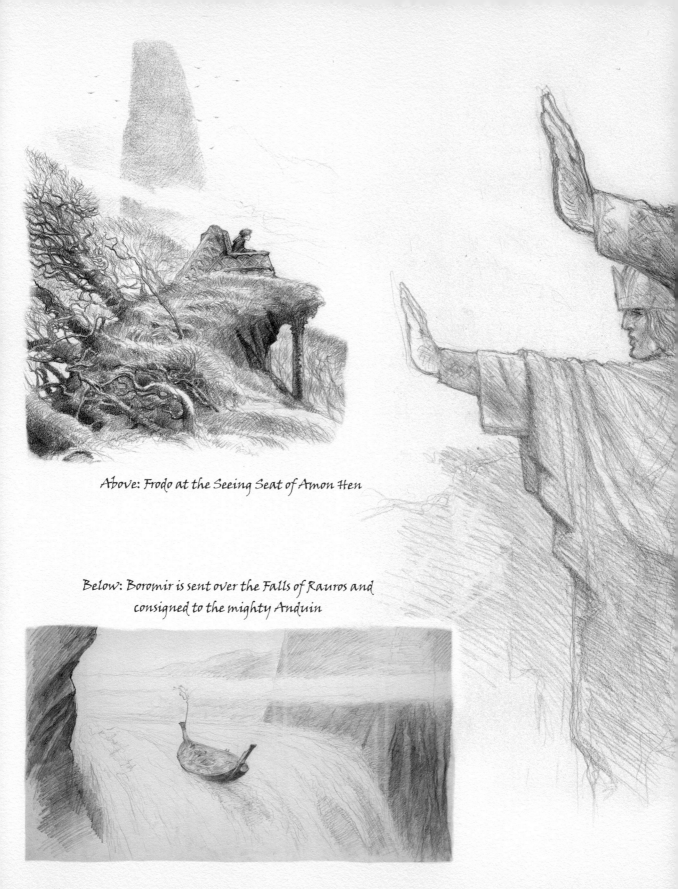

Above: Frodo at the Seeing Seat of Amon Hen

Below: Boromir is sent over the Falls of Rauros and consigned to the mighty Anduin

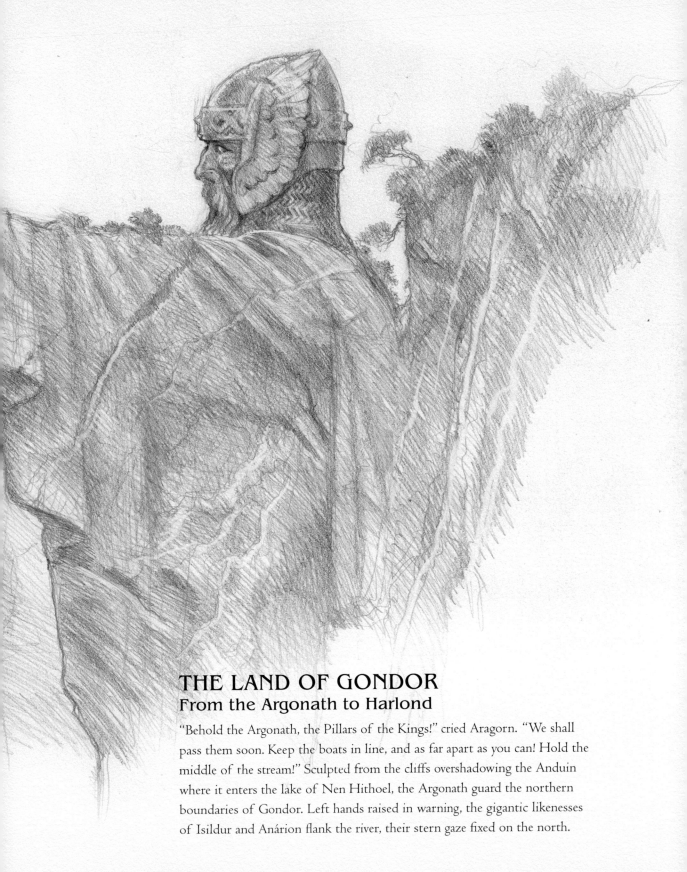

THE LAND OF GONDOR
From the Argonath to Harlond

"Behold the Argonath, the Pillars of the Kings!" cried Aragorn. "We shall pass them soon. Keep the boats in line, and as far apart as you can! Hold the middle of the stream!" Sculpted from the cliffs overshadowing the Anduin where it enters the lake of Nen Hithoel, the Argonath guard the northern boundaries of Gondor. Left hands raised in warning, the gigantic likenesses of Isildur and Anárion flank the river, their stern gaze fixed on the north.

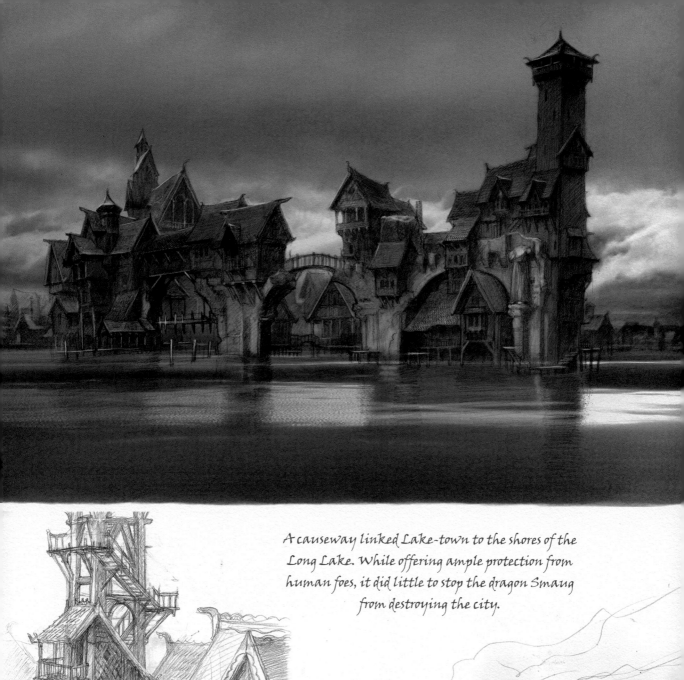

A causeway linked Lake-town to the shores of the
Long Lake. While offering ample protection from
human foes, it did little to stop the dragon Smaug
from destroying the city.

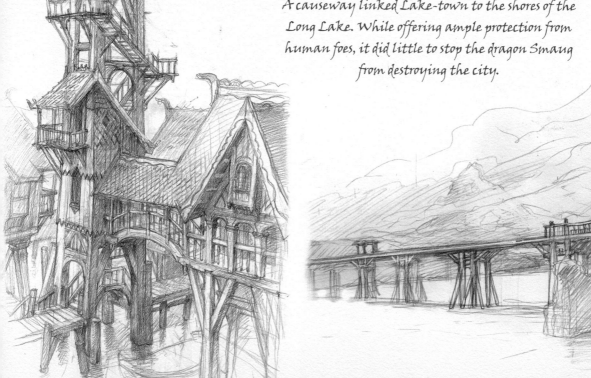

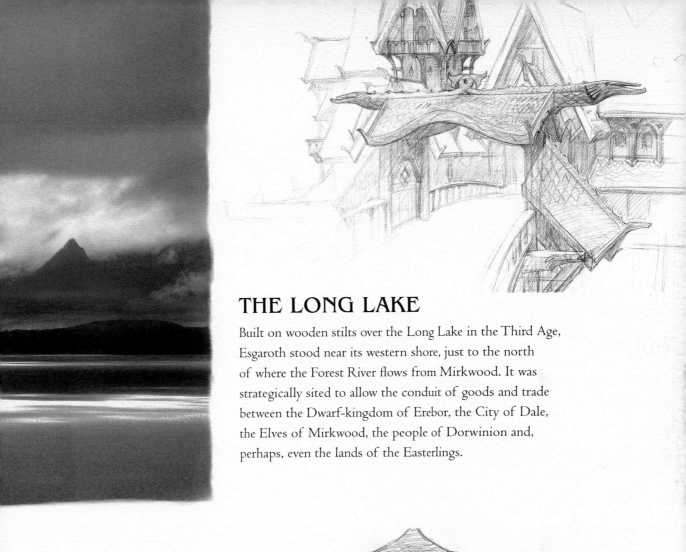

THE LONG LAKE

Built on wooden stilts over the Long Lake in the Third Age, Esgaroth stood near its western shore, just to the north of where the Forest River flows from Mirkwood. It was strategically sited to allow the conduit of goods and trade between the Dwarf-kingdom of Erebor, the City of Dale, the Elves of Mirkwood, the people of Dorwinion and, perhaps, even the lands of the Easterlings.

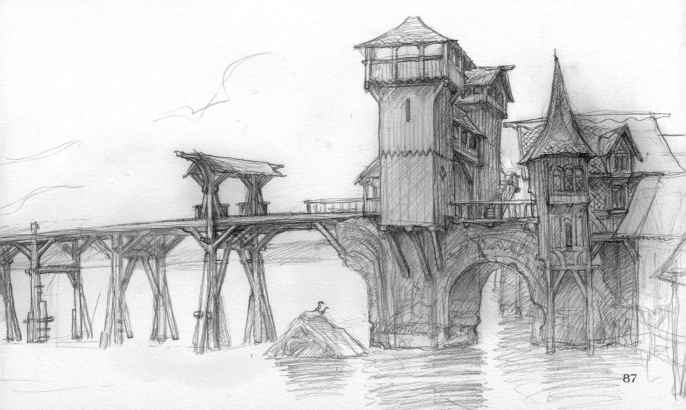

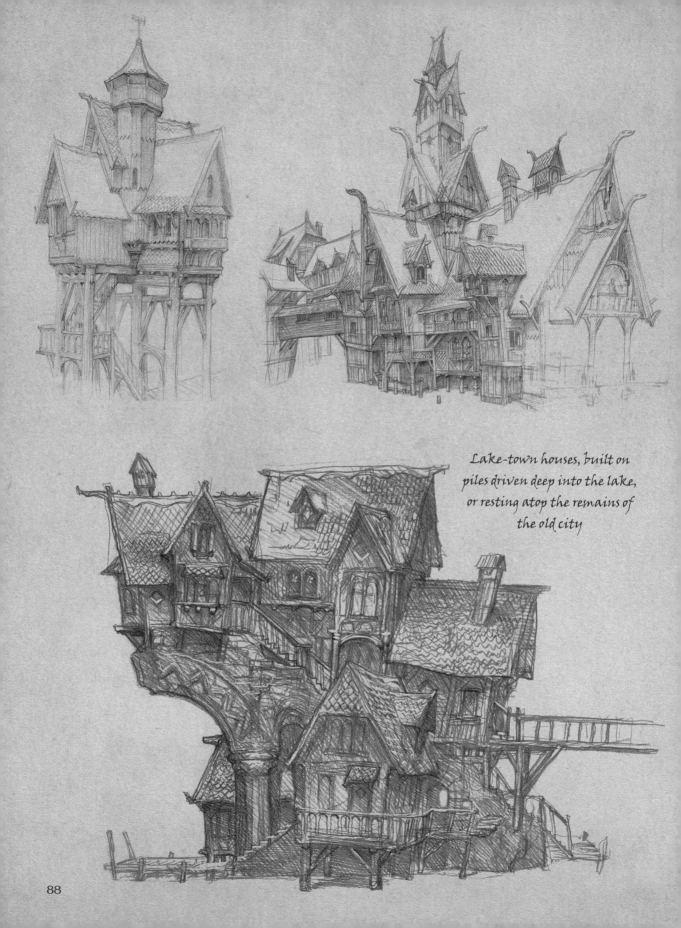

Lake-town houses, built on
piles driven deep into the lake,
or resting atop the remains of
the old city

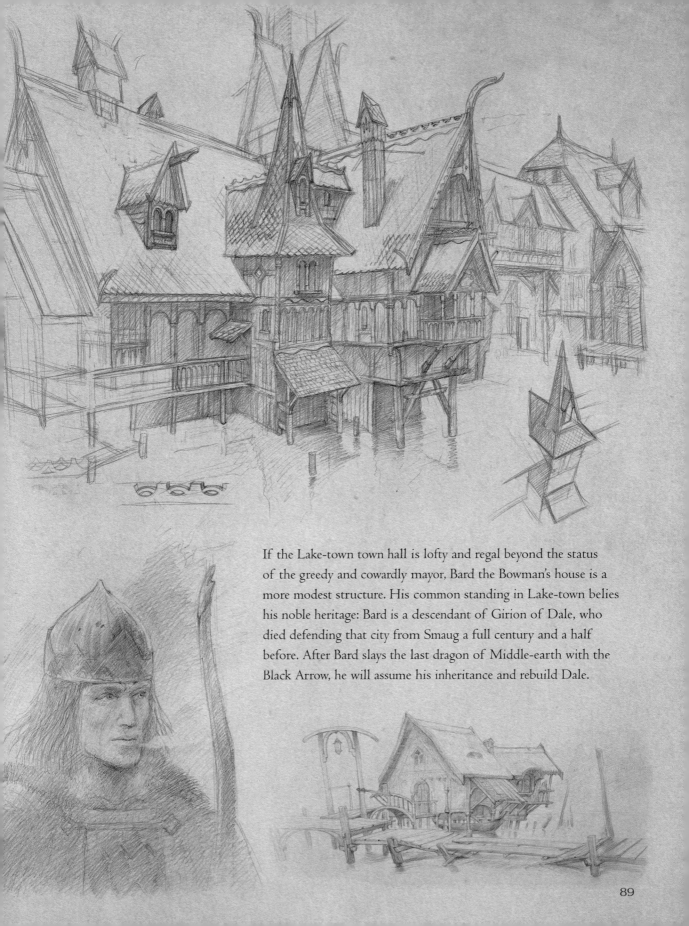

If the Lake-town town hall is lofty and regal beyond the status of the greedy and cowardly mayor, Bard the Bowman's house is a more modest structure. His common standing in Lake-town belies his noble heritage: Bard is a descendant of Girion of Dale, who died defending that city from Smaug a full century and a half before. After Bard slays the last dragon of Middle-earth with the Black Arrow, he will assume his inheritance and rebuild Dale.

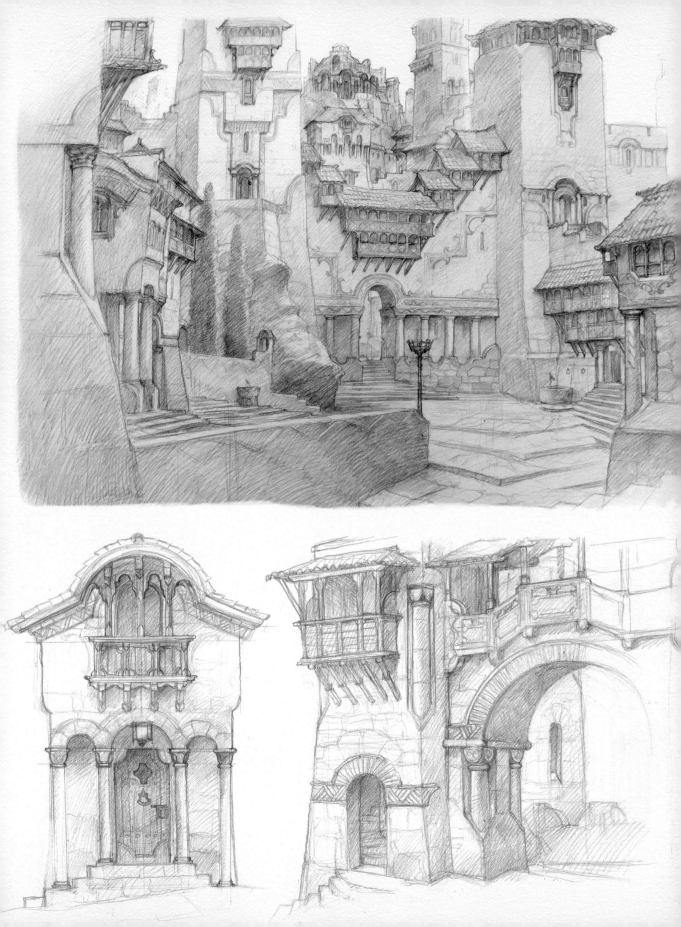

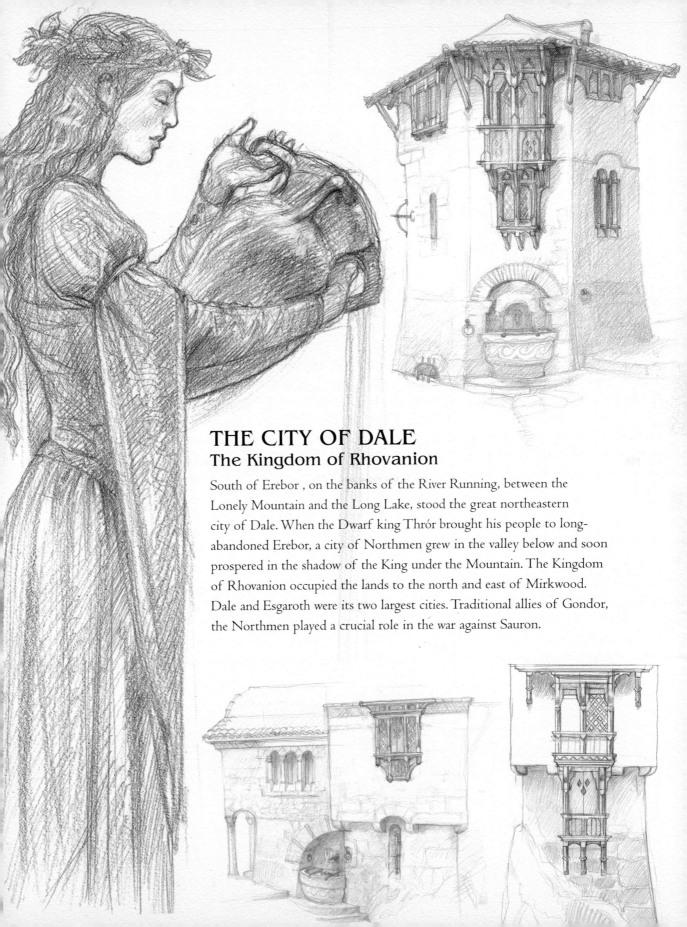

THE CITY OF DALE
The Kingdom of Rhovanion

South of Erebor , on the banks of the River Running, between the
Lonely Mountain and the Long Lake, stood the great northeastern
city of Dale. When the Dwarf king Thrór brought his people to long-
abandoned Erebor, a city of Northmen grew in the valley below and soon
prospered in the shadow of the King under the Mountain. The Kingdom
of Rhovanion occupied the lands to the north and east of Mirkwood.
Dale and Esgaroth were its two largest cities. Traditional allies of Gondor,
the Northmen played a crucial role in the war against Sauron.

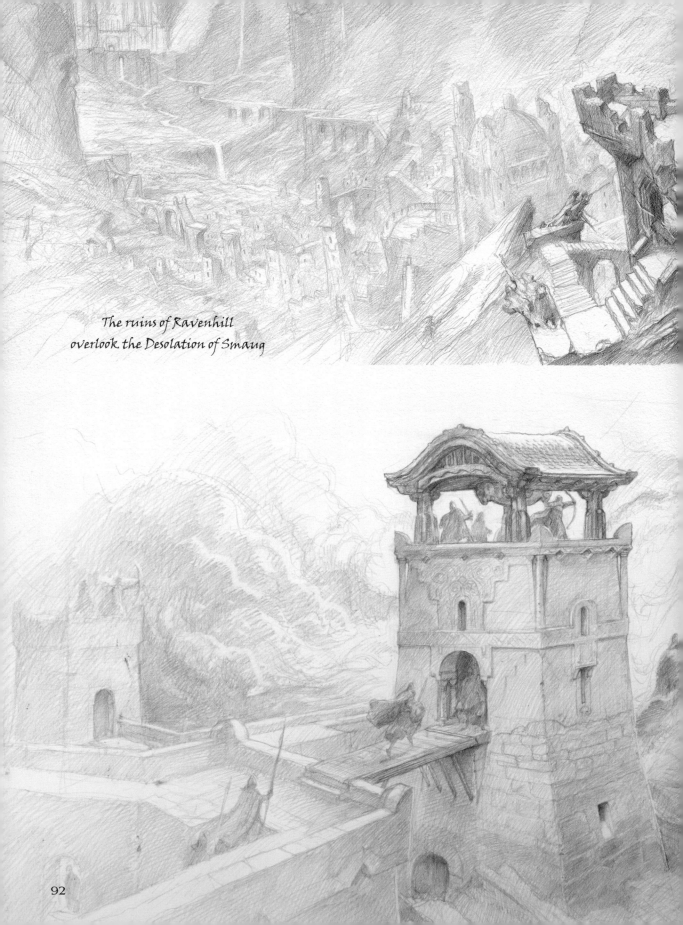

The ruins of Ravenhill
overlook the Desolation of Smaug

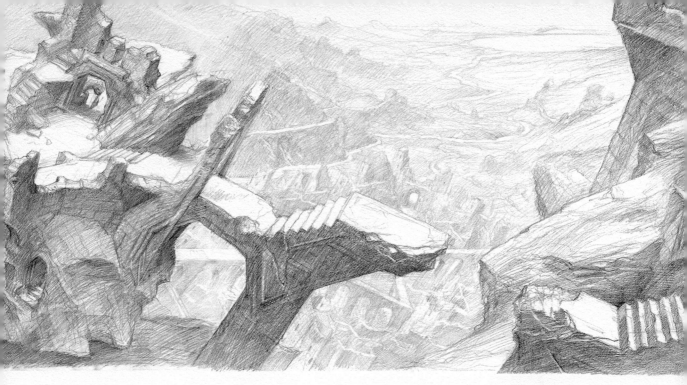

Lured by the fame and wealth of Erebor, Smaug the Golden came like a storm from the North in the year 2770 of the Third Age, destroying the city of Dale. Once he had taken up residence in Erebor, Smaug would emerge at night to devour any human he found.

THE RUINS OF DALE

When Thorin and Company journeyed through Dale on their way to the Lonely Mountain they found it a blackened and sinister ruin. After Smaug's death, Bard became the Lord of Dale; his descendant Brand, allied with Dáin Ironfoot of Erebor, defended the valley against Sauron's Easterlings at the Battle of Dale during the War of the Ring.

AT THE SIGN OF THE PRANCING PONY

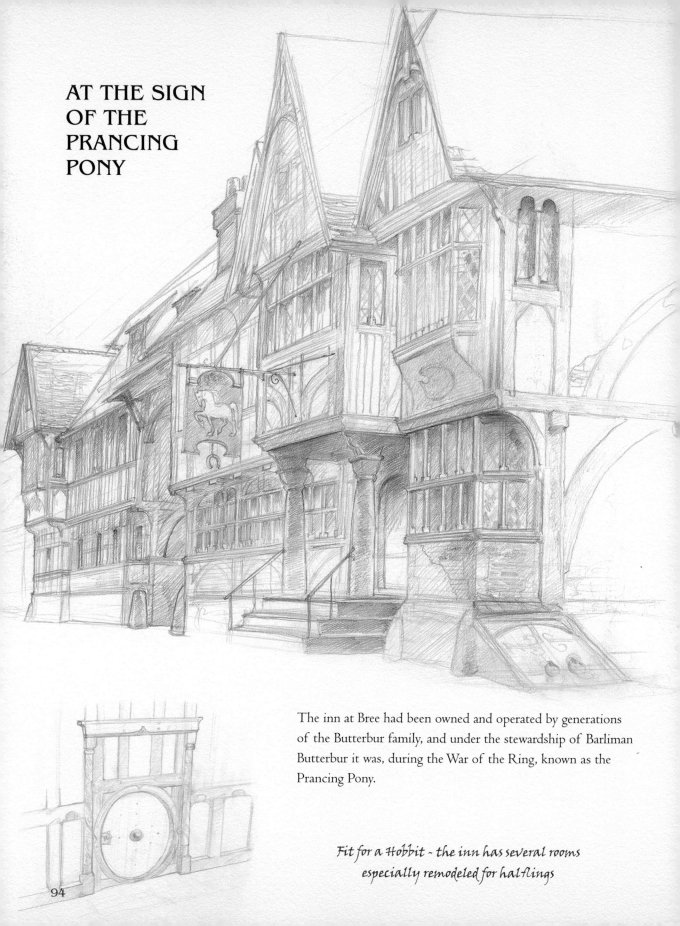

The inn at Bree had been owned and operated by generations of the Butterbur family, and under the stewardship of Barliman Butterbur it was, during the War of the Ring, known as the Prancing Pony.

Fit for a Hobbit - the inn has several rooms especially remodeled for halflings

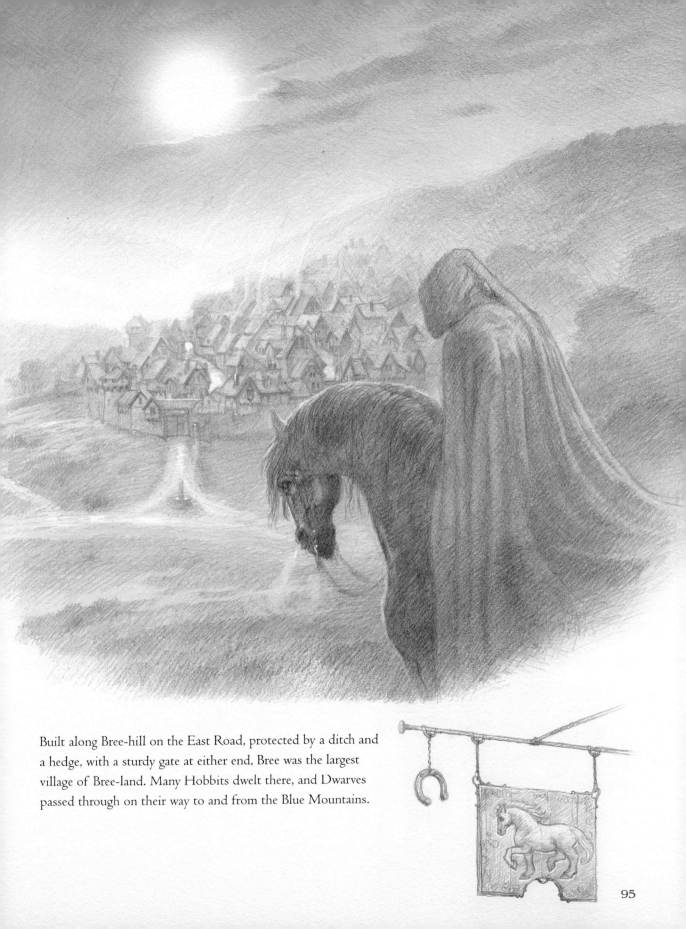

Built along Bree-hill on the East Road, protected by a ditch and a hedge, with a sturdy gate at either end, Bree was the largest village of Bree-land. Many Hobbits dwelt there, and Dwarves passed through on their way to and from the Blue Mountains.

95

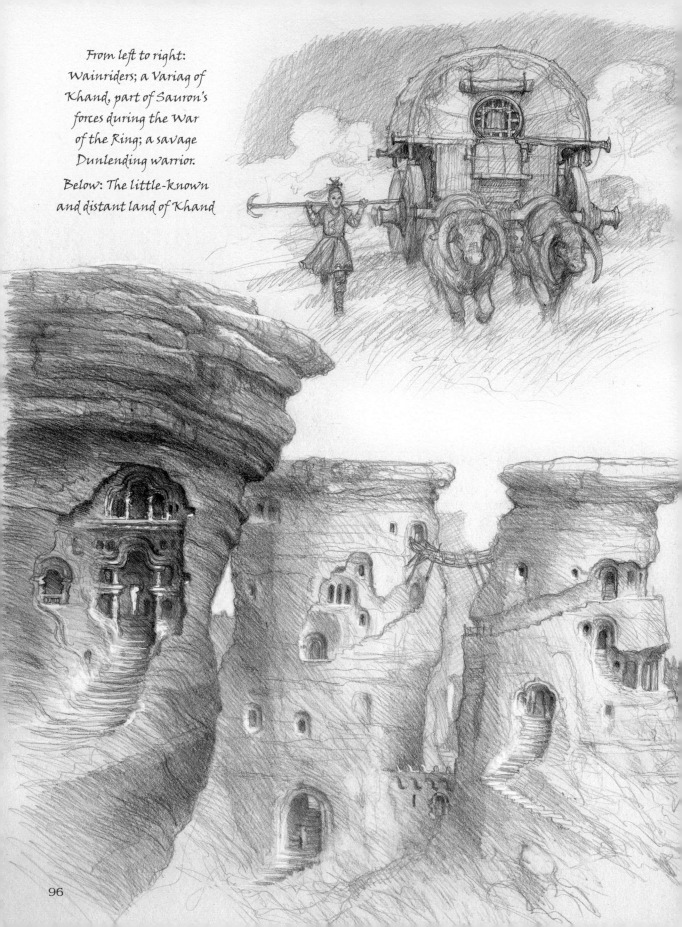

From left to right:
Wainriders; a Variag of
Khand, part of Sauron's
forces during the War
of the Ring; a savage
Dunlending warrior.

Below: The little-known
and distant land of Khand

96

KHAND, HARAD AND UMBAR

East and South of the lands described by Tolkien are places less familiar: Dunland, home to the Dunlendings, bordered Rohan to the east. From farther east came the Wainriders, who often troubled the Northmen of Rhovanion. Southeast of Mirkwood dwelled the Balchoth or "cruel people", a savage tribe of raiders. Umbar, to the south, was peopled by fierce pirates; faraway Khand, the land of the Variags, bordered upon Mordor from the south-east. Near Harad lay to the south of Gondor, and beyond that the vast land of Far Harad, peopled by the mûmakil-riding Southrons. East of Rhovanion lay the Brown Lands, and beyond that, the Sea of Rhûn, where the Kine of Araw, large and hardy wild-oxen, roamed in earlier ages. The Horn of Gondor, sounded in vain by Boromir before his death at Amon Hen, came from one of those creatures.

Chapter Seven

OCEANS OF GRASS

THE LAND OF ROHAN
Kingdom of the Horse Lords

From the Misty Mountains to the north and the White Mountains to
the south, from the Fords of Isen to the west and the great River Anduin
to the east, lies Rohan, the kingdom of the Rohirrim. The Horse Lords
call themselves the Eorlinga, descendants of Eorl the Young, first king
of Rohan.

Edoras, the capital, stands on a high hill in the valley of Harrowdale,
under the shadow of the snow-capped Starkhorn, from whose feet
springs the swift Snowbourn. The North-South Road fords the river
before the gates of Edoras.

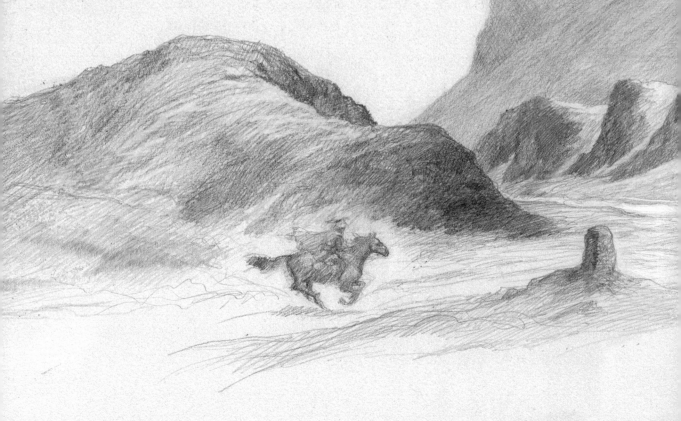

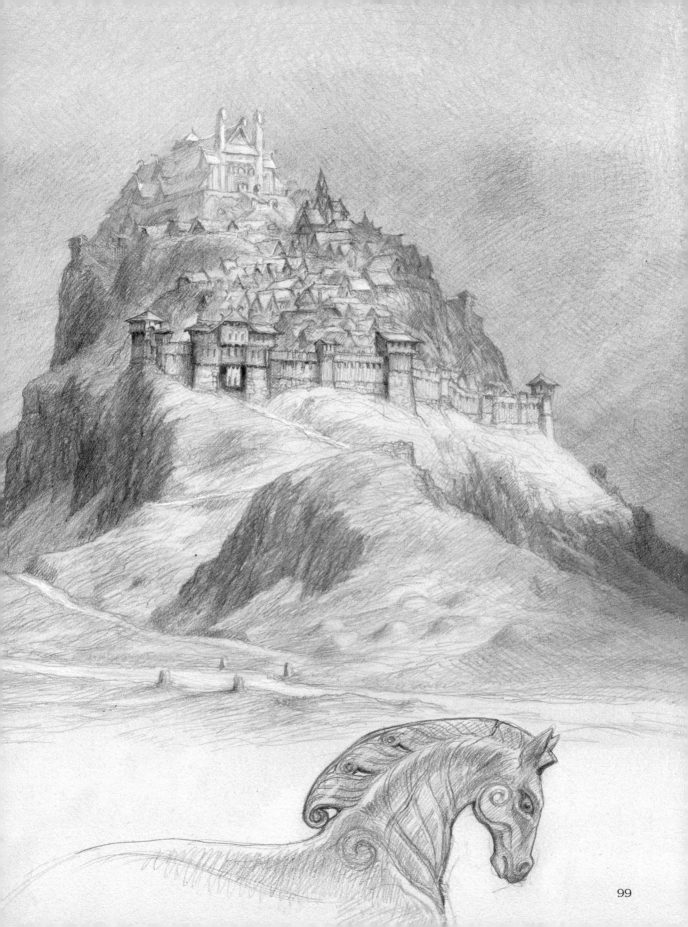

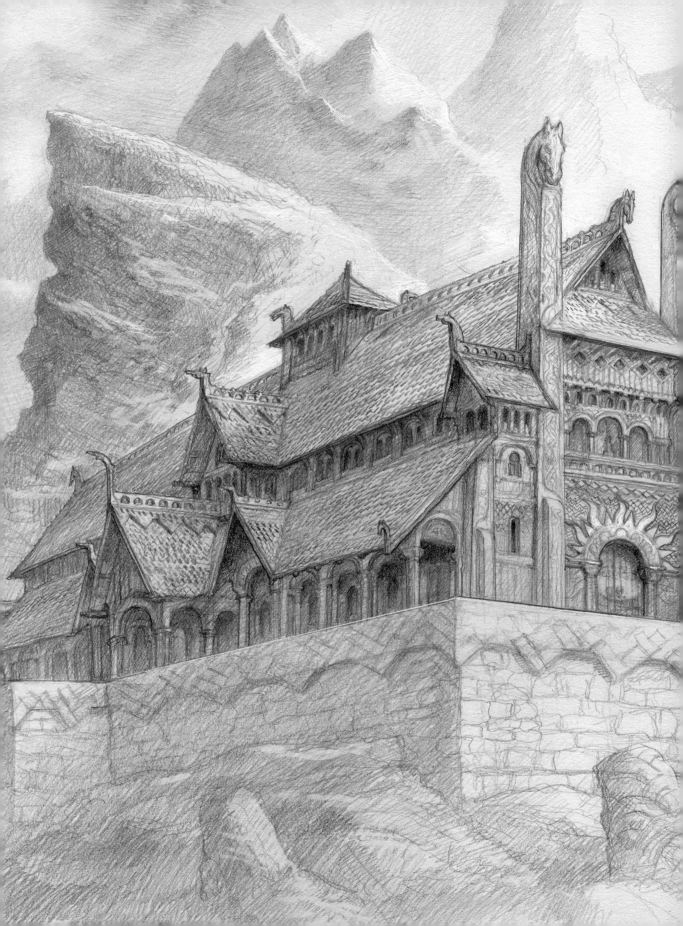

MEDUSELD

In Edoras, stands Meduseld, the Golden Hall. Built by
Brego, son of Eorl, it was completed in 2569 of the Third
Age, four centuries before the War of the Ring. Standing
on the summit of the hill, when first glimpsed by
Aragorn, Legolas and Gimli, in the company of Gandalf
the White, its roofs seem to glow golden in the sun.

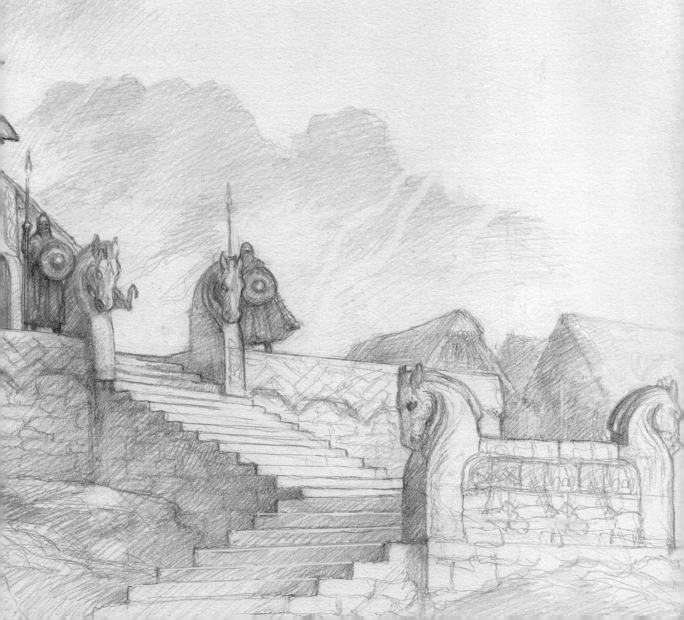

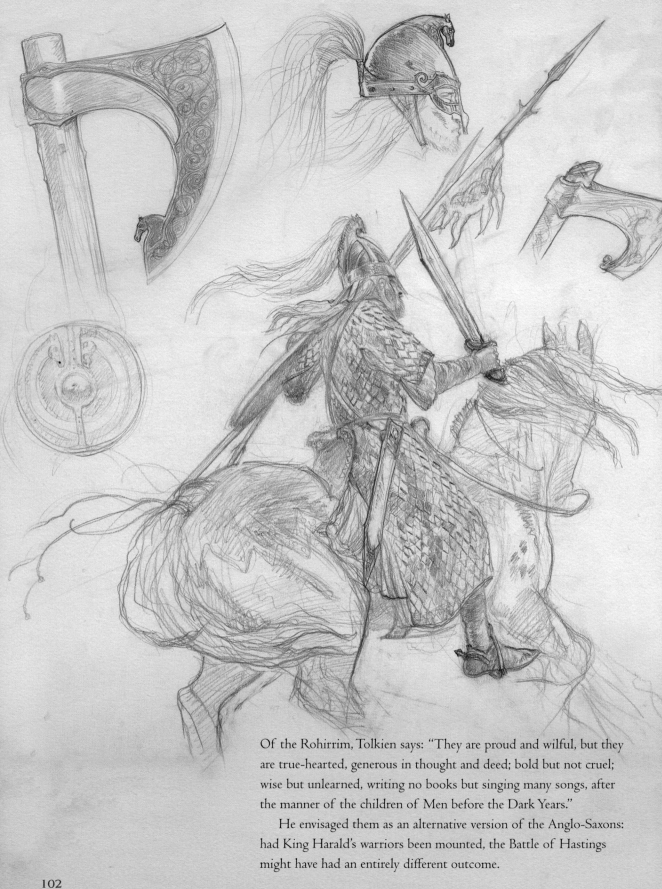

Of the Rohirrim, Tolkien says: "They are proud and wilful, but they are true-hearted, generous in thought and deed; bold but not cruel; wise but unlearned, writing no books but singing many songs, after the manner of the children of Men before the Dark Years."

He envisaged them as an alternative version of the Anglo-Saxons: had King Harald's warriors been mounted, the Battle of Hastings might have had an entirely different outcome.

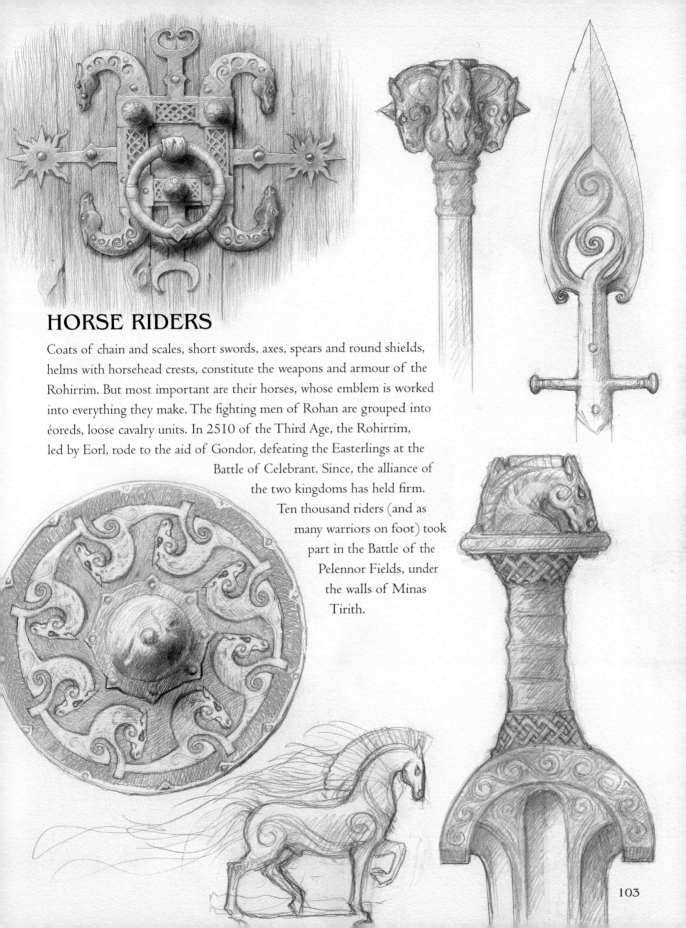

HORSE RIDERS

Coats of chain and scales, short swords, axes, spears and round shields, helms with horsehead crests, constitute the weapons and armour of the Rohirrim. But most important are their horses, whose emblem is worked into everything they make. The fighting men of Rohan are grouped into éoreds, loose cavalry units. In 2510 of the Third Age, the Rohirrim, led by Eorl, rode to the aid of Gondor, defeating the Easterlings at the Battle of Celebrant. Since, the alliance of the two kingdoms has held firm. Ten thousand riders (and as many warriors on foot) took part in the Battle of the Pelennor Fields, under the walls of Minas Tirith.

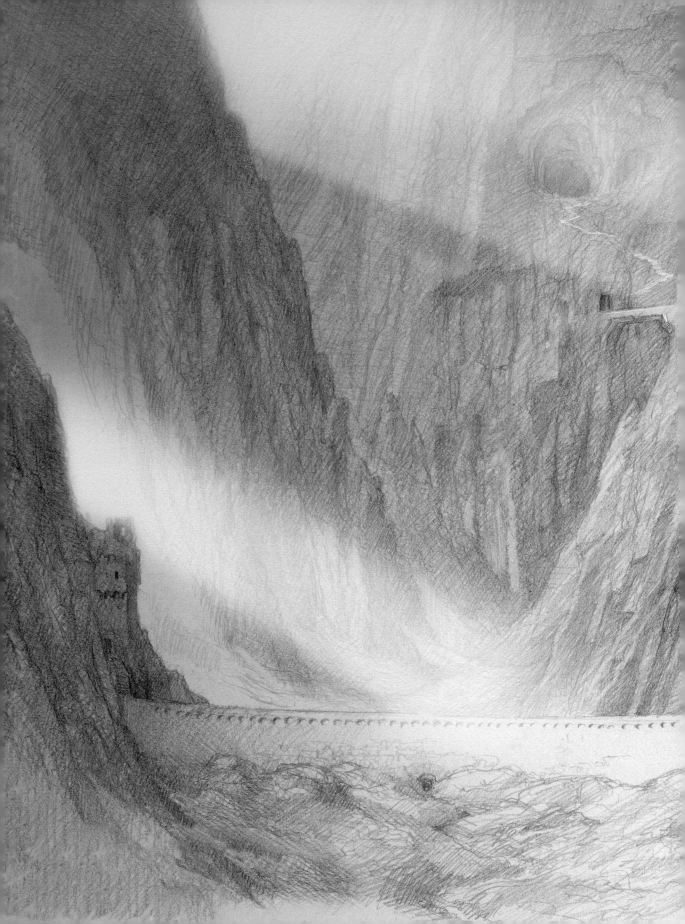

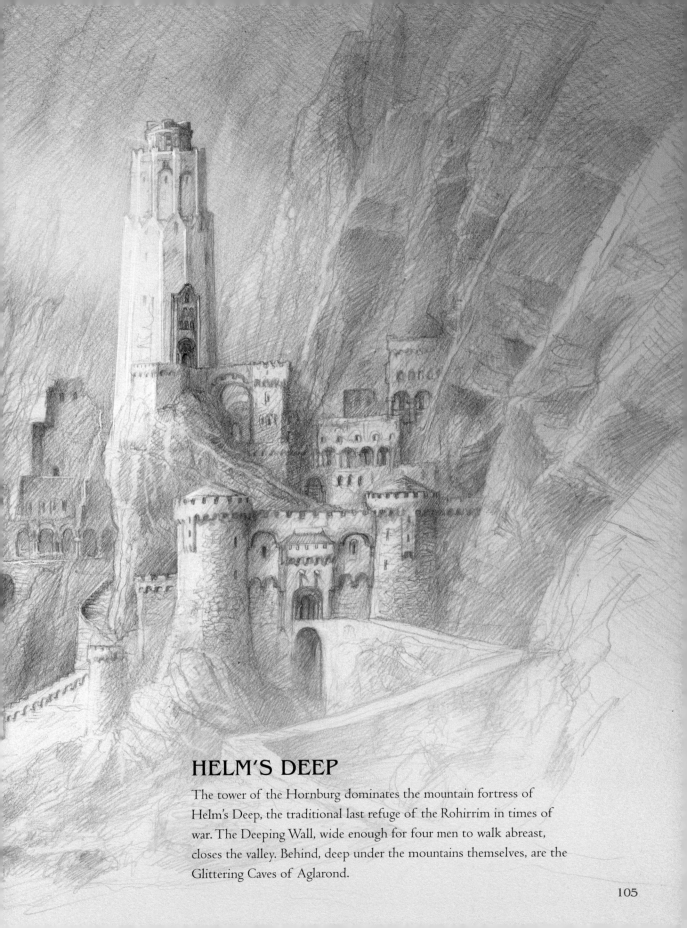

HELM'S DEEP

The tower of the Hornburg dominates the mountain fortress of
Helm's Deep, the traditional last refuge of the Rohirrim in times of
war. The Deeping Wall, wide enough for four men to walk abreast,
closes the valley. Behind, deep under the mountains themselves, are the
Glittering Caves of Aglarond.

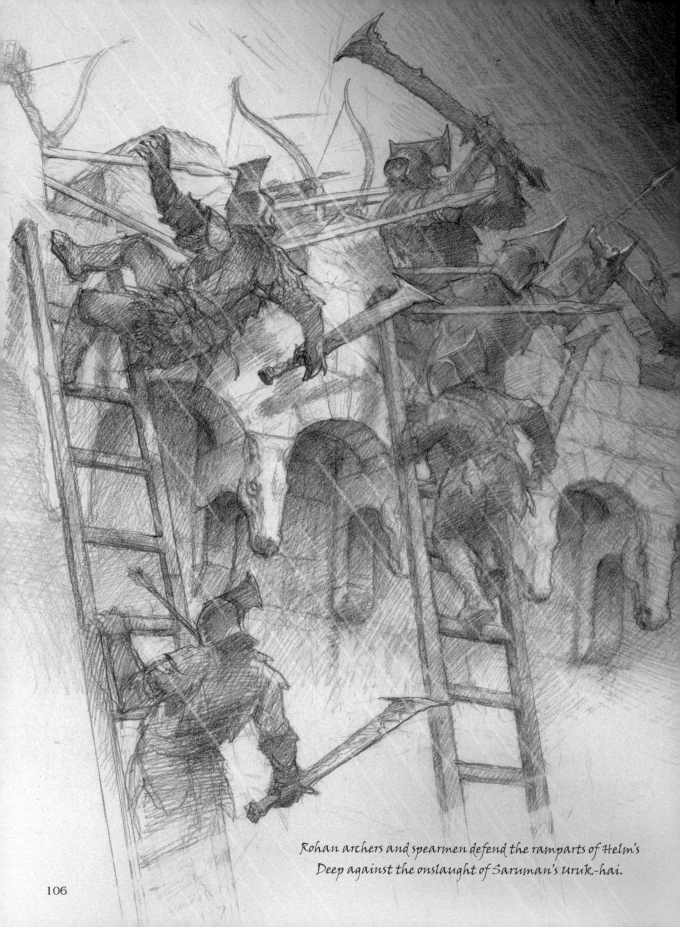

Rohan archers and spearmen defend the ramparts of Helm's Deep against the onslaught of Saruman's Uruk-hai.

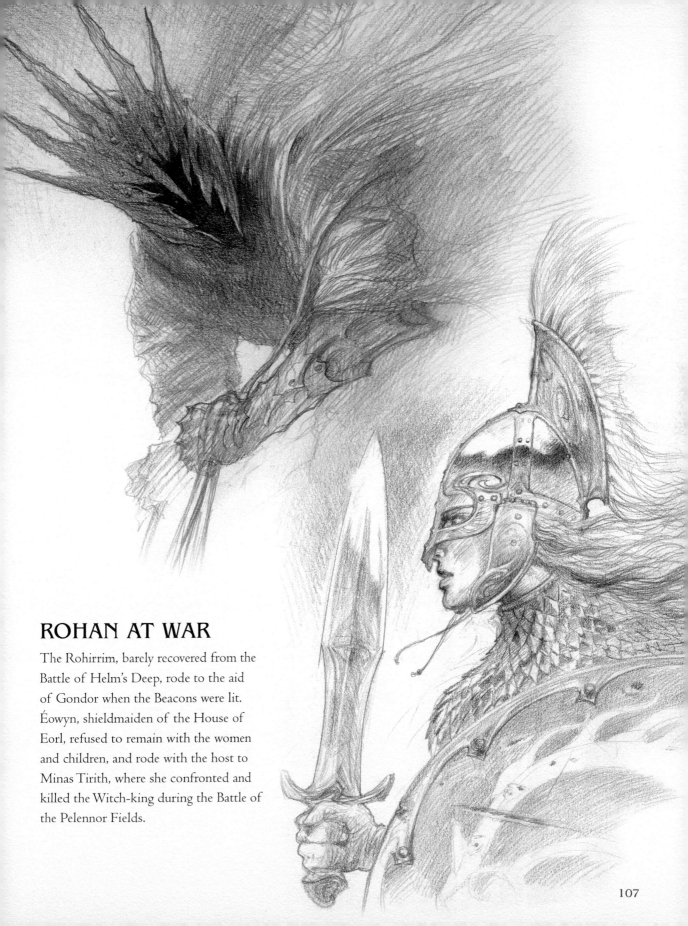

ROHAN AT WAR

The Rohirrim, barely recovered from the Battle of Helm's Deep, rode to the aid of Gondor when the Beacons were lit. Éowyn, shieldmaiden of the House of Eorl, refused to remain with the women and children, and rode with the host to Minas Tirith, where she confronted and killed the Witch-king during the Battle of the Pelennor Fields.

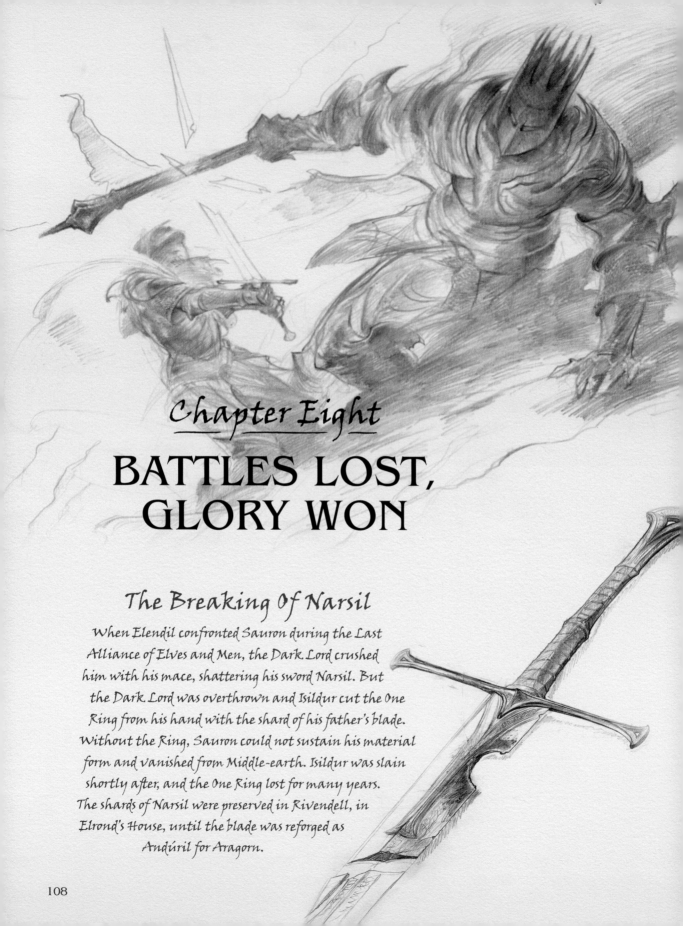

Chapter Eight

BATTLES LOST, GLORY WON

The Breaking Of Narsil

When Elendil confronted Sauron during the Last Alliance of Elves and Men, the Dark Lord crushed him with his mace, shattering his sword Narsil. But the Dark Lord was overthrown and Isildur cut the One Ring from his hand with the shard of his father's blade. Without the Ring, Sauron could not sustain his material form and vanished from Middle-earth. Isildur was slain shortly after, and the One Ring lost for many years. The shards of Narsil were preserved in Rivendell, in Elrond's House, until the blade was reforged as Andúril for Aragorn.

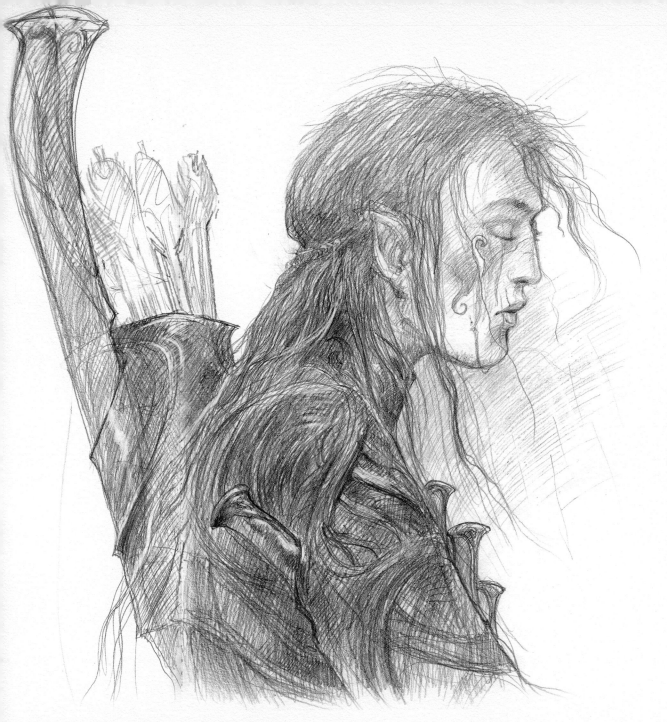

WAR IN MIDDLE-EARTH

Mistrust, betrayal and strife always existed between the Free Peoples, but Elves, Dwarves and Men would set aside quarrels and differences to unite against the forces of Darkness: first Morgoth, against whom they fought in the First and Second Ages, then his lieutenant, Sauron, until the final destruction of the One Ring and the shattering of Barad-dûr. The death of the Dark Lord, along with the demise of the last dragon, Smaug, some sixty years before, would signal the end of the Third Age — and ultimately of magic — in Middle-earth. But not of war.

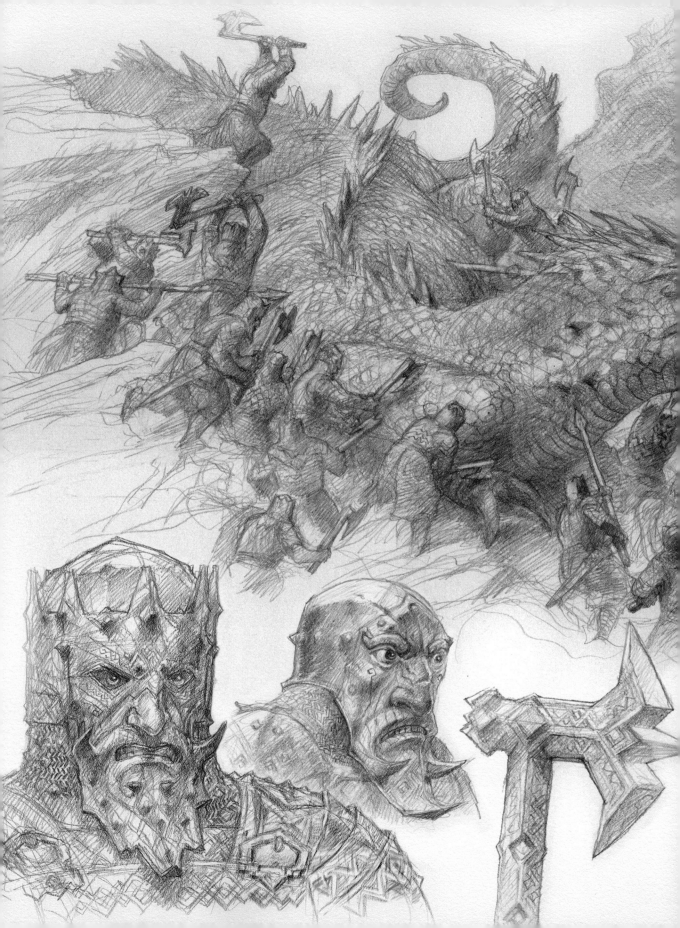

DAGOR NIRNAETH ARNOEDIAD
The Battle of Unnumbered Tears

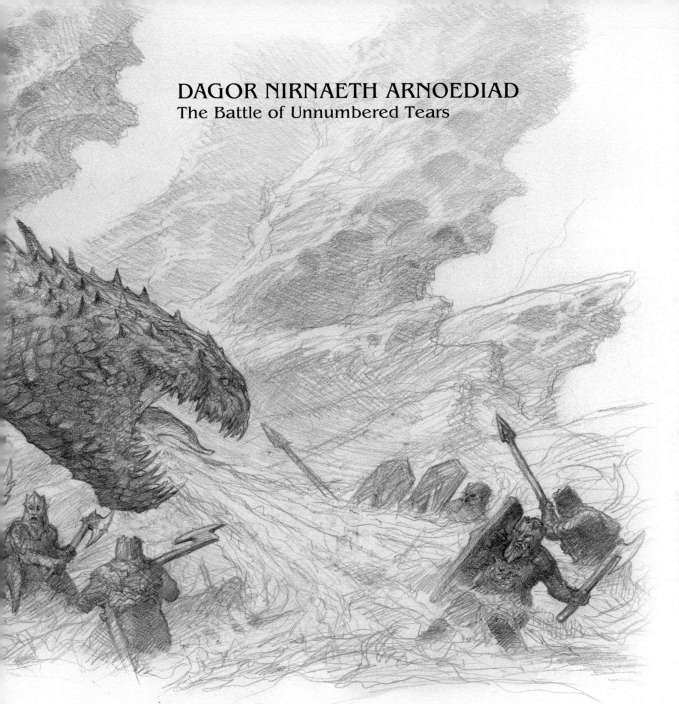

"Last of all the eastern force to stand firm were the Dwarves of Belegost, and thus they won renown. For the Naugrim withstood fire more hardily than either Elves or Men, and it was their custom moreover to wear great masks in battle hideous to look upon; and those stood them in good stead against the dragons. And but for them Glaurung and his brood would have withered all that was left of the Noldor. But the Naugrim made a circle about him when he assailed them, and even his mighty armour was not full proof against the blows of their great axes; and when in his rage Glaurung turned and struck down Azaghâl, Lord of Belegost, and crawled over him, with his last stroke Azaghâl drove a knife into his belly, and so wounded him that he fled the field, and the beasts of Angband in dismay followed after him."

The Gathering Storm

With the death of Smaug, many eyes turn to the Lonely Mountain and the Dwarven treasure piled deep in the halls of Erebor. Thorin knows he and his warriors are too few to defend Erebor, but Roäc, son of Carc, has welcome news. Dain is coming from the Iron Hills with all speed. As for Bilbo, he would miss the battle; knocked unconscious, he would awake the following dawn, to be found by soldiers wandering the field in search of the still-living. Bilbo survived the great battle, but only to find Thorin on his deathbed and discovering Fili and Kili had fallen defending him. Beorn had arrived, crushing the Goblin leader Bolg, but too late to save Thorin's life.

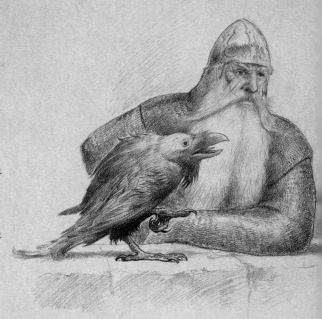

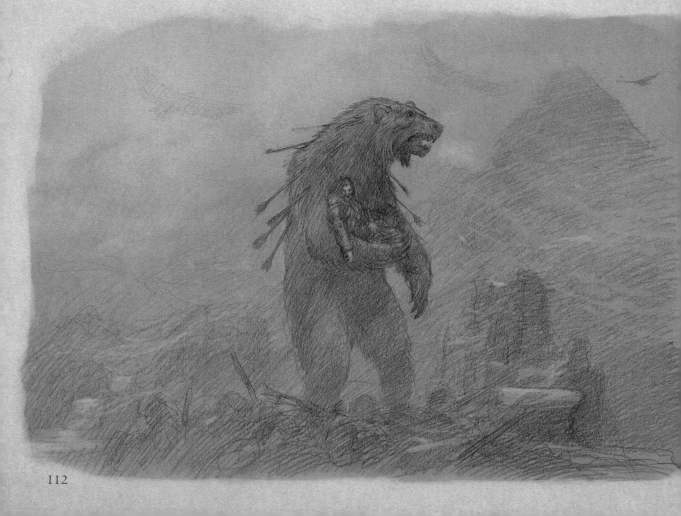

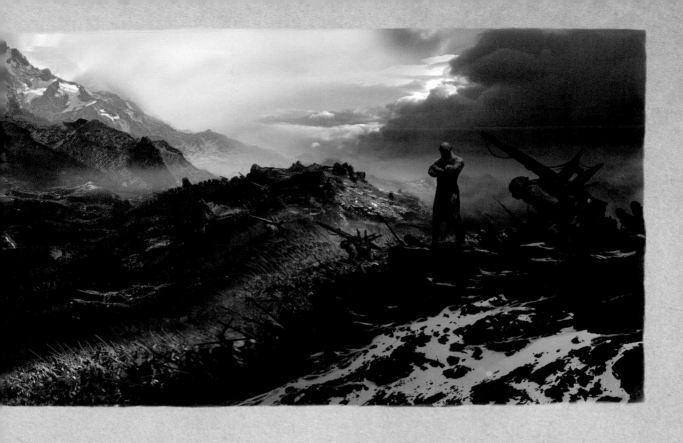

The Battle of the Five Armies

"So began the battle in a fashion none had expected. And it was called after the Battle of Five Armies, and it was very terrible. For upon one side were the Goblins and the Wolves and upon the other were men, elves and dwarves."

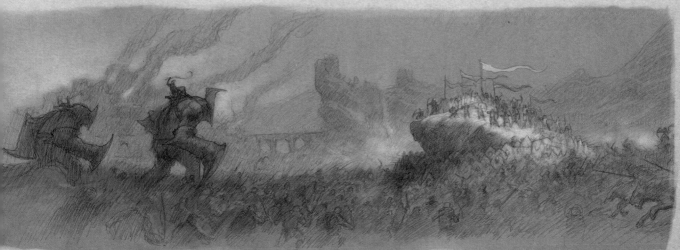

THE BATTLE OF THE PELENNOR FIELDS

The greatest battle of the War of the Ring took place on the fields of the Pelennor, before the walls of Minas Tirith. The Riders of Rohan raced to the aid of Gondor, to confront Sauron's forces: Orcs, Easterlings and Haradrim mounted on gigantic mûmakil. The Witch-king of Angmar, mounted on a foul flying steed, slew Théoden, and was in turn slain by Éowyn. The arrival of Aragorn, leading the Army of the Dead, saved Gondor from certain defeat.

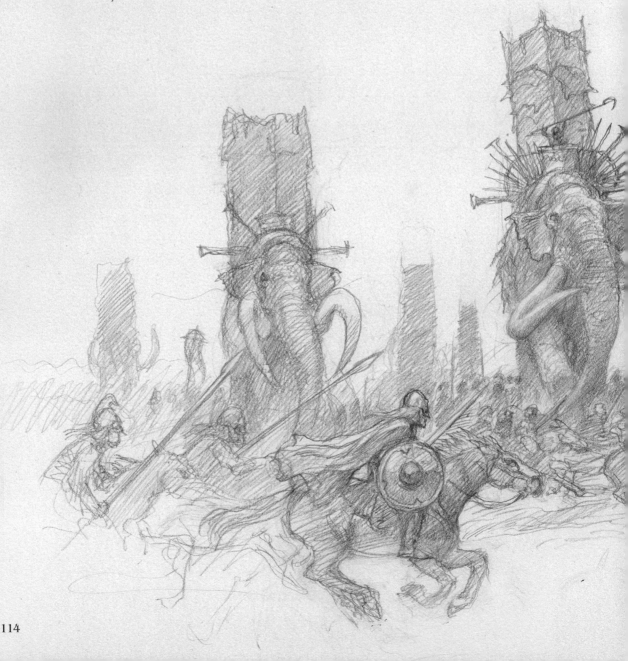

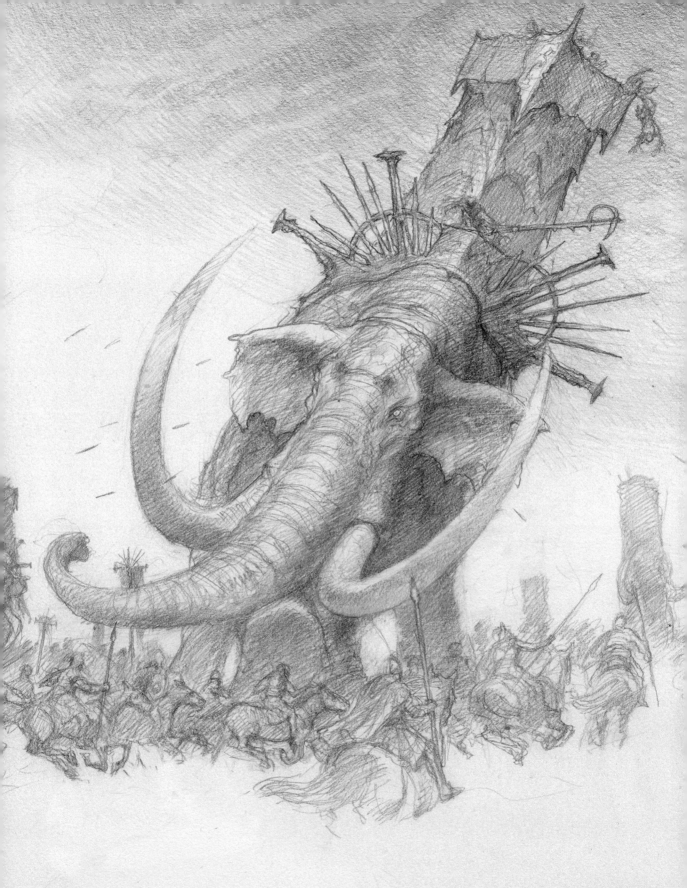

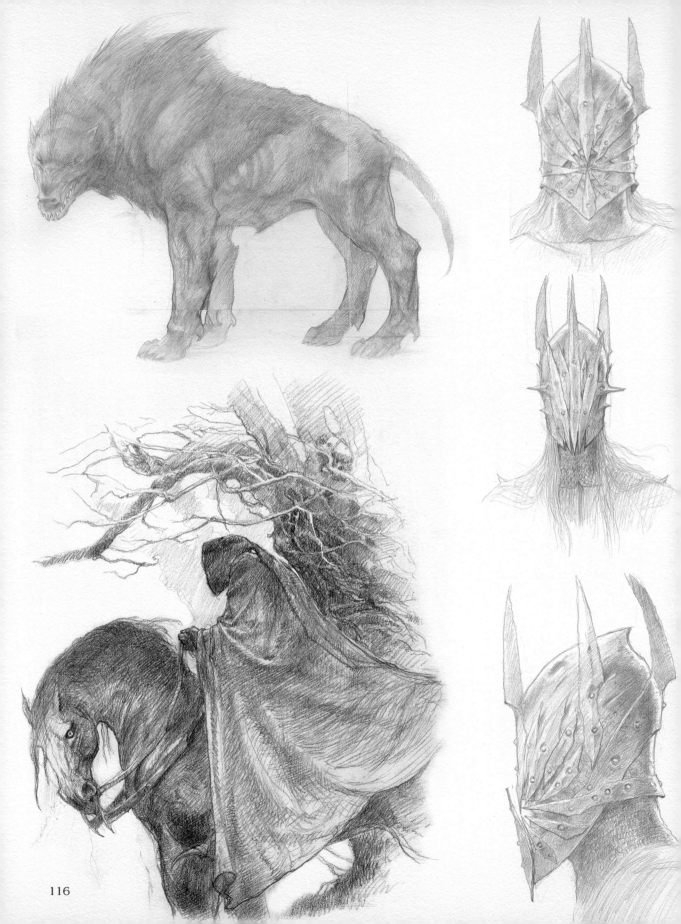

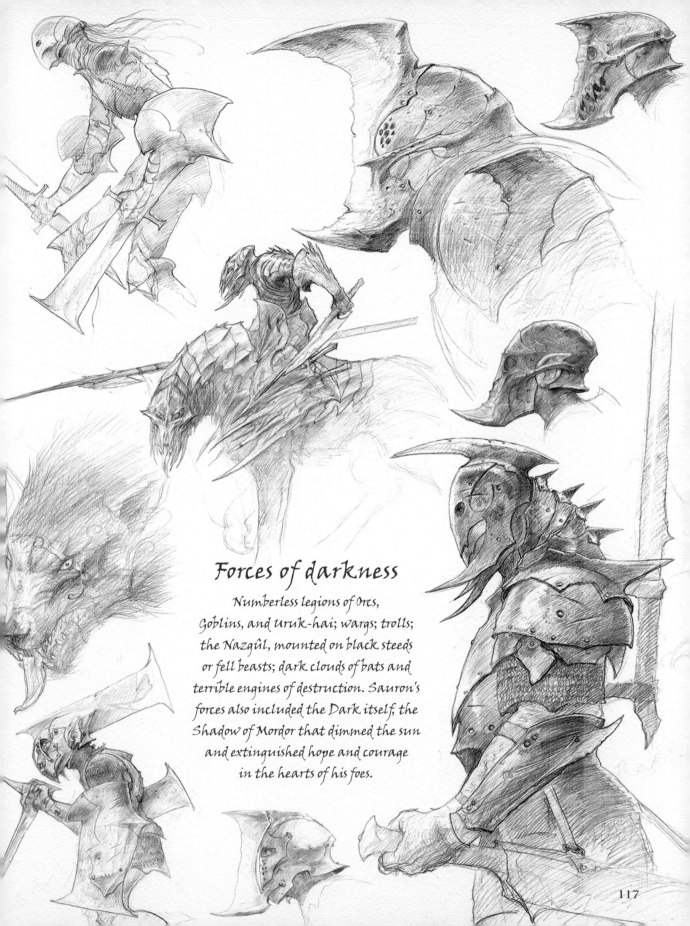

Forces of darkness

Numberless legions of Orcs,
Goblins, and Uruk-hai; wargs; trolls;
the Nazgûl, mounted on black steeds
or fell beasts; dark clouds of bats and
terrible engines of destruction. Sauron's
forces also included the Dark itself; the
Shadow of Mordor that dimmed the sun
and extinguished hope and courage
in the hearts of his foes.

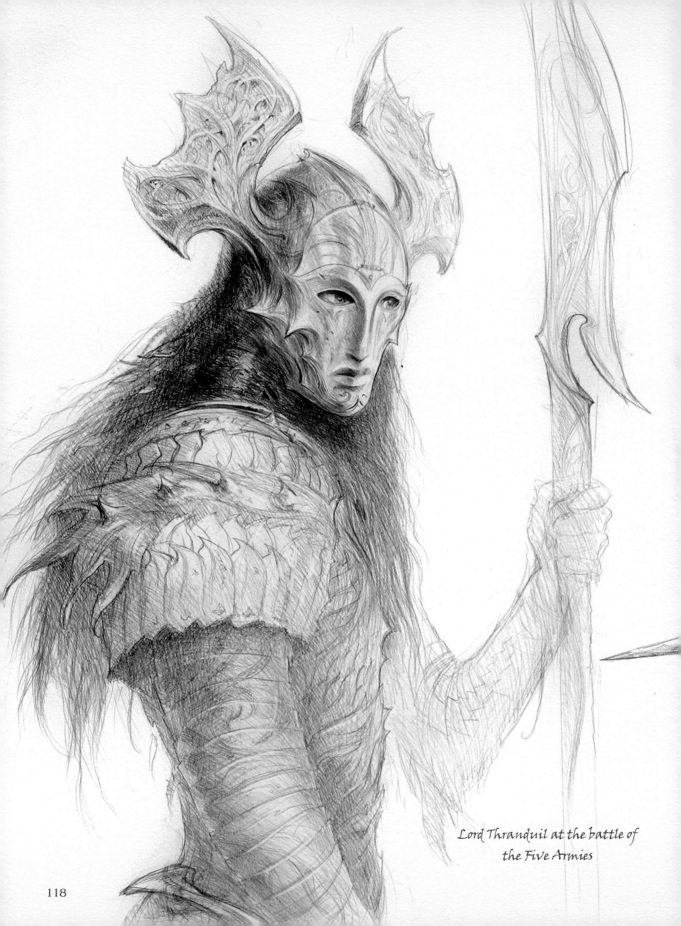

Lord Thranduil at the battle of
the Five Armies

THE LONG DEFEAT

"For the Lord of the Galadhrim is accounted the wisest of the Elves of Middle-earth, and a giver of gifts beyond the power of kings. He has dwelt in the West since the days of dawn, and I have dwelt with him years uncounted; for ere the fall of Nargothrond or Gondolin I passed over the mountains, and together through the ages of the world we have fought the long defeat." Thus, Galadriel speaks of Celeborn to Frodo; the Elves have been battling the forces of evil since their awakening, and of all the Free Peoples, the Elves have paid the greatest toll.

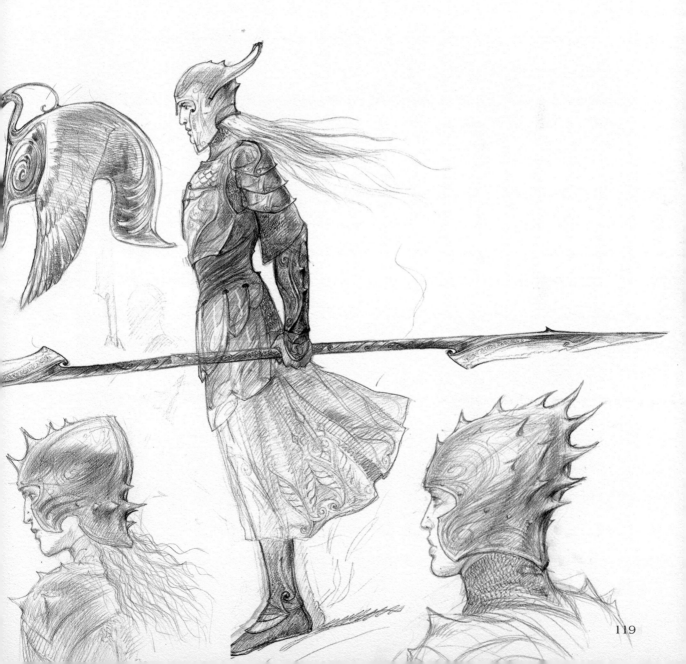

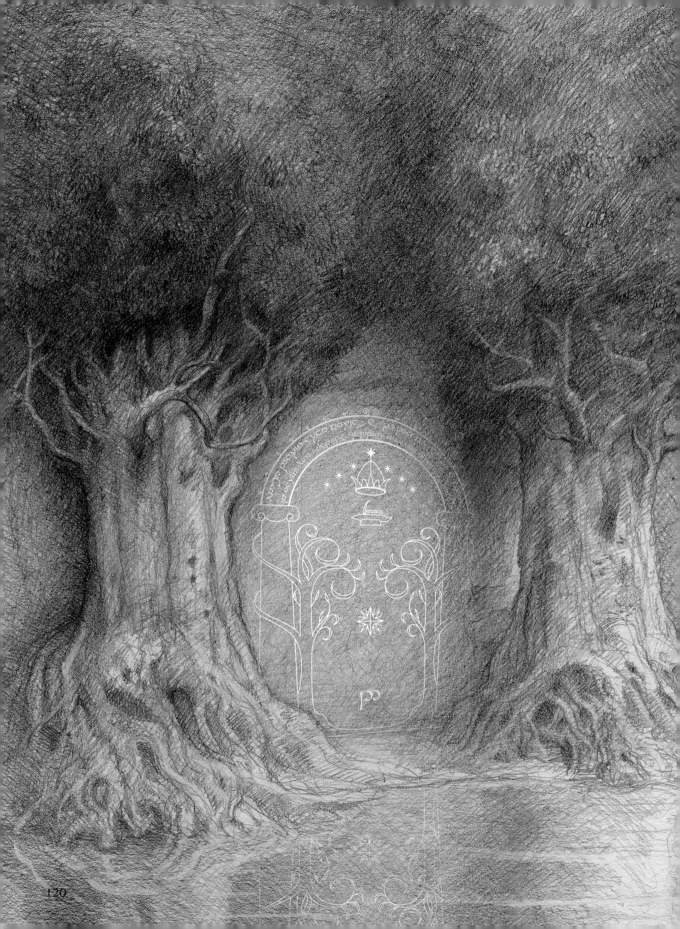

Chapter Nine

DEEP DELVINGS

THE DWARVEN KINGDOMS

The Dwarven kingdom of Khazad-dûm could be entered from the west through the Doors of Durin. Fashioned by Elves, cloaked in magic, they were carved in the Second Age into the dark cliffs of Celebdil. Since the demise of the kingdom, the doors have remained shut. The Dwarf-road is now broken, a murky lake has flooded Dimrill Dale and laps the base of the cliffs, where two great holly trees flank a smooth section of rock. There stand the doors that only words of magic will open again.

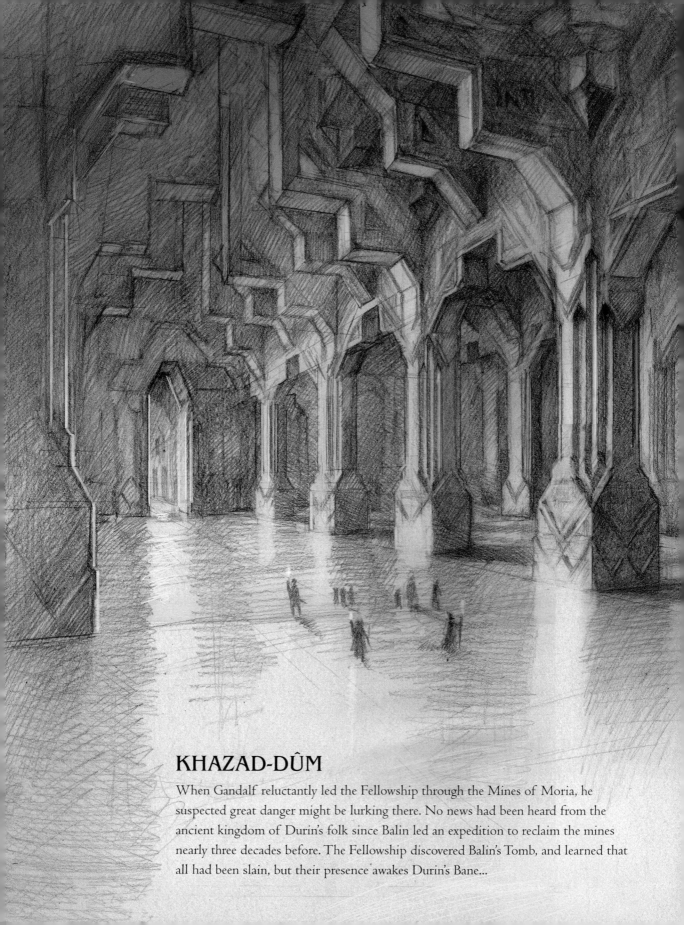

KHAZAD-DÛM

When Gandalf reluctantly led the Fellowship through the Mines of Moria, he
suspected great danger might be lurking there. No news had been heard from the
ancient kingdom of Durin's folk since Balin led an expedition to reclaim the mines
nearly three decades before. The Fellowship discovered Balin's Tomb, and learned that
all had been slain, but their presence awakes Durin's Bane...

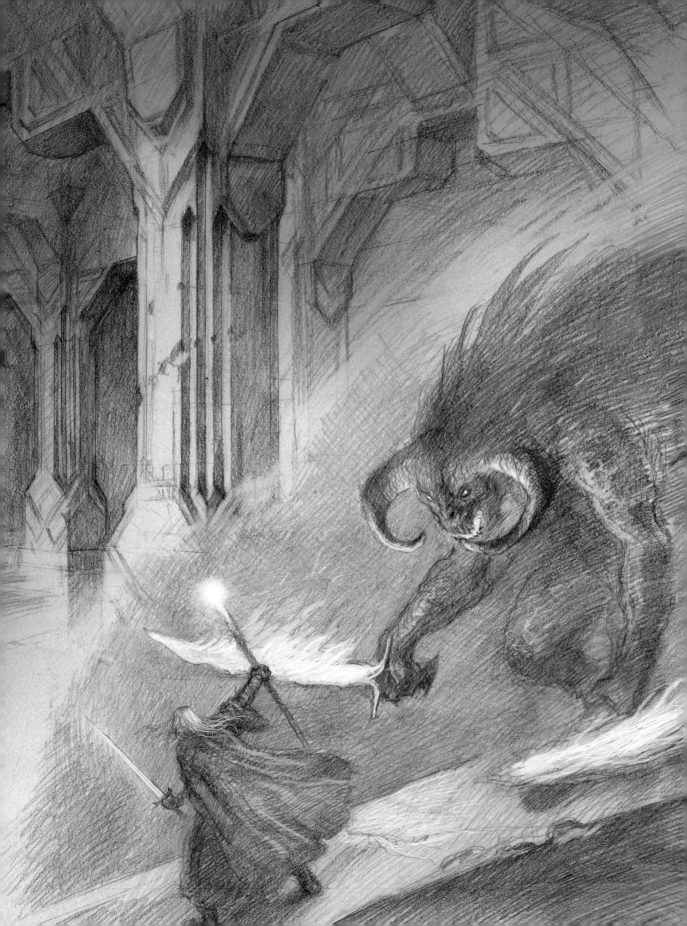

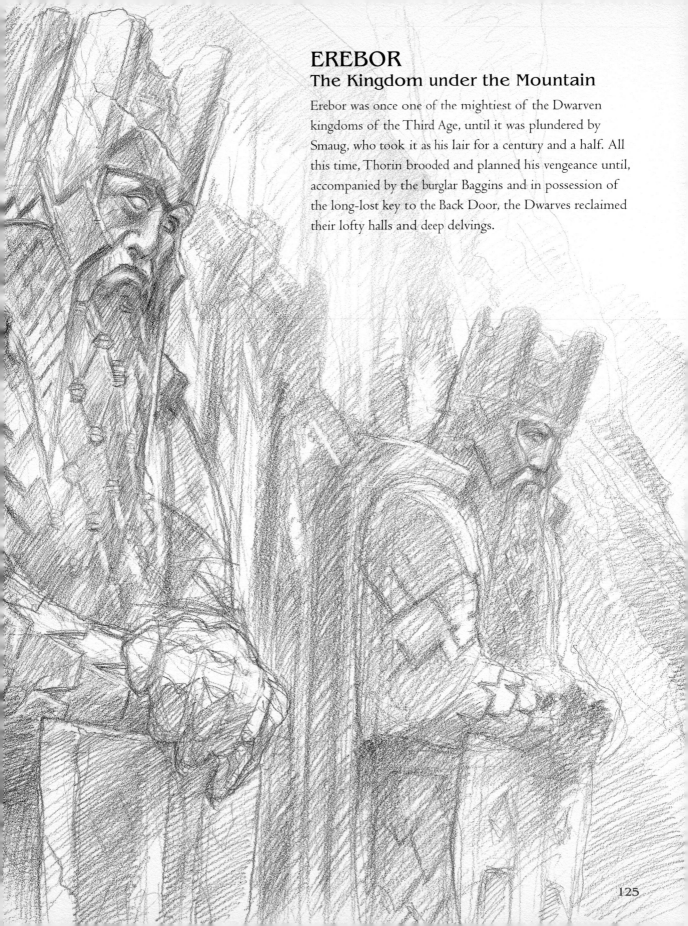

EREBOR
The Kingdom under the Mountain

Erebor was once one of the mightiest of the Dwarven kingdoms of the Third Age, until it was plundered by Smaug, who took it as his lair for a century and a half. All this time, Thorin brooded and planned his vengeance until, accompanied by the burglar Baggins and in possession of the long-lost key to the Back Door, the Dwarves reclaimed their lofty halls and deep delvings.

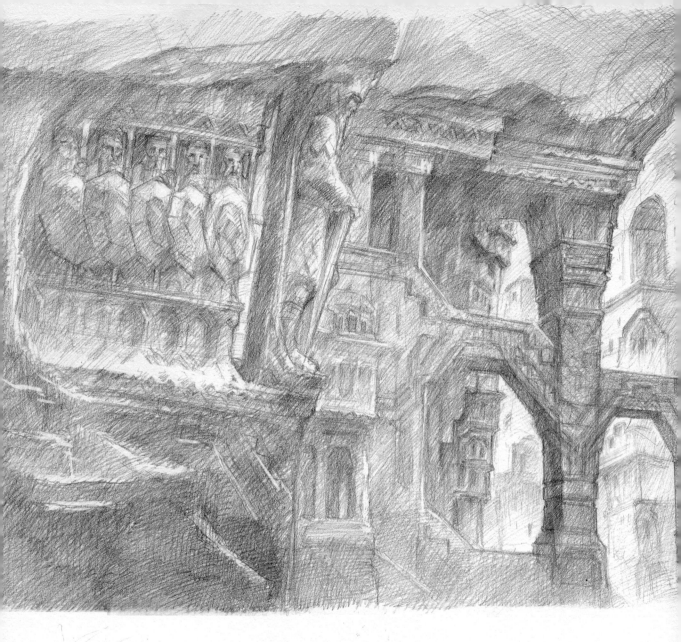

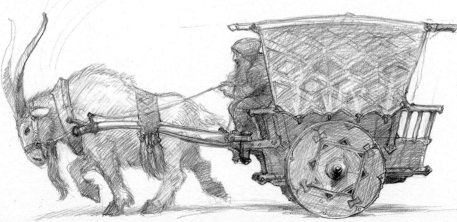

Between the mines of Khazad-dûm and the Iron Hills far to the North lay a Dwarven road, much travelled by Dwarf merchants and traders. With the destruction of Erebor, many Dwarves fled north to the Hills. It was from there that Dáin led the reinforcements that would decide the Battle of Erebor.

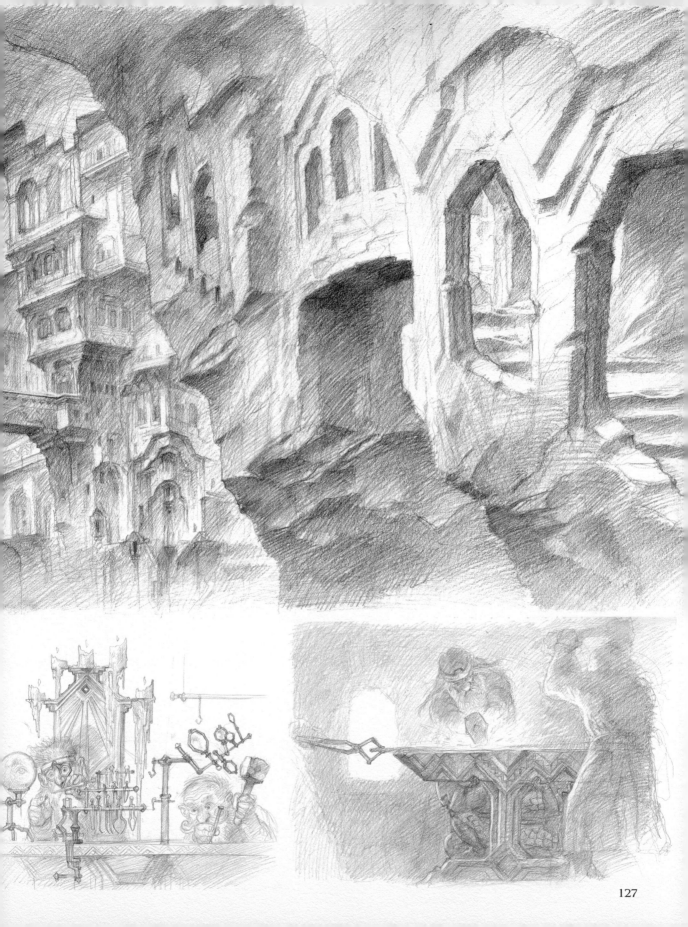

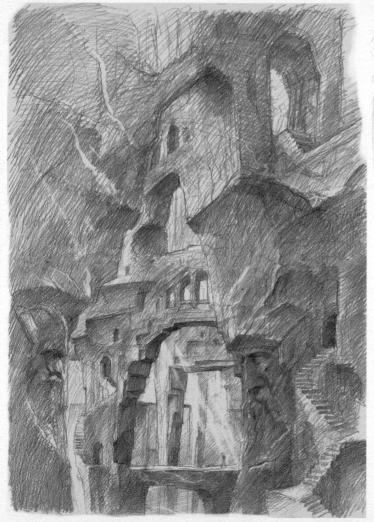

Giants Under the Mountain

Erebor's vaulted halls are supported by gigantic stone warriors bearing the weight of the Lonely Mountain on their granite shoulders.

Right: Armed with little more than his considerable courage, (and his precious Ring) Bilbo descends into the depths of Erebor, and Smaug's lair.

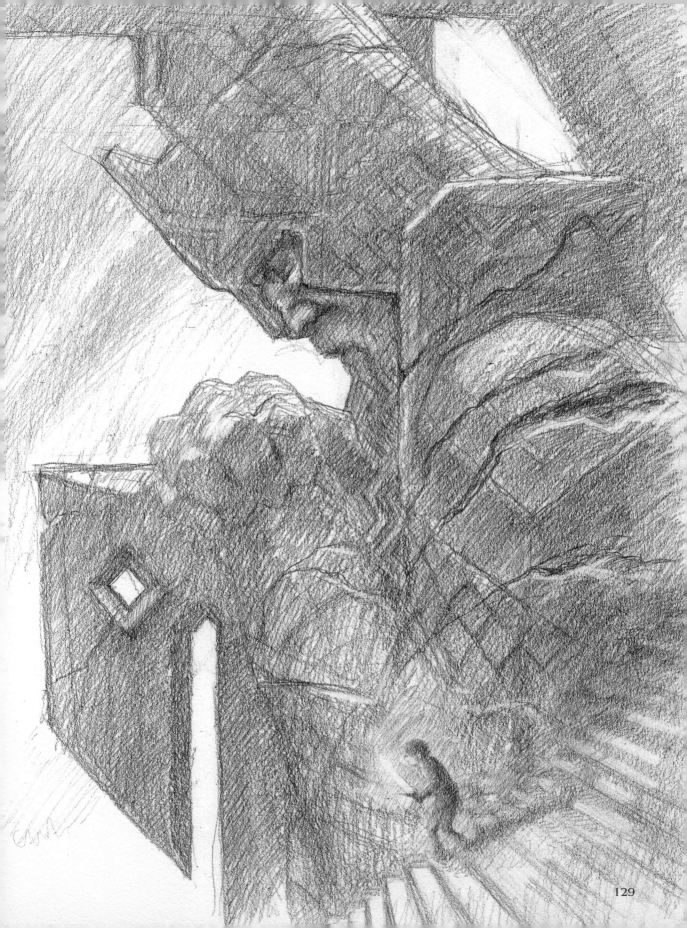

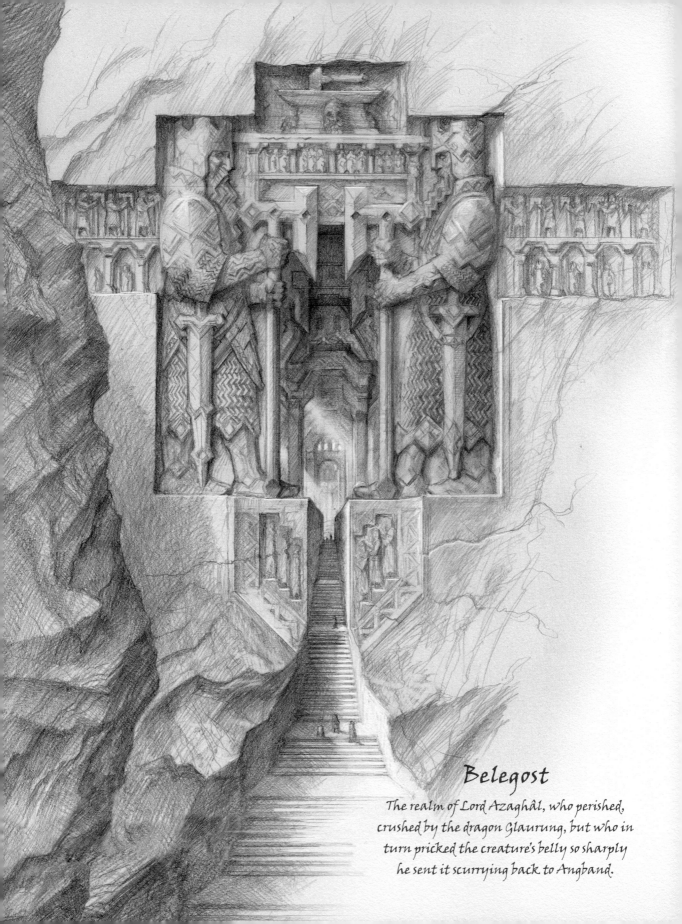

Belegost

The realm of Lord Azaghâl, who perished,
crushed by the dragon Glaurung, but who in
turn pricked the creature's belly so sharply
he sent it scurrying back to Angband.

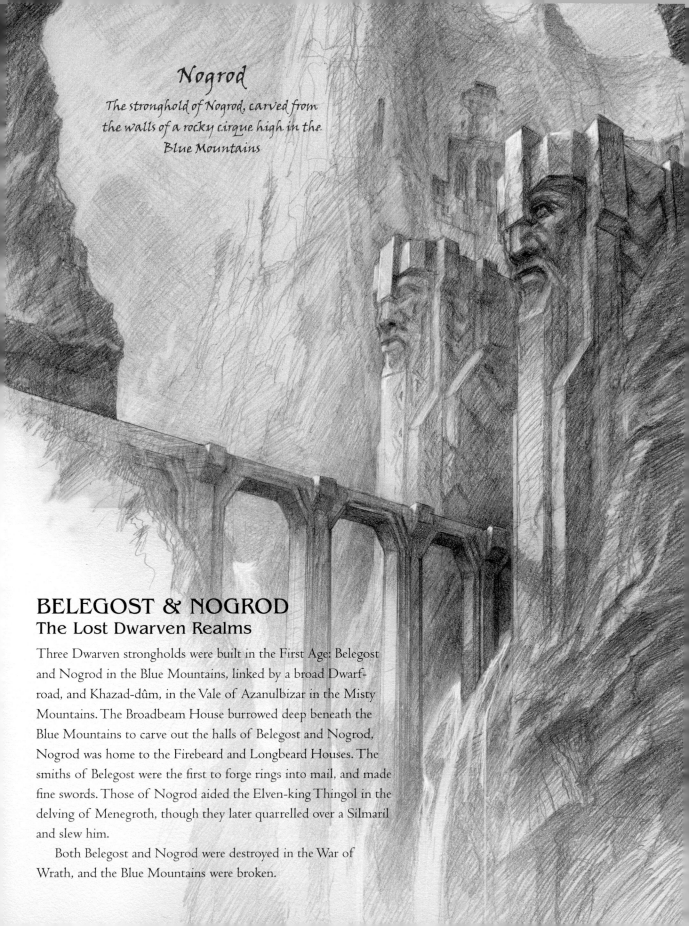

Nogrod

The stronghold of Nogrod, carved from
the walls of a rocky cirque high in the
Blue Mountains

BELEGOST & NOGROD
The Lost Dwarven Realms

Three Dwarven strongholds were built in the First Age: Belegost
and Nogrod in the Blue Mountains, linked by a broad Dwarf-
road, and Khazad-dûm, in the Vale of Azanulbizar in the Misty
Mountains. The Broadbeam House burrowed deep beneath the
Blue Mountains to carve out the halls of Belegost and Nogrod,
Nogrod was home to the Firebeard and Longbeard Houses. The
smiths of Belegost were the first to forge rings into mail, and made
fine swords. Those of Nogrod aided the Elven-king Thingol in the
delving of Menegroth, though they later quarrelled over a Silmaril
and slew him.

Both Belegost and Nogrod were destroyed in the War of
Wrath, and the Blue Mountains were broken.

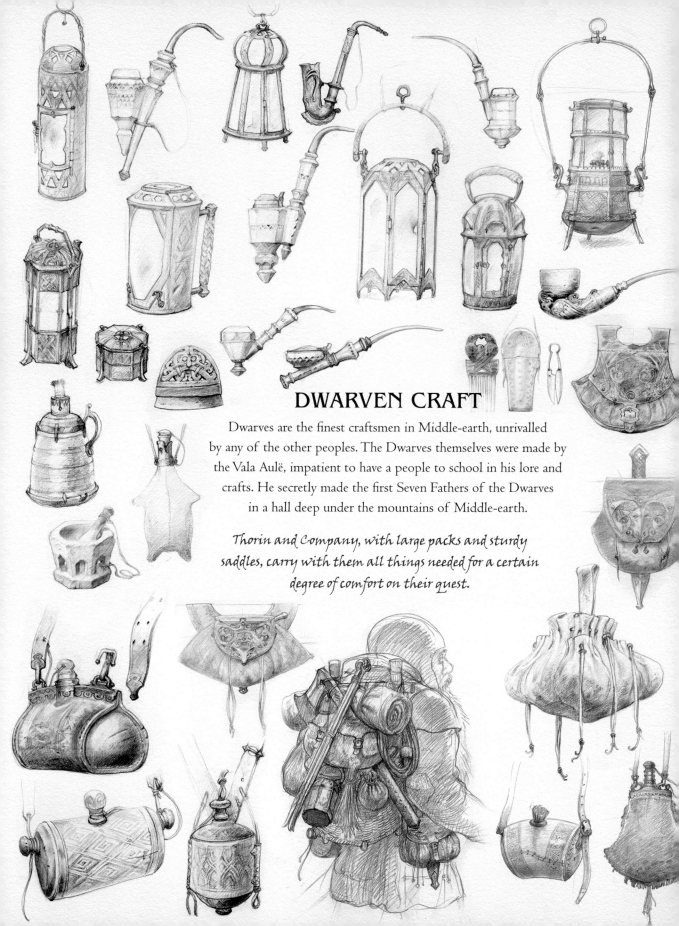

DWARVEN CRAFT

Dwarves are the finest craftsmen in Middle-earth, unrivalled by any of the other peoples. The Dwarves themselves were made by the Vala Aulë, impatient to have a people to school in his lore and crafts. He secretly made the first Seven Fathers of the Dwarves in a hall deep under the mountains of Middle-earth.

Thorin and Company, with large packs and sturdy saddles, carry with them all things needed for a certain degree of comfort on their quest.

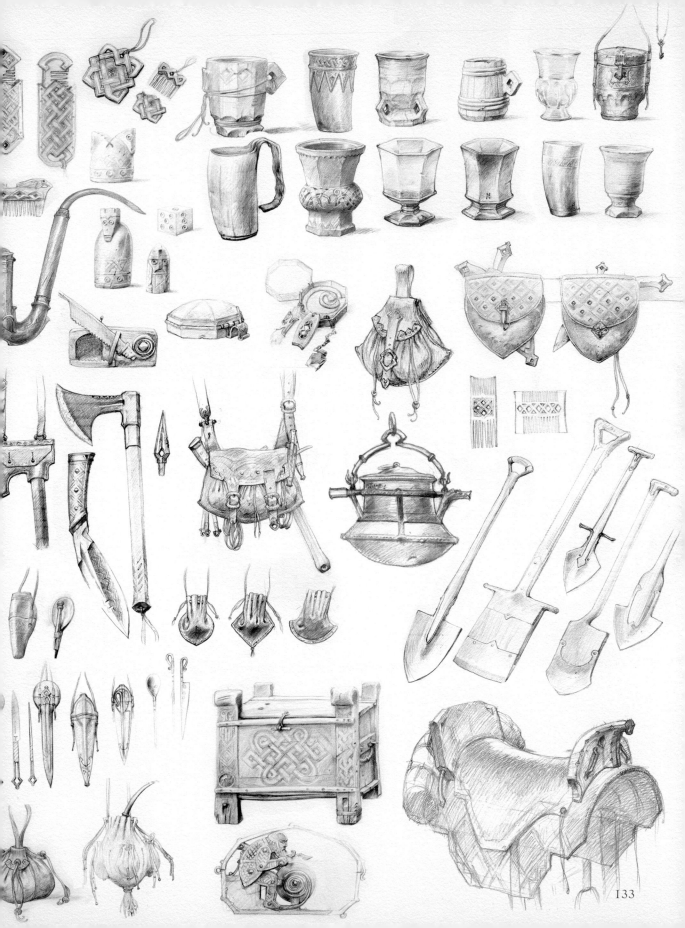

133

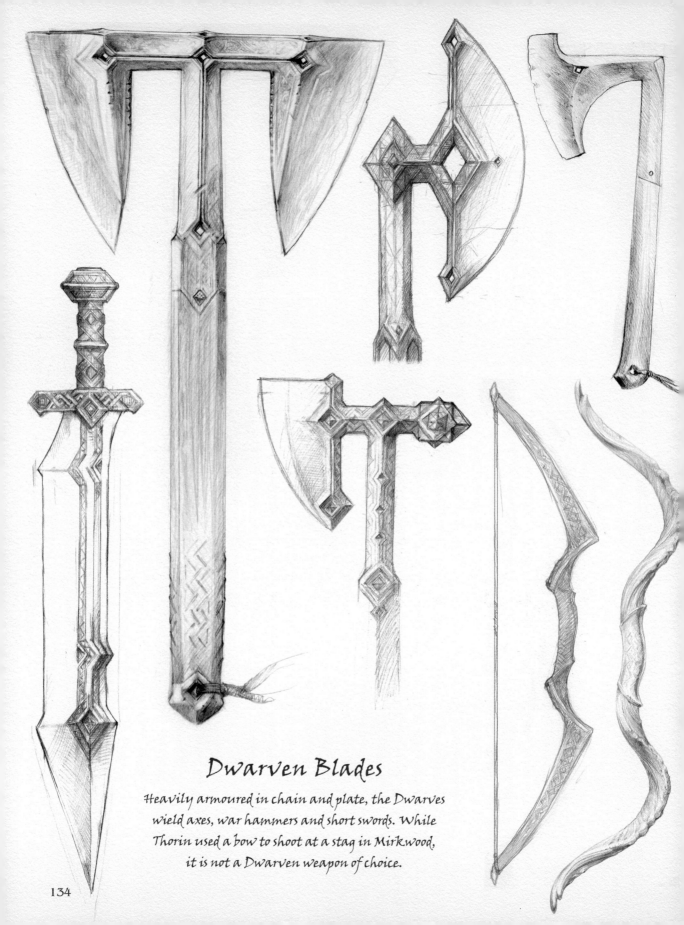

Dwarven Blades

Heavily armoured in chain and plate, the Dwarves
wield axes, war hammers and short swords. While
Thorin used a bow to shoot at a stag in Mirkwood,
it is not a Dwarven weapon of choice.

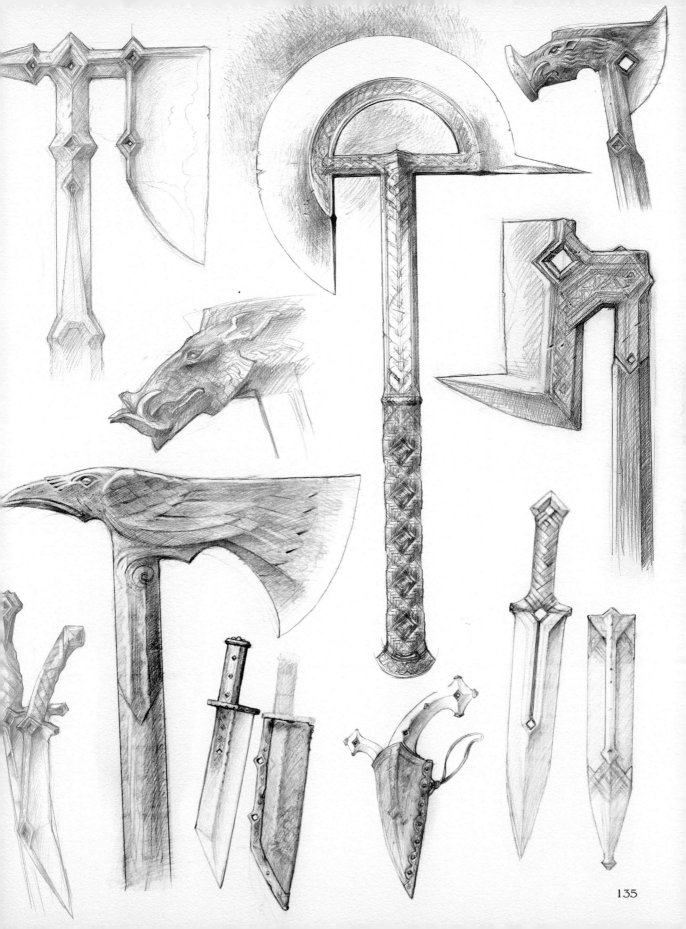

135

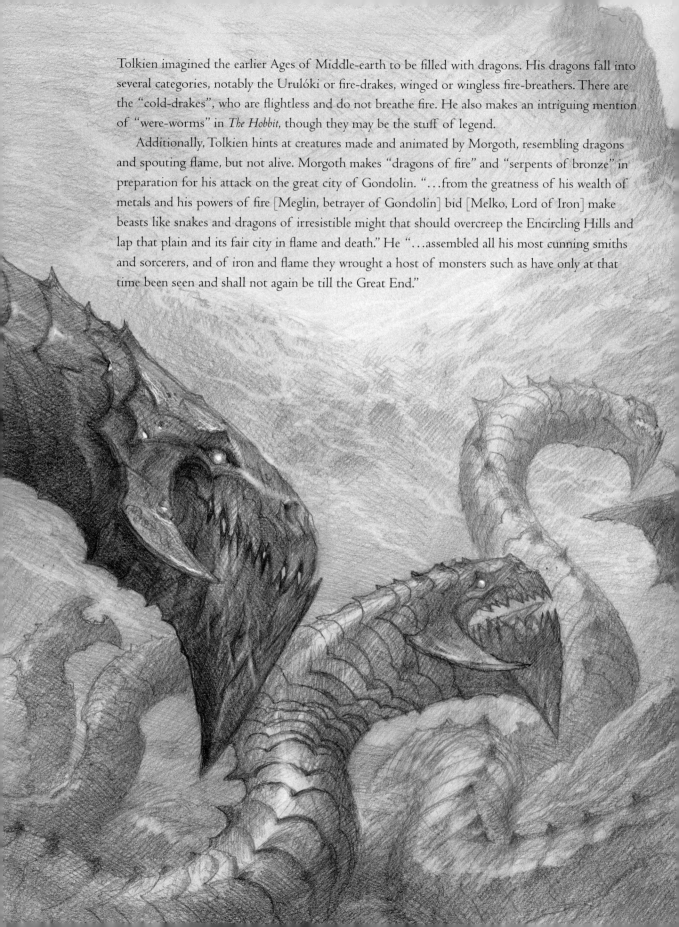

Tolkien imagined the earlier Ages of Middle-earth to be filled with dragons. His dragons fall into several categories, notably the Urulóki or fire-drakes, winged or wingless fire-breathers. There are the "cold-drakes", who are flightless and do not breathe fire. He also makes an intriguing mention of "were-worms" in *The Hobbit*, though they may be the stuff of legend.

Additionally, Tolkien hints at creatures made and animated by Morgoth, resembling dragons and spouting flame, but not alive. Morgoth makes "dragons of fire" and "serpents of bronze" in preparation for his attack on the great city of Gondolin. "…from the greatness of his wealth of metals and his powers of fire [Meglin, betrayer of Gondolin] bid [Melko, Lord of Iron] make beasts like snakes and dragons of irresistible might that should overcreep the Encircling Hills and lap that plain and its fair city in flame and death." He "…assembled all his most cunning smiths and sorcerers, and of iron and flame they wrought a host of monsters such as have only at that time been seen and shall not again be till the Great End."

Chapter Ten

HERE BE DRAGONS

GLAURUNG
Dragon of Legend

Tolkien was combating monsters of his own when creating Middle-earth. Rather than fighting against dragons, he was jousting on their behalf. Tolkien deplored the poor esteem in which *Beowulf* was held by scholars because of the presence of fantastical elements. At best, Beowulf's bane was considered an anecdote, at worst anachronism or distraction. He stated: "A dragon is no idle fancy. Whatever may be his origins, in fact or invention, the dragon in legend is a potent creation of men's imagination, richer in significance than his barrow is in gold..."

Tolkien well knew *wyrms* could not be written off so lightly. Glaurung resumes in every way his deep convictions of the legendary nature of the dragon, and borrows many characteristics from Fáfnir of the *Volsunga Saga* and the dragon that slays and is slain by Sigurd. Both are archetypal dragons of legend, supernatural but very real creatures from beyond the light of the hearth, denizens of the dark, of disorder and destruction. Both are creatures from the margins of the world, a physical and a spiritual menace.

Like Sigurd, Túrin Turambar pierces Glaurung from below, through the creature's softer underbelly. Both dragons pass on knowledge: Sigurd tastes Fáfnir's blood and can understand poetic wisdom (characterized as the language of birds), a step that takes him closer to his own death, and dying Glaurung's words drive Túrin and Nienor to suicide in despair.

Most importantly, Glaurung embodies fate (a word that also gives us "fay" and "faerie"), literally "that which comes," the destiny spun and meted out by the *wyrd* sisters, doom inescapable. The curse of the dragon is the final playing out of the tragedy.

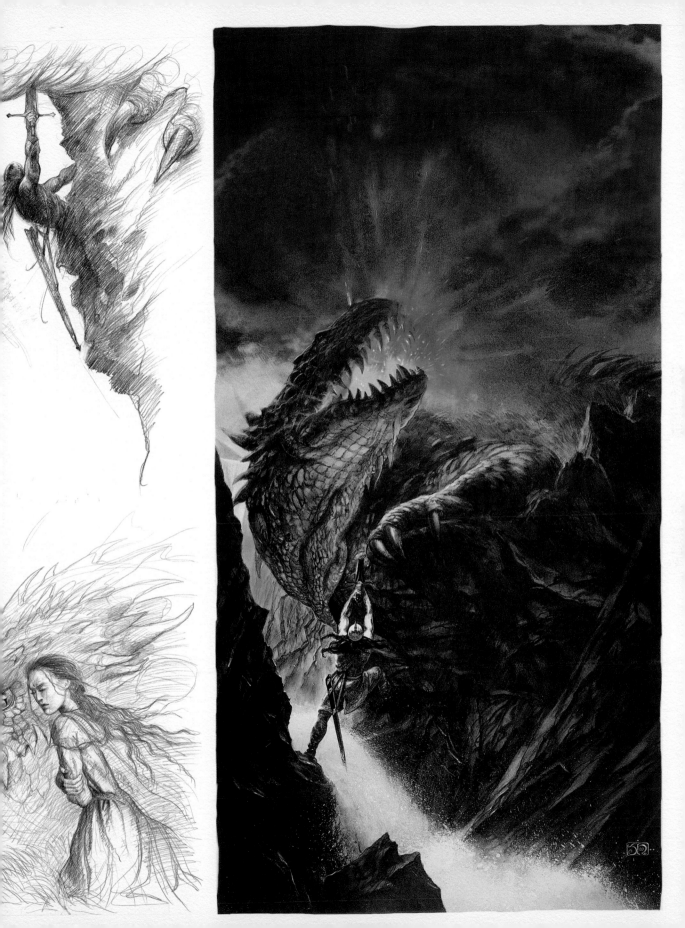

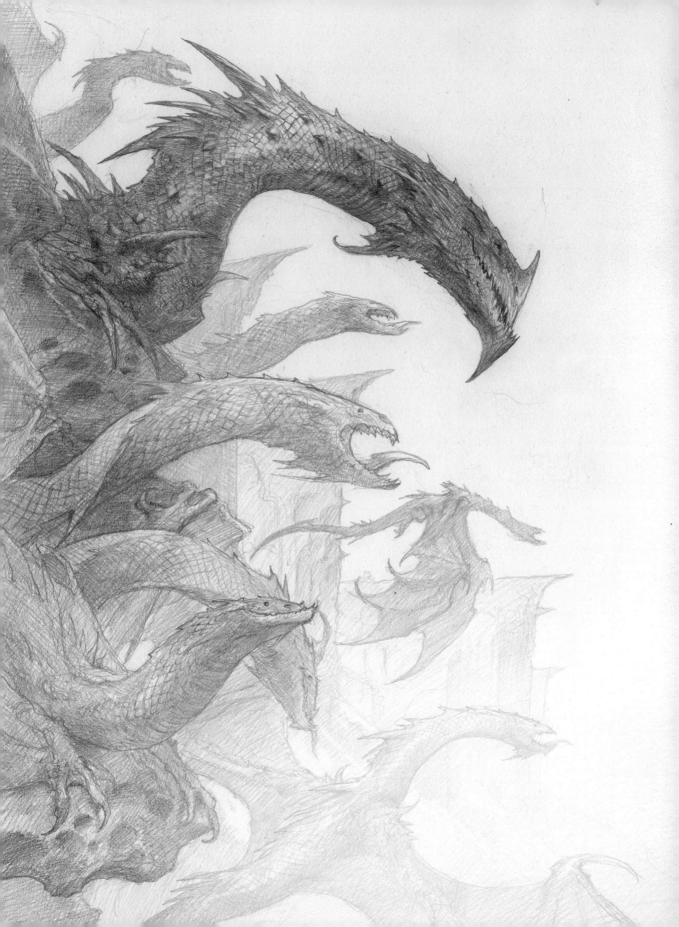

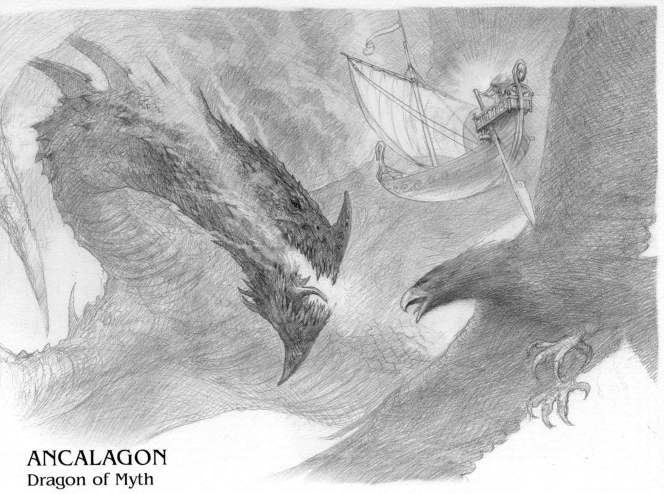

ANCALAGON
Dragon of Myth

Tolkien was well aware of the special place the dragon occupies in myth and legend. Agents of fate, doom and ruin, whether from the margins of the known world or the darkness of the human psyche, Tolkien's dragons are well suited to the roles they must play.

Tolkien had Morgoth create many monsters: the werewolves Draugluin and Carcharoth, evil spirits in gigantic wolf-shape; and the Balrogs who were demons with whips of flame. Completing this dreadful host were trolls and of course the Orc-kind. Most devastating and dangerous, however, were dragons.

Said to be the greatest dragon ever seen in Middle-earth, Ancalagon the Black was one of the first dragons bred by Morgoth. In Sindarin, the name means "Rushing Jaws" or "Biting Storm." Ancalagon is described in mythological terms; his wings could block out the sun, he is the incarnation of the destroying dark. He is a king of dragons, at the head of a horde of lesser *wyrms*, an army of crawling, flying, fire-breathing creatures few foes can face.

Ancalagon the Black is only defeated by the power of the Silmaril on Eärendil's brow, which holds a glimmer of the light of the Lamps and Trees. This is a mythic struggle, light and hope against darkness and deepest despair, only accomplished because the adversaries of the beast, Eärendil and Thorondor, are essentially mythical figures themselves. Both are archetypes with supernatural powers; only they can defeat the archetypal dragon and cast him from the sky to ruin upon the towers of Thangorodrim.

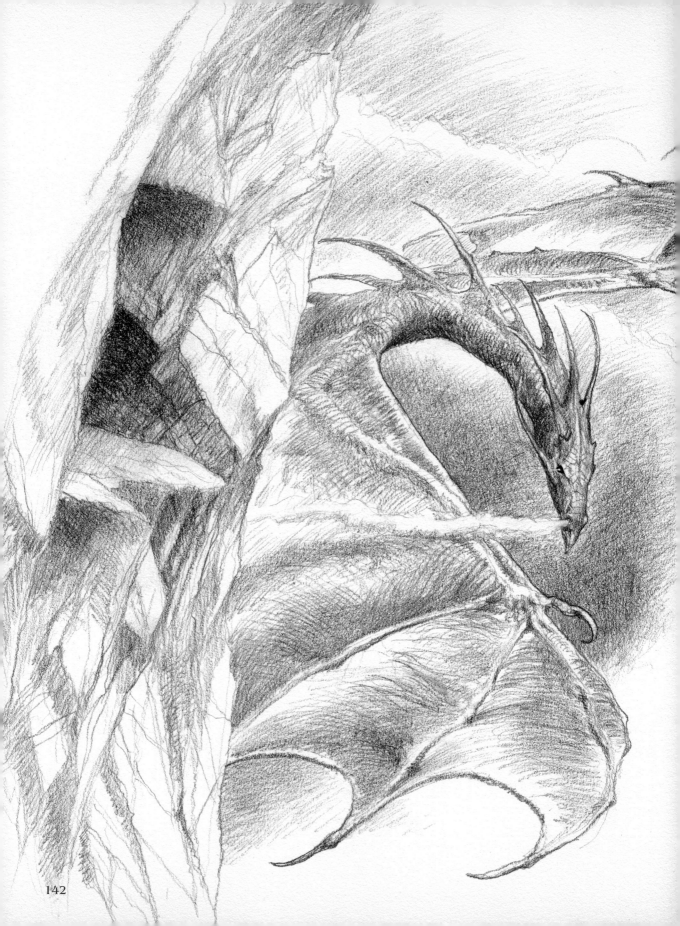

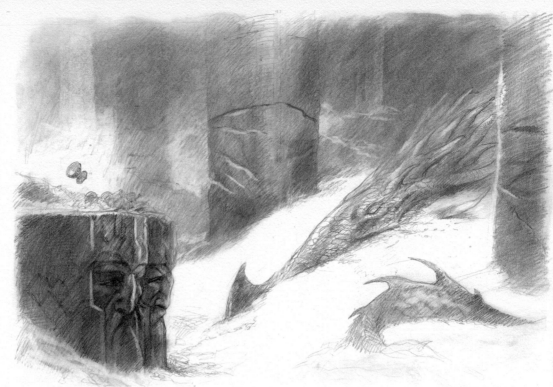

SMAUG THE GOLDEN

Smaug's priceless waistcoat of jewels, besides being an appealing plot device, is a disguise. Most of the characters of *The Hobbit* are of a like nature – myth masquerading as a children's story, but with none of the eager bowdlerization that removed so much of the substance of Grimm and older tales. It is also an inversion of the tale of Siegfried, where the hero's vulnerable spot, caused by the linden leaf that lands on his shoulderblade when he is bathed by the dragon's blood, is transferred to the dragon. (Tolkien never explains Smaug's greed, he does not need to. Bilbo is like the fox in Phaedrus' tale, meeting the dragon in his hole full of treasure. It is simply in Smaug's nature to love gold.) During their conversation, the glamour of Smaug's voice draws much information Bilbo never intended to reveal – the same power that Fáfnir's voice possesses – the insidious poison of canny wisdom and suave persuasion.

Tolkien noted, (speaking of Beowulf's Bane) "Fáfnir in the late Norse versions of the Sigurd-story is better; and Smaug and his conversation obviously is in debt there." He did steal a jewelled cup from *Beowulf*, though.

But Tolkien adds a touch of his own to Smaug's character: the fire-drake of the North is curious, almost inquisitive, and clearly he enjoys the company of the diminutive thief. In many ways, this is a poignant revelation; Smaug is the last of his kind: opportunities for conversations are rare. Once the cup is stolen, though, his draconic nature reasserts itself, his fiery attack on Lake-town setting the stage for the final fatal encounter with the descendant of Girion of Dale.

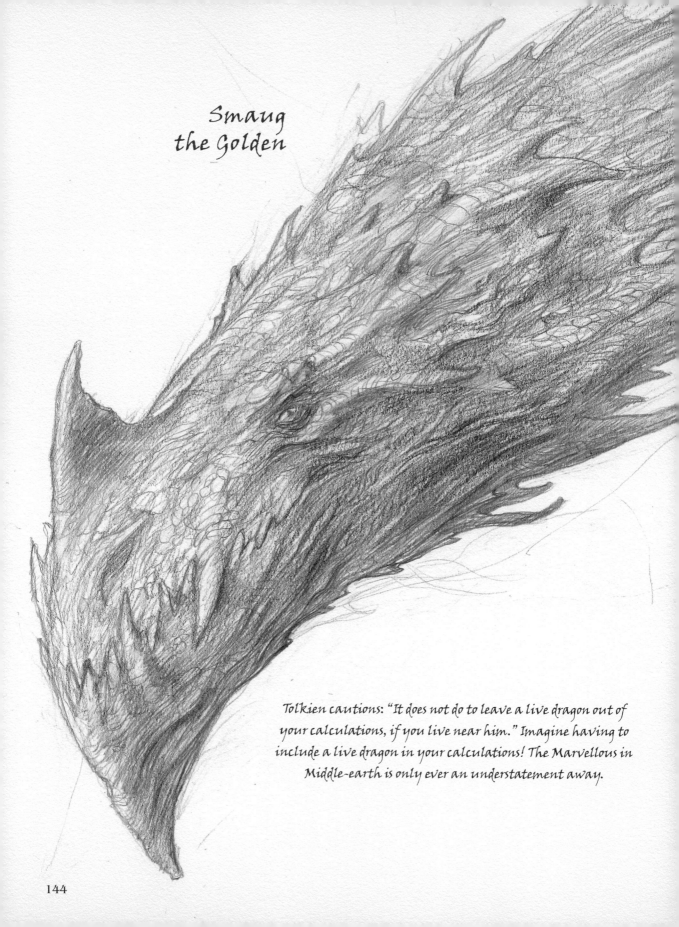

Smaug
the Golden

Tolkien cautions: "It does not do to leave a live dragon out of your calculations, if you live near him." Imagine having to include a live dragon in your calculations! The Marvellous in Middle-earth is only ever an understatement away.

When Bilbo, armed with little more than his considerable courage, descends into the dark depths of Erebor, and finally arrives in the Dwarven treasure chamber, he meets a dragon that sums up not only the fairy-tale dragon, but also the darker *nid-draca*, the treasure-haunting *wyrm*.

In many Icelandic and Norse tales, the chieftain reluctant to let even death separate him from his gold is buried with his treasure. Like Fáfnir, whose greed twists his body into that of a great armour-scaled dragon, these undead men assume the forms of demons or dragons, ferocious guardians of the wealth that benefits no one. They brood endlessly in the dark in the midst of their gold, only rousing themselves when their dark musings are broken by the arrival of thieves or intruders.

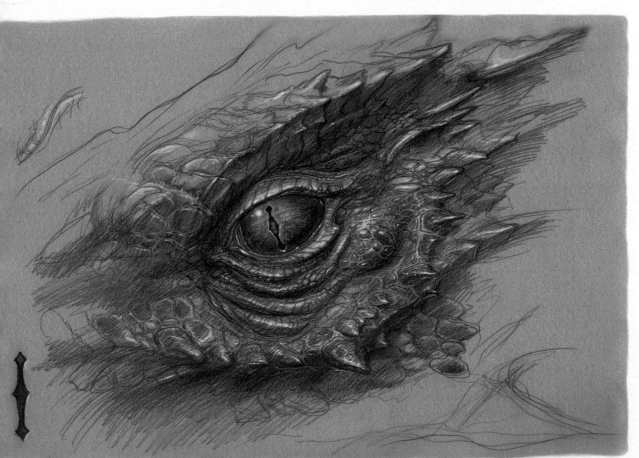

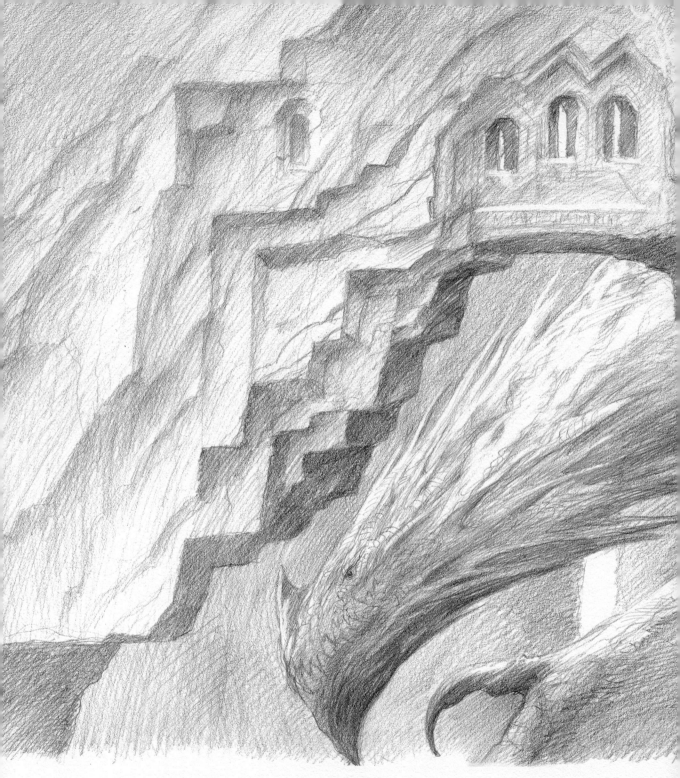

Bilbo does not kill Smaug, he has not the qualities of the classical hero; that is the reserve of Bard, who seems to have lived his whole existence for the instant that he looses the Black Arrow. Bilbo is an anti-hero, an Everyman in unusual circumstance, counting on his down-to-earth qualities to triumph. Burglar-for-hire, he measures wits with Smaug, and provokes the events that lead to the death of the last dragon in Middle-earth. But he is no dragon-slayer.

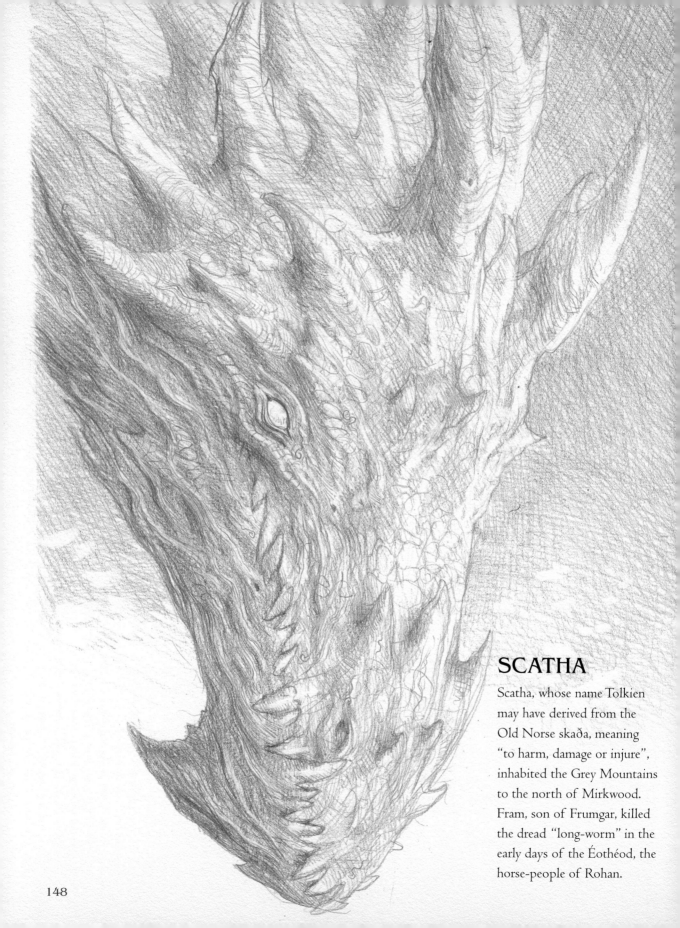

SCATHA

Scatha, whose name Tolkien
may have derived from the
Old Norse skaða, meaning
"to harm, damage or injure",
inhabited the Grey Mountains
to the north of Mirkwood.
Fram, son of Frumgar, killed
the dread "long-worm" in the
early days of the Éothéod, the
horse-people of Rohan.

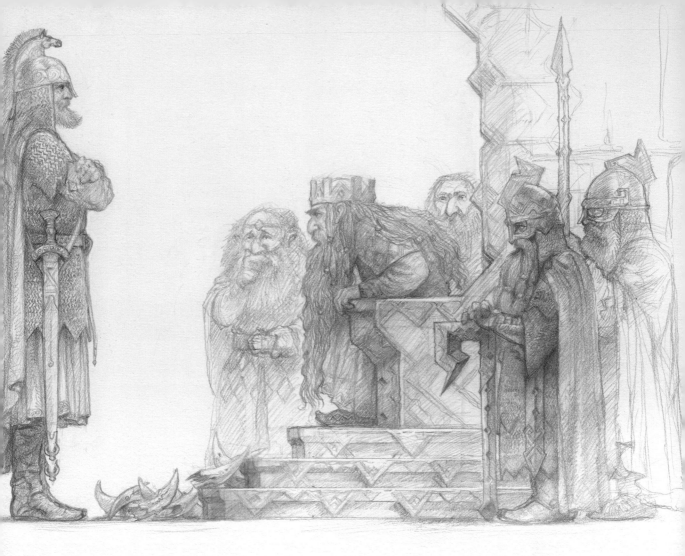

The Dwarves of Ered Mithrin claimed Scatha's treasure, but Fram sent them the creature's teeth, saying "Jewels such as these you will not match in your treasuries, for they are hard to come by." Fram apparently lost his life in the troubles that followed. Although the dispute was later settled, distrust long remained between Dwarves and Horse-lords.

In Scatha's hoard was found a silver horn, Dwarf-made and engraved with horsemen and runes of power. Later known as the Horn of the Mark, it was eventually given by Éomer and Éowyn to Meriadoc Brandybuck.

149

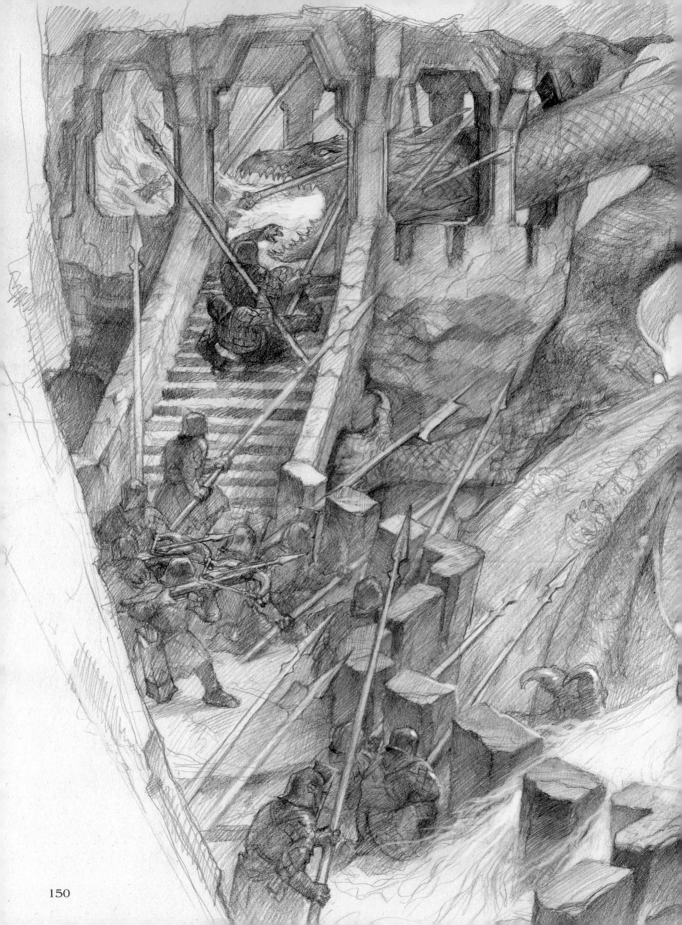

THE WAR OF DRAGONS
& DWARVES

Centuries after Scatha, and two hundred years before
Smaug's attack on Erebor, fire-breathing winged
dragons attacked the Dwarf kingdoms of the Grey
Mountains, the Ered Mithrin. The War of Dragons
and Dwarves raged for nearly two decades, ending
with the death of King Dáin the First, and his second
son Frór. Dáin's eldest son Thrór led many survivors
to Erebor, under the Lonely Mountain, while his
younger brother Grór led others to the Iron Hills.
Ered Mithrin was abandoned.

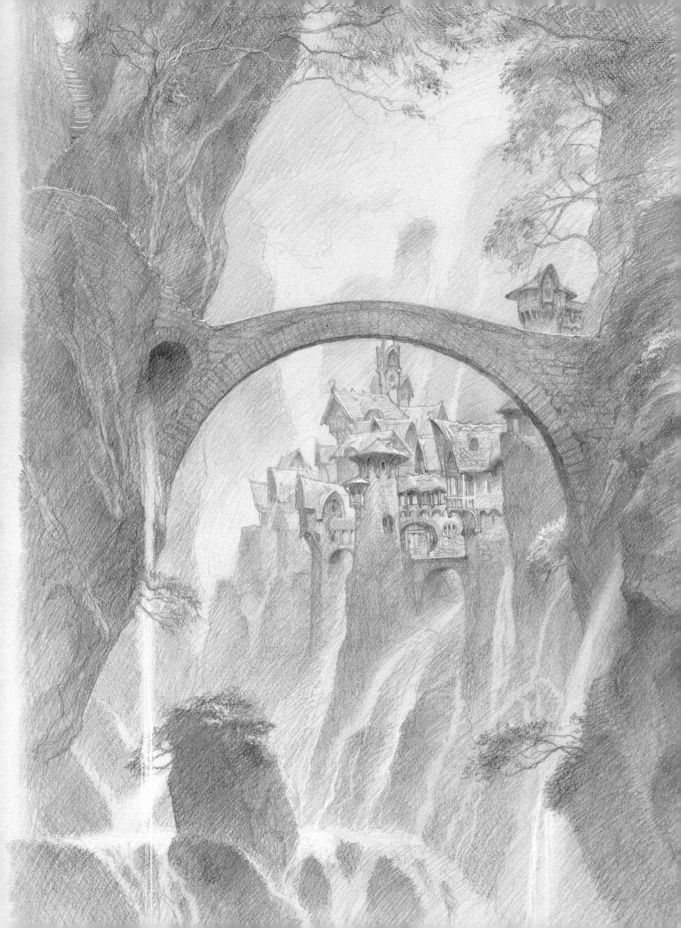

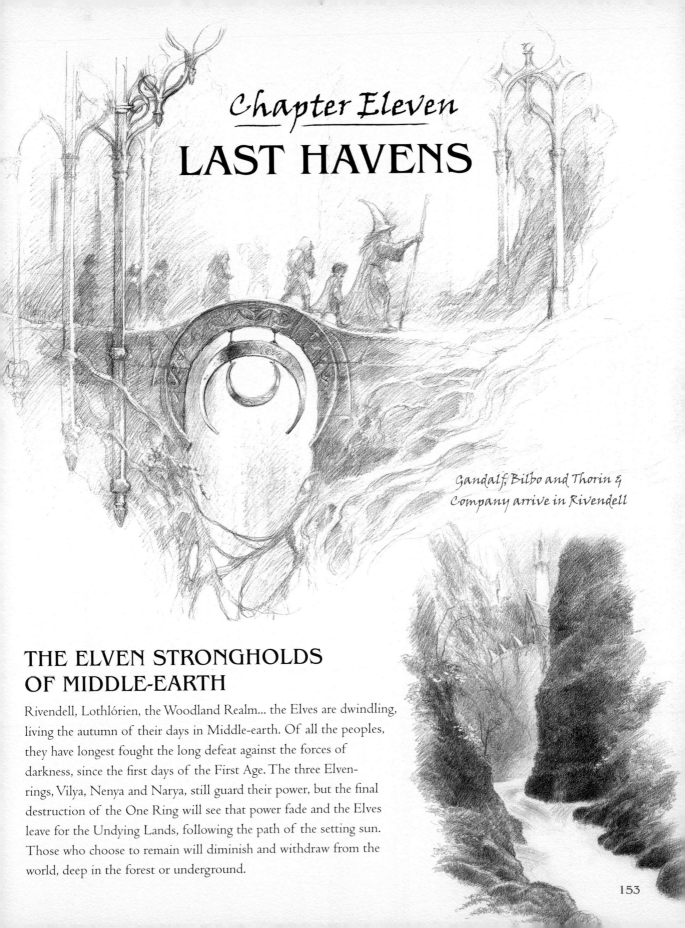

Chapter Eleven
LAST HAVENS

*Gandalf, Bilbo and Thorin &
Company arrive in Rivendell*

THE ELVEN STRONGHOLDS
OF MIDDLE-EARTH

Rivendell, Lothlórien, the Woodland Realm... the Elves are dwindling,
living the autumn of their days in Middle-earth. Of all the peoples,
they have longest fought the long defeat against the forces of
darkness, since the first days of the First Age. The three Elven-
rings, Vilya, Nenya and Narya, still guard their power, but the final
destruction of the One Ring will see that power fade and the Elves
leave for the Undying Lands, following the path of the setting sun.
Those who choose to remain will diminish and withdraw from the
world, deep in the forest or underground.

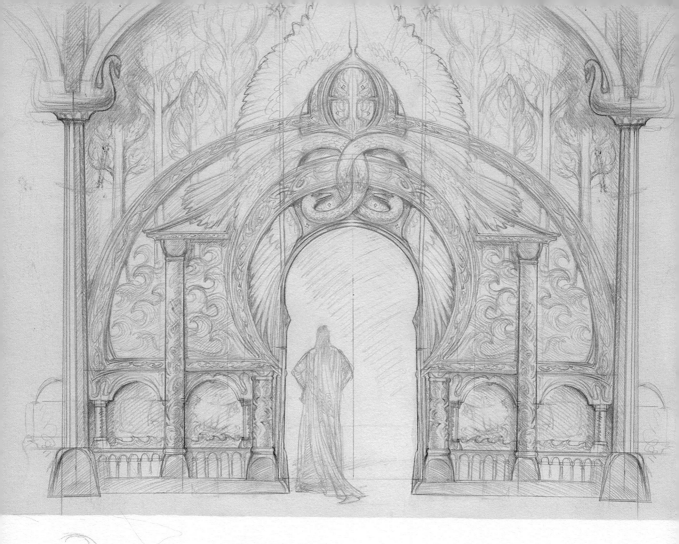

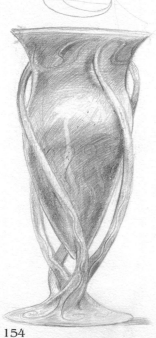

RIVENDELL

The ornate facade of Elrond's house recounts the history of his people from Beleriand to the deep valley where he founded Rivendell in 1697 of the Second Age. Elrond remained Lord of Rivendell for thousands of years, harbouring the Dúnedain, offering them safe haven in their long struggle against Sauron's forces to the north. After the War of the Ring, Elrond sailed west from the shores of Middle-earth in the company of the Ringbearer Frodo.

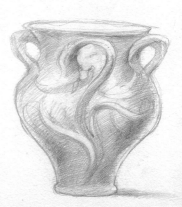

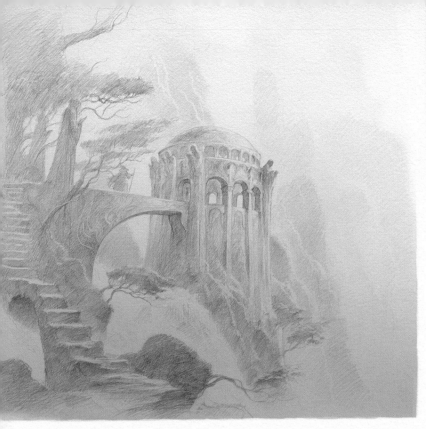

Not a little awestruck,
Thorin's company of Dwarves
arrives in Rivendell.

The White Council met in Rivendell to discuss the growing threat in Dol Guldur. Gandalf, who had determined that the mysterious Necromancer was Sauron, and that his strength was growing, urged action, but Saruman, leader of the White Council, dissuaded them.

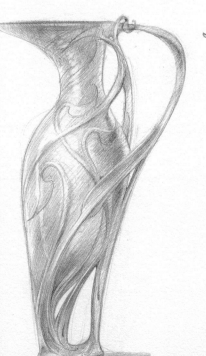

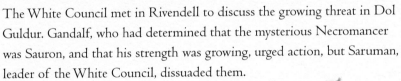

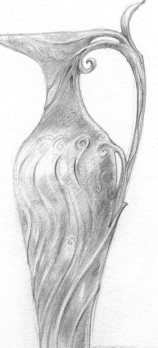

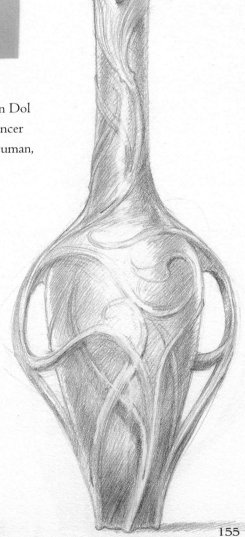

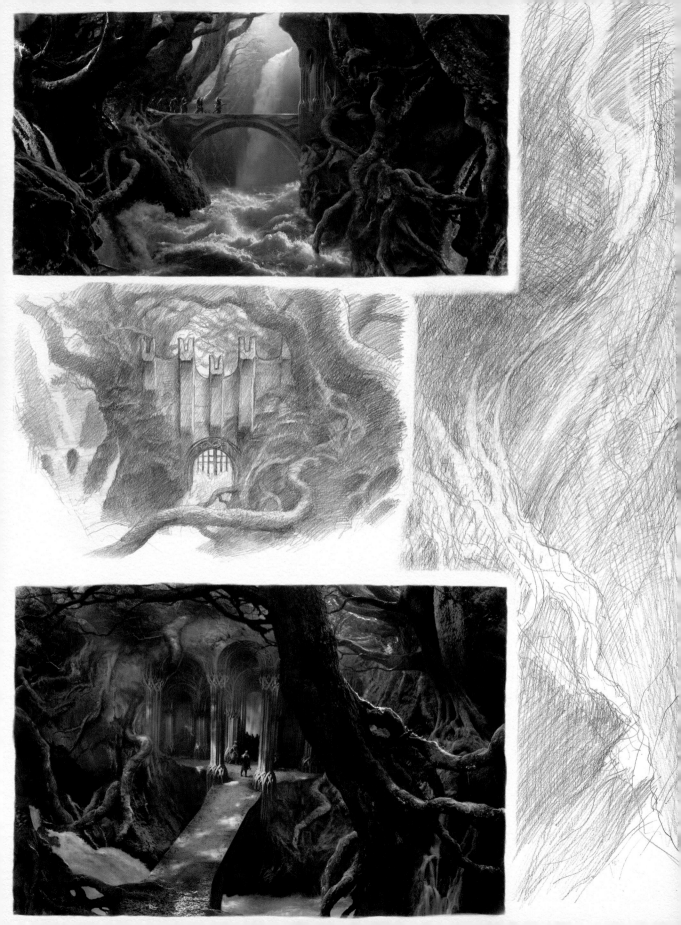

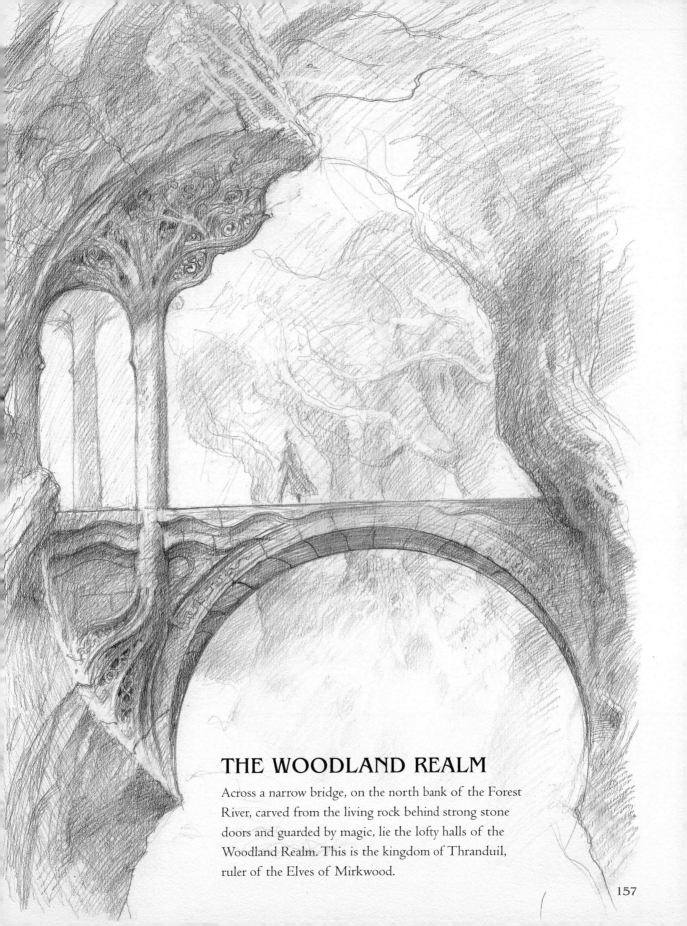

THE WOODLAND REALM

Across a narrow bridge, on the north bank of the Forest
River, carved from the living rock behind strong stone
doors and guarded by magic, lie the lofty halls of the
Woodland Realm. This is the kingdom of Thranduil,
ruler of the Elves of Mirkwood.

157

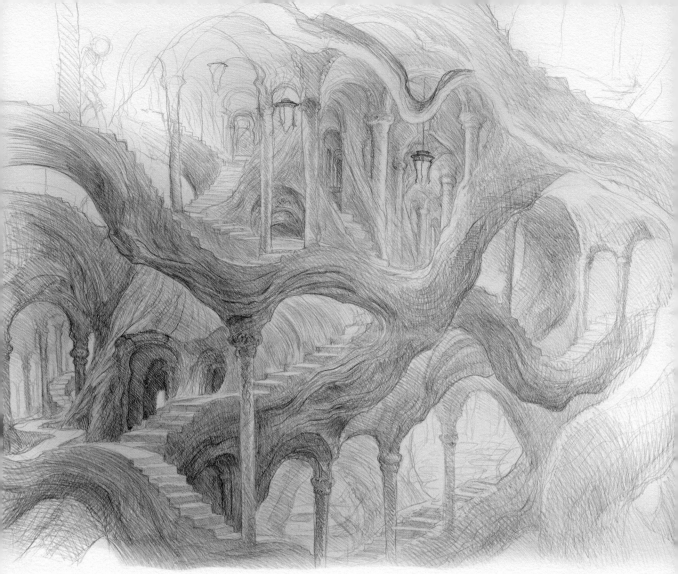

The Woodland Realm

Thranduil's Realm is no simple succession
of caves: the roots of huge trees have been
carved and sculpted over the years to create
a cathedral-like cavern, full of light
filtering down and water rushing through
channels beneath.

Thorin's Company of Dwarves were thrown
into deep dungeons, far underground, with
no hope of rescue. Once again though, their
burglar, with his magic ring, would find the only
possible means of escape: empty barrels due to
be returned down the Forest River to Lake-town.

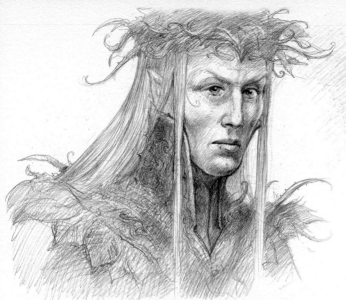

King Thranduil

The king of the Elves of Northern Mirkwood
had been ruling an ever-shrinking kingdom
since the beginning of the Third Age and the
rise of the Necromancer in Dol Guldur. Inclined
to shun the world beyond the forest, Thranduil
would nonetheless lead his warriors to the
Battle of the Five Armies, and later take part
in the War of the Ring.

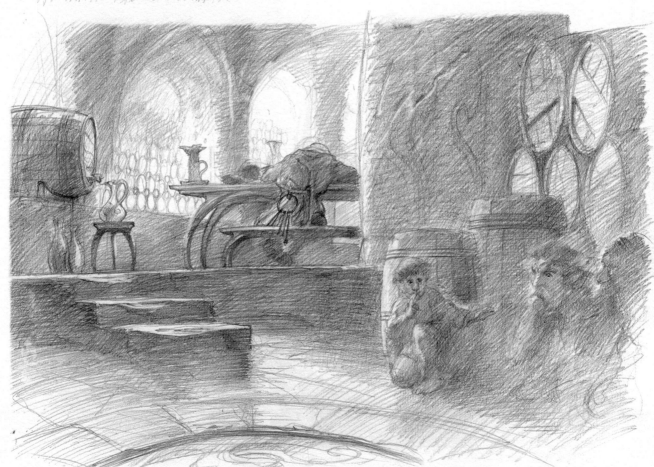

"So following the hobbit, down into the lowest cellars they crept.
They passed a door through which the chief guard and the butler could
be seen still happily snoring with smiles upon their faces. The wine of
Dorwinion brings deep and pleasant dreams."

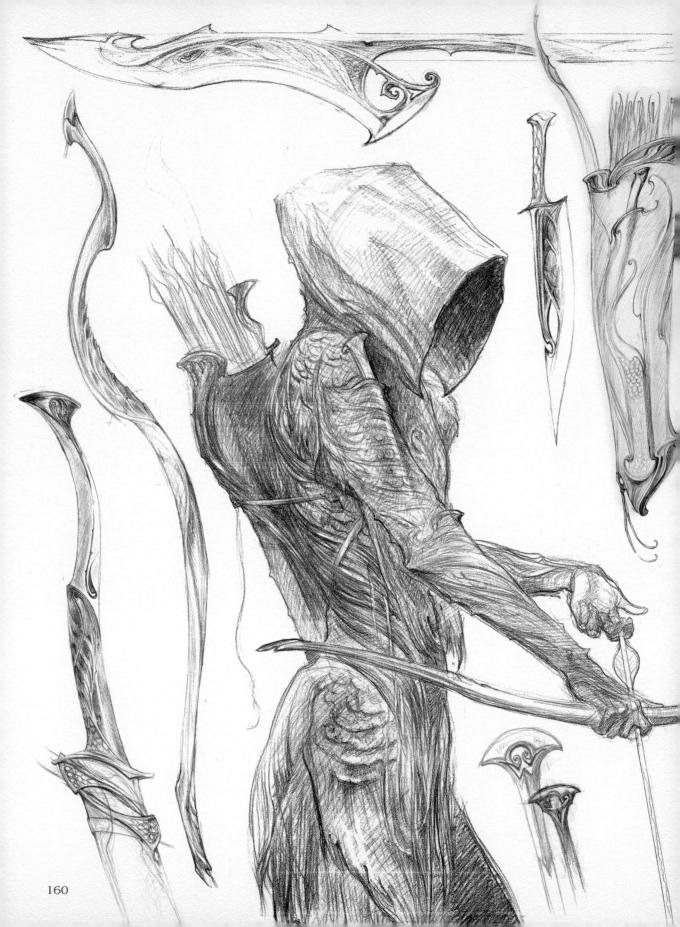

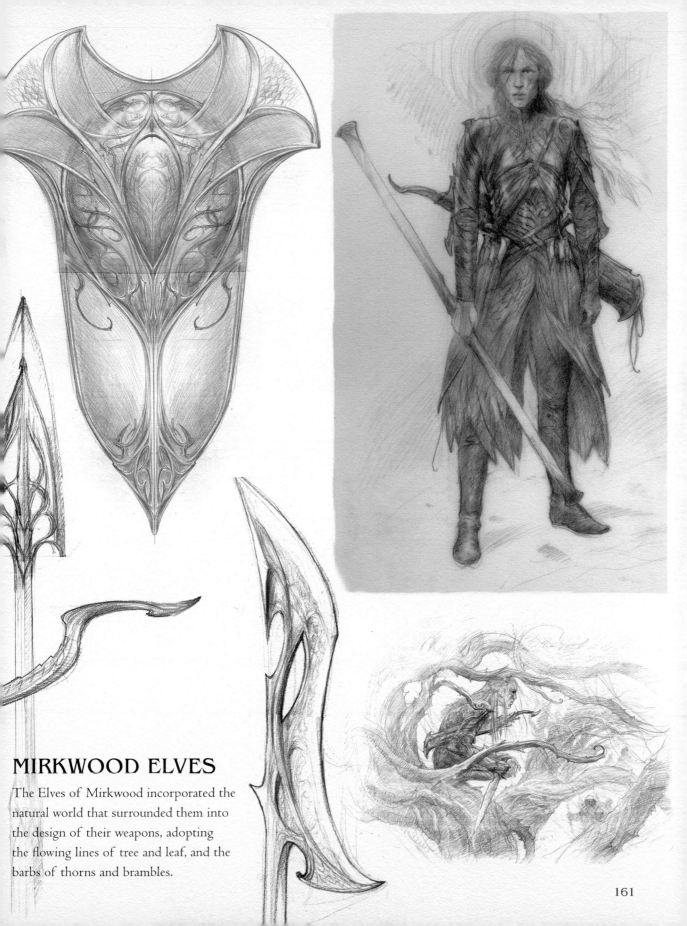

MIRKWOOD ELVES

The Elves of Mirkwood incorporated the natural world that surrounded them into the design of their weapons, adopting the flowing lines of tree and leaf, and the barbs of thorns and brambles.

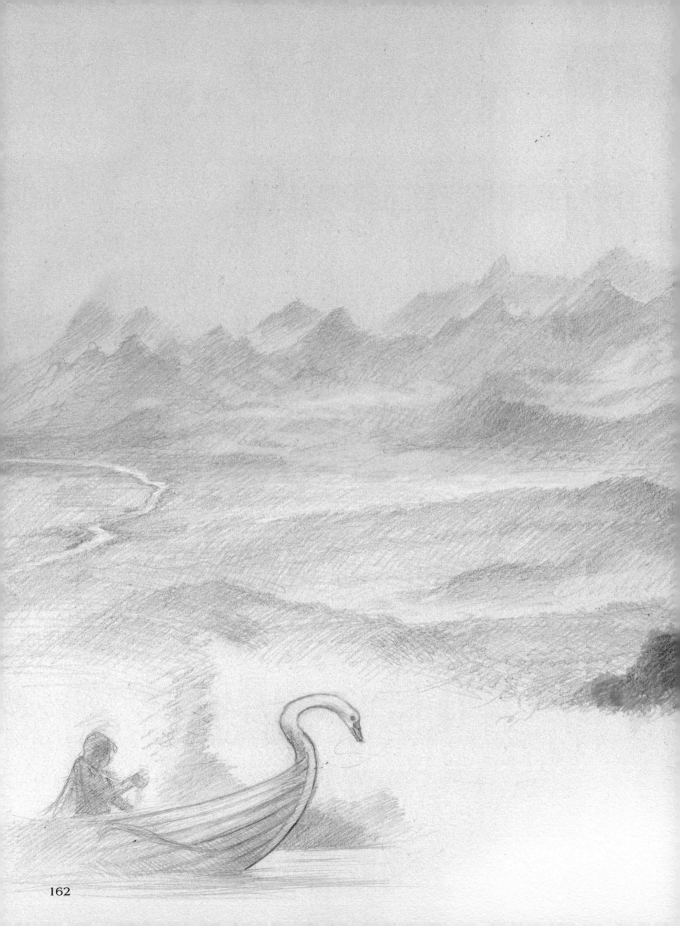

LOTHLÓRIEN

Founded in the Second Age by Galadriel between the Misty Mountains and the River
Anduin, and protected by the power of her Ring, Nenya, the forested realm of Lothlórien
was a haven for the Silvan Elves. Its capital, Caras Galadhon, stood on a hill in its midst,
surrounded by a grass-covered dike and a deep ditch. Mallorn trees grow thickly on Caras
Galadhon: tall, smooth grey trunks and leaves of brightest green with silver undersides, leaves
that turned bright gold in autumn. Lorien Elves lived in the trees on platforms called flets,
high in the branches. On a flet in on the tallest Mallorns lived the lady Galadriel and her
husband, Lord Celeborn.

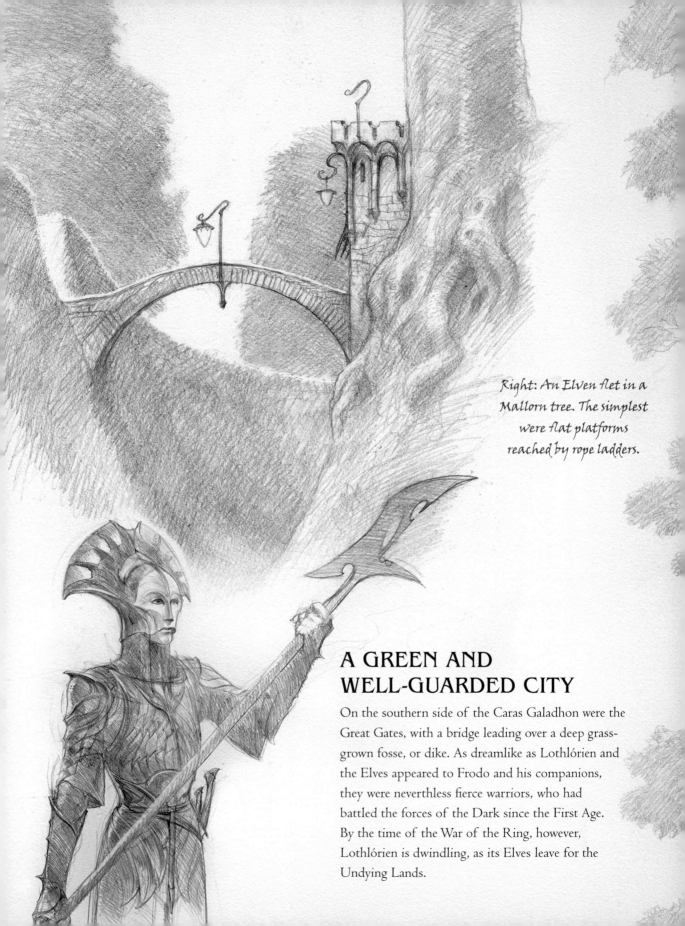

*Right: An Elven flet in a
Mallorn tree. The simplest
were flat platforms
reached by rope ladders.*

A GREEN AND
WELL-GUARDED CITY

On the southern side of the Caras Galadhon were the
Great Gates, with a bridge leading over a deep grass-
grown fosse, or dike. As dreamlike as Lothlórien and
the Elves appeared to Frodo and his companions,
they were nevertheless fierce warriors, who had
battled the forces of the Dark since the First Age.
By the time of the War of the Ring, however,
Lothlórien is dwindling, as its Elves leave for the
Undying Lands.

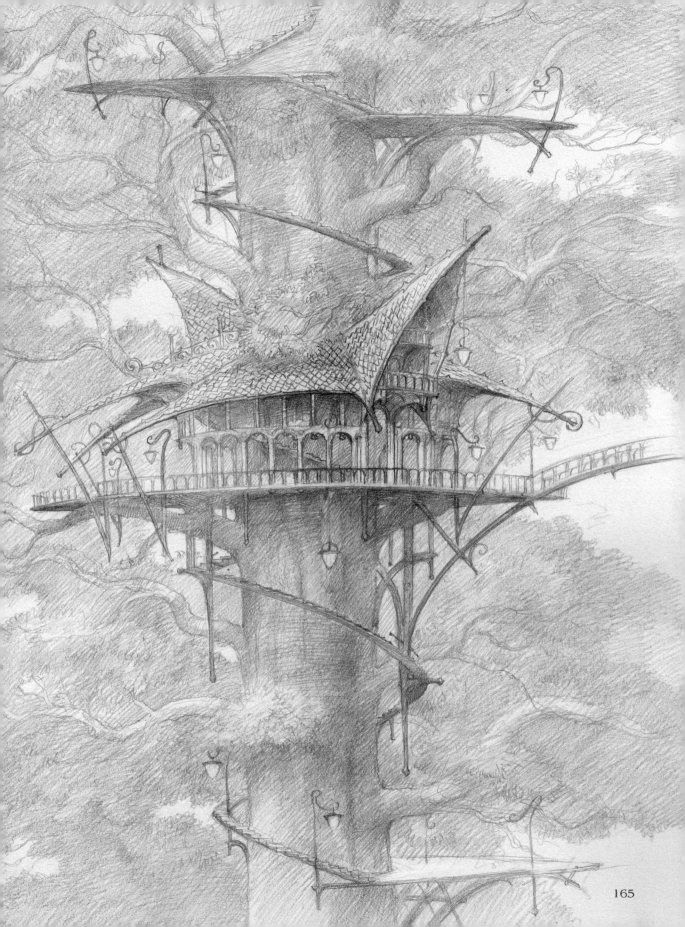

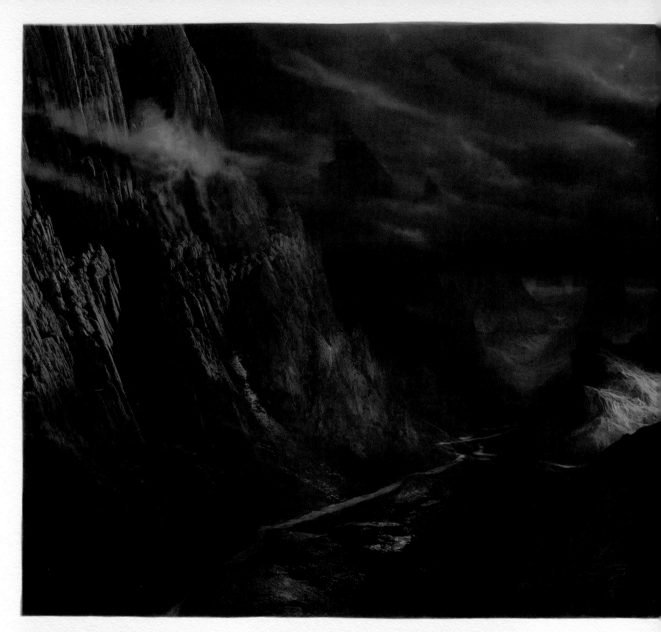

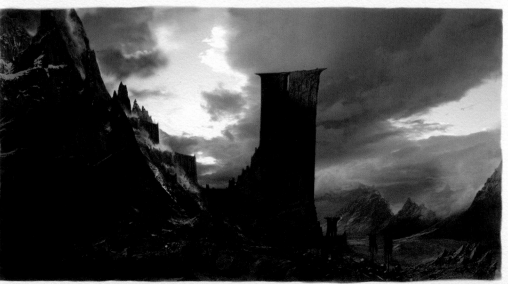

Above: The ragged pe[aks]
of Angmar. Its capita[l is]
Carn Dûm, peopled [by]
Orcs, hill-men and ot[her]
creatures of darkness [who]
have succumbed to t[he]
spell of Sauron.

Left: The iron-clad for[tress]
of Gundabad holds t[he]
pass to the realm of t[he]
Witch-king of Angm[ar.]

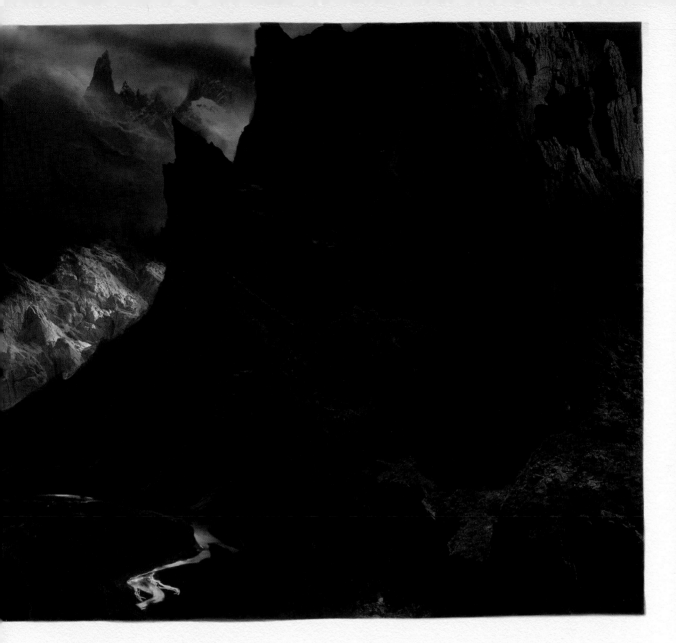

Chapter Twelve

THE DARKENED LANDS
From Angmar to Mordor

The lands of Shadow would grow and diminish as Sauron and his allies extended their powers or were driven back in hard-fought and endless wars. The kingdoms of Men crumbled by assault from without and treachery and greed from within. The Shadow would recede before the bright bravery of Elves, Dwarves and Men, only to return, darker and more menacing than before, for as long as the One Ring endured.

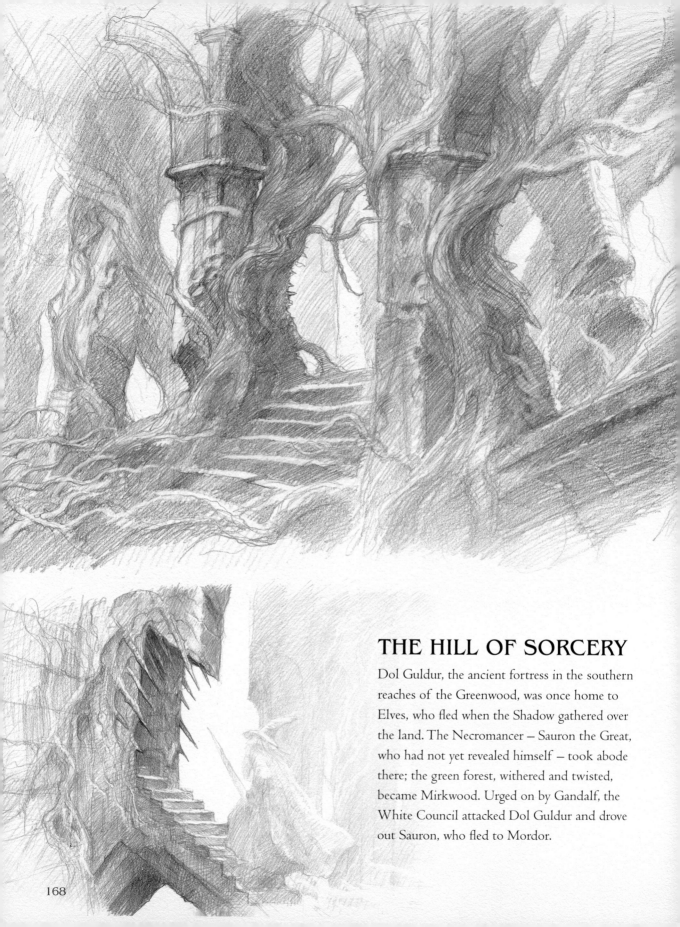

THE HILL OF SORCERY

Dol Guldur, the ancient fortress in the southern reaches of the Greenwood, was once home to Elves, who fled when the Shadow gathered over the land. The Necromancer – Sauron the Great, who had not yet revealed himself – took abode there; the green forest, withered and twisted, became Mirkwood. Urged on by Gandalf, the White Council attacked Dol Guldur and drove out Sauron, who fled to Mordor.

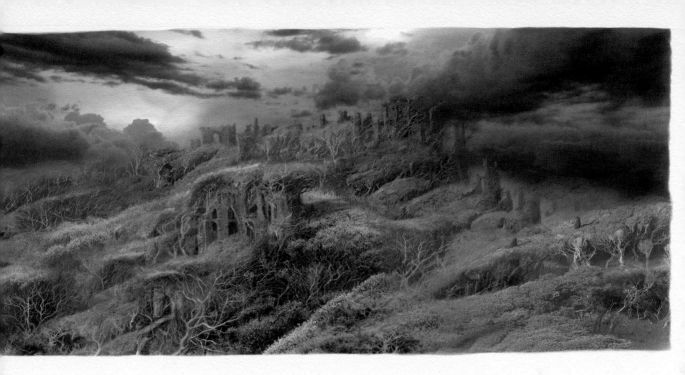

The crumbling ruins of Dol Guldur are buried amongst the twisted trunks of Mirkwood's benighted growth.

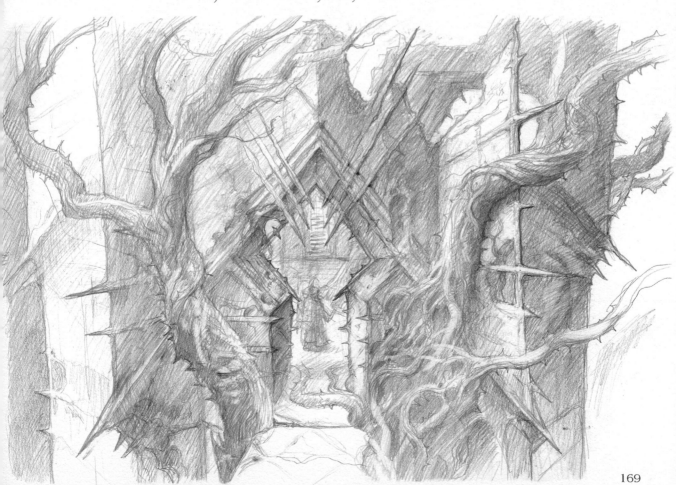

The Sea of Rhûn, far to the East, once a vista of restless waves, is now
a desolation of fierce and jagged rock, as if the waves themselves had been suddenly
transfixed and frozen into a stormy sea of stone.

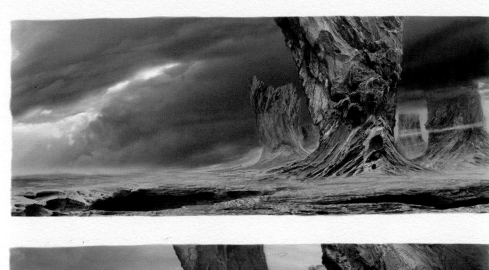

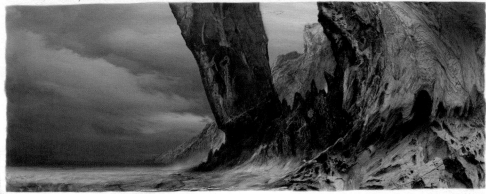

THE SEA OF RHÛN

The "Eastern Sea" was a vast salt-water lake in the First Age of Middle-earth. Men lived on its shores, and went in boats upon it. Beyond it lay the land of Rhûn, where it is said that Saruman and the Blue Wizards once ventured. Only Saruman returned to the West. Of the seven houses of the Dwarves, four, those who refused the trek west, are thought to still dwell there under hills and mountains. Swarthy axe-wielders from Rhûn fought in the Battle of the Pelennor Fields, as did Variags from Khand, even farther east.

By the end of the Third Age, the Sea of Rhûn is no longer a sea but a desert, a parched and tortured land. The River Running, flowing from the Long Lake, and the Redwater from the Iron Hills, lose themselves in the ravines and fissures of Rhûn. Near the eastern edge, once an island that stood above the waves, stands a ragged hill sculpted by the dry winds, the shallow remains of the once-wide sea lapping listlessly at its base.

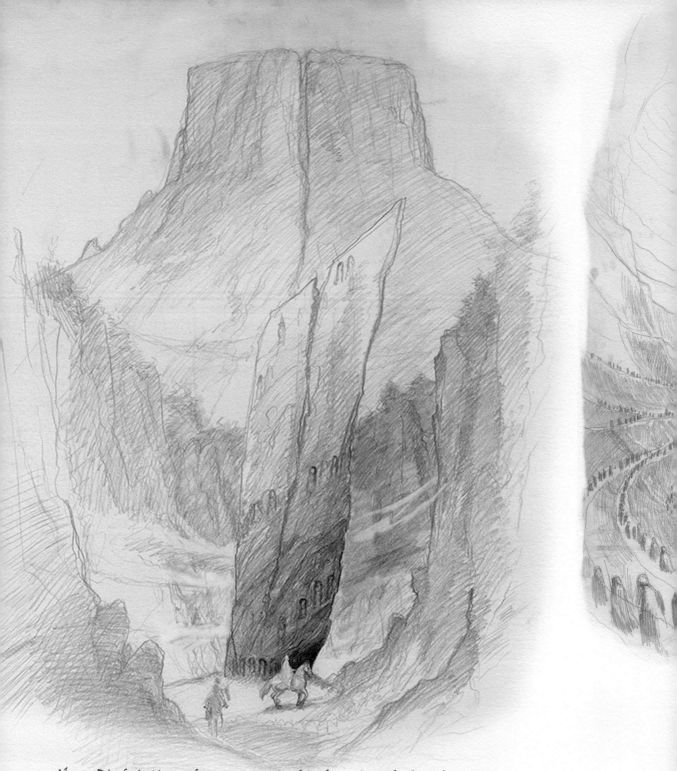

Above: Dimholt Glen, where even Legolas felt the cold touch of death clinging eternally to life. Beyond the standing stone, the Dwimorberg, the Haunted Mountain and the Dark Door to the Paths of the Dead.

Right: The Oathbreakers come in answer to Aragorn's challenge.

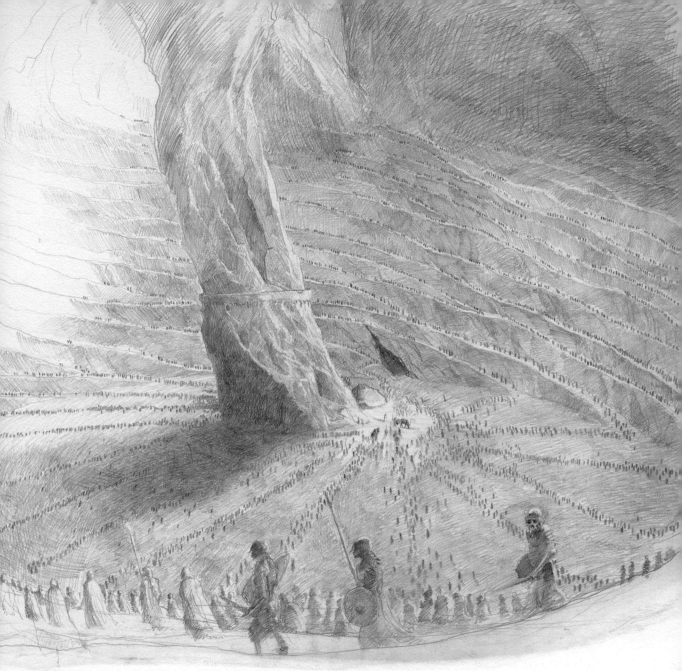

THE PATHS OF THE DEAD

The archetypal hero's life often includes a journey to the Otherworld. When Aragorn passes through the Dark Door under the glowering shadow of Dwimorberg, he is going to confront the restless dead, the Oathbreakers cursed by Isildur. Many things can hinder the passage from life to death, and the departed souls never truly arrive in the afterlife until the grievance is satisfied, through sacrifice, propitiation or righting of wrongs. The terror that seizes Gimli and deeply troubles Legolas is the same as that felt by Odysseus when he descends into Hades to query Tireseas' ghost.

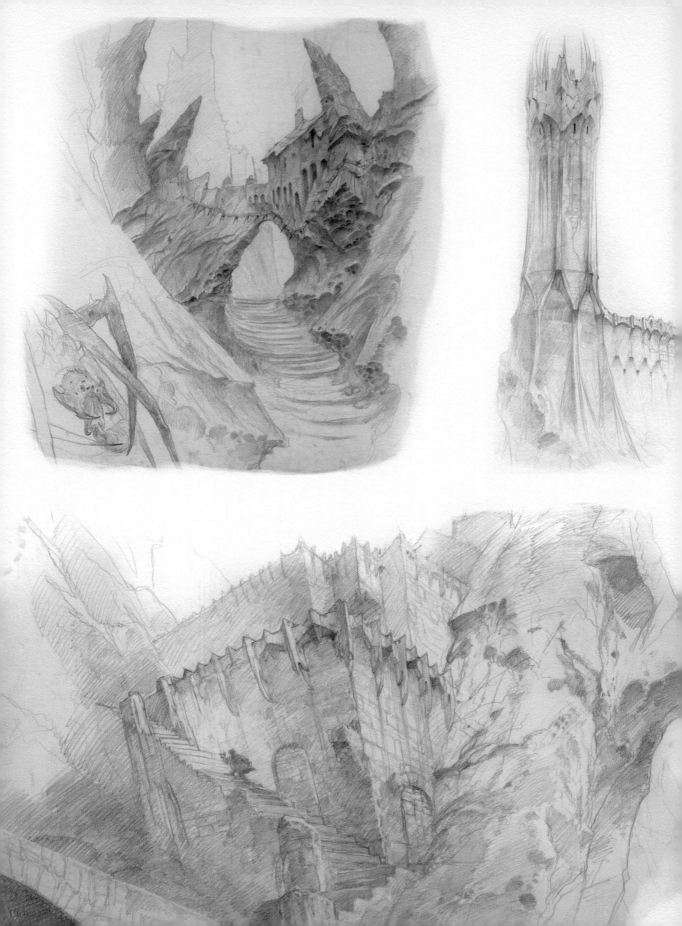

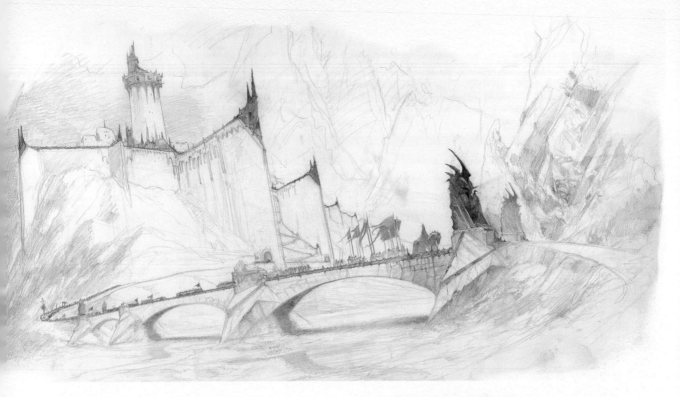

GATES AND TOWERS

All the gates to Mordor are guarded: the
Black Gates of Udûn, the cursed city of
Minas Morgul, the fortress of Cirith Ungol,
all are filled with watchful eyes and wicked,
well-armed fighters. Nevertheless, by dint of
courage and luck, Frodo and Sam make their
perilous journey into Mordor to destroy the
Ring in the fires of Mount Doom.

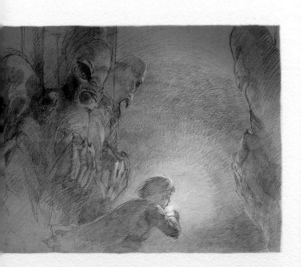

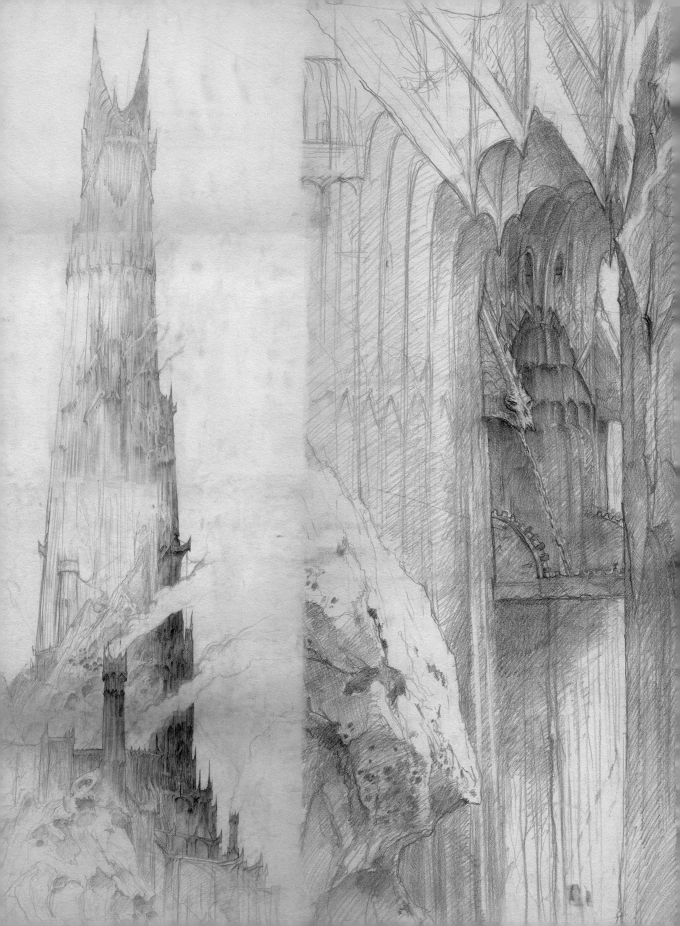

Sauron's Dark Tower of Barad-dûr was the greatest fortress built since
Angband was destroyed in the War of Wrath at the end of the First Age.
No longer able to assume a material form, the Dark Tower is both
a symbol of Sauron's power and his earthy prison.

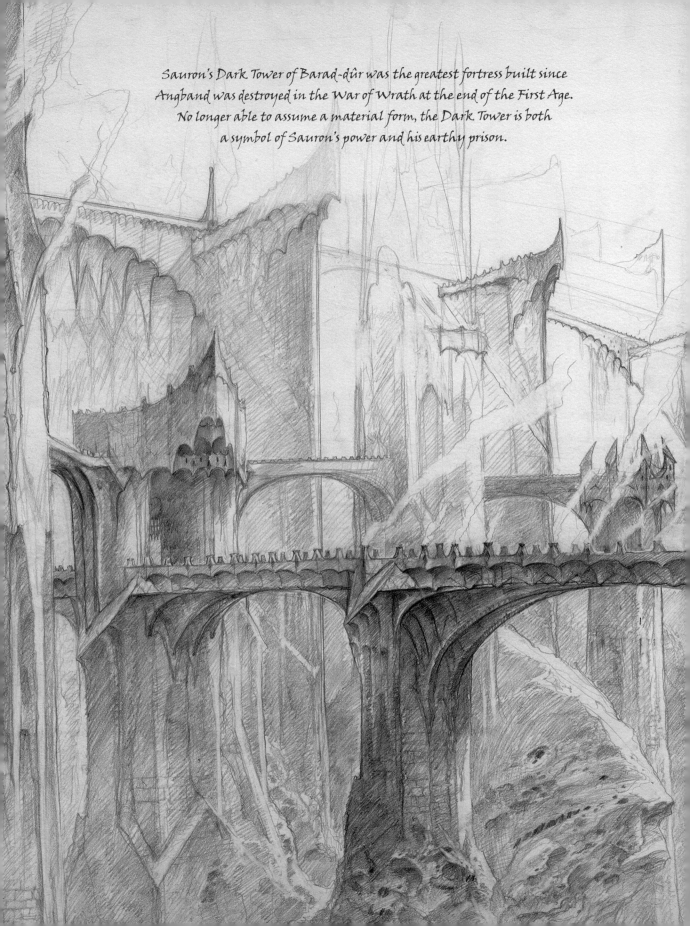

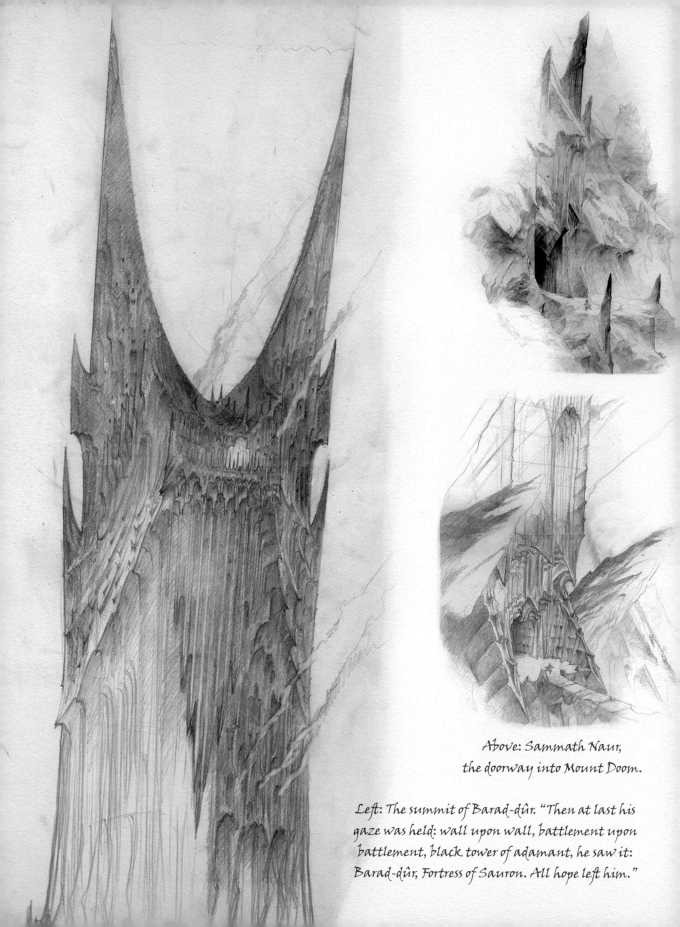

*Above: Sammath Naur,
the doorway into Mount Doom.*

*Left: The summit of Barad-dûr. "Then at last his
gaze was held: wall upon wall, battlement upon
battlement, black tower of adamant, he saw it:
Barad-dûr, Fortress of Sauron. All hope left him."*

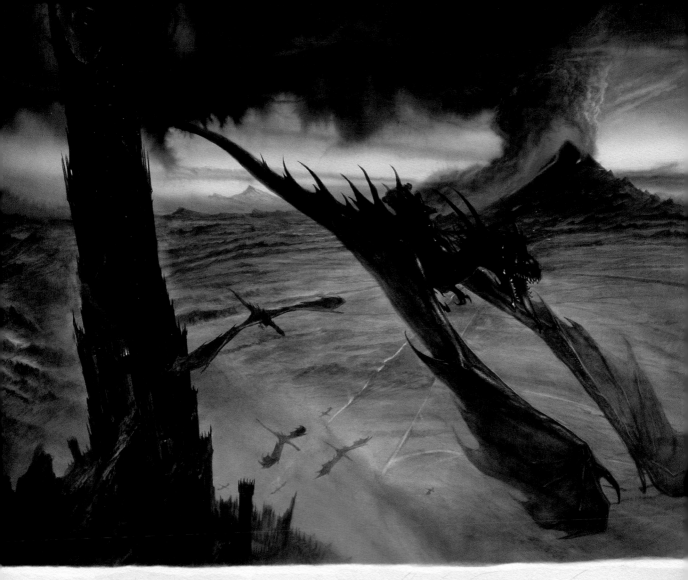

BARAD-DÛR, ORODRUIN AND THE CRACKS OF DOOM
HEART OF DARKNESS

When Gollum fell with the Ring into the molten heart of Mount Doom, Barad-dûr crumbled and the
mountain and the tortured plain split asunder, swallowing the Orcish army. Mordor was destroyed.
With Sauron's death and the unmaking of the Ring, the Ringwraiths' living death was ended; and the
power of the Elven-rings faded, and magic itself dwindled from the world of Middle-earth.

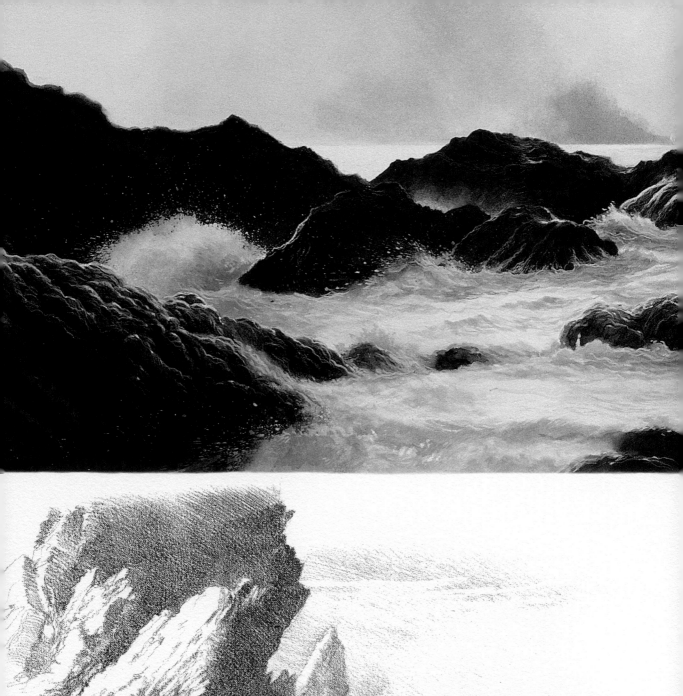

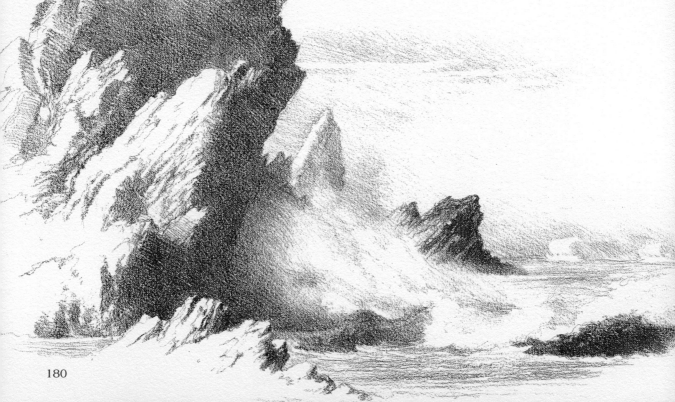

Chapter Thirteen

LONELY CAPES & WILD SHORES
The Coastlines of Middle-earth

While J. R. R. Tolkien's *The Hobbit* and *The Lord of the Rings* take place for the most part far from the sea, the seacoasts and oceans of Middle-earth play a crucial role in the history of Tolkien's world. During the *Akallabêth* (the account of the downfall of Númenor, swallowed by the waves) in the later part of the Second Age, Eru Ilúvatar "bent" the sea and made the world round. Aman, land of the Valar, was removed from the world to another realm in Eä. Only Elves and a chosen few could sail there, travelling the Lost Road to Valinor. Mortal seafarers sailing west searching for the lost land might, by fate or by the grace of the Valar, eventually come to Tol Eressëa, an island bathed in the light of the Two Trees in the Undying Lands.

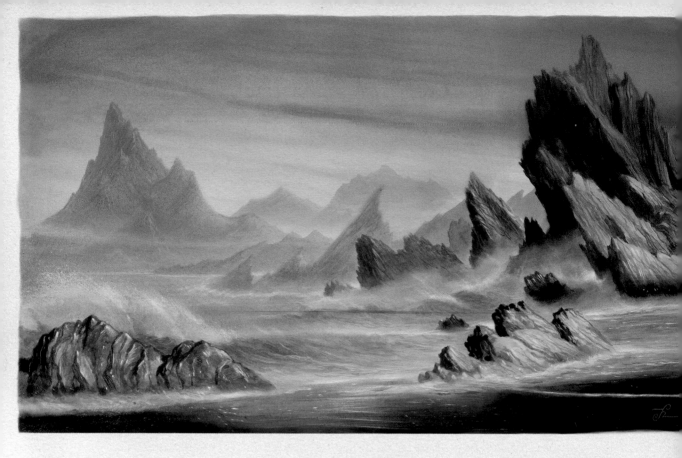

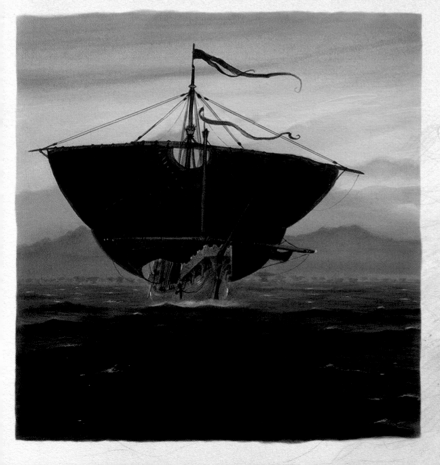

Above: Cape Forostar, the
northernmost cape of the Island
of Númenor. High cliffs fall
sheer into the sea at the foot of
the mountain, Sorontil.

Left: Ar-Pharazôn, last King
of Númenor, led his great fleet to
Valinor to challenge the Valar,
provoking Ilúvatar to destroy the
fleet and cause Númenor to be
broken and swallowed by the sea.

AKALLABÊTH:
THE DOWNFALL OF NÚMENOR

Tales of lands vanished beneath the waves as punishment for the arrogance of mankind are many. The story of Plato's Atlantis closely parallels Tolkien's *Akallabêth*: a mighty and arrogant kingdom dares measure itself against the will of the gods and pays the price with its destruction and drowning beneath the waves.

Sauron built a monstrous temple in the capital of Númenor, the Golden City of Armenelos. Under a vast silver dome blackened by the smoke of human sacrifices, he openly worshipped Morgoth.

Emyn Beraid, the Tower Hills
THE WHITE TOWERS

In year 600 of the Second Age, when the first ship of the Númenóreans sailed up the Gulf of Lune, there was a meeting between the men from the sea and their distant Elven kinsmen in the Tower Hills. The White Towers were built before the end of the Second Age by Gil-galad, High King of the Noldor, for his friend Elendil. During the Third Age, Elves would go in pilgrimage to Elostirion in order to gain a glimpse of the West through the Elostirion-stone. The Palantír remained in its tower until the end of the Age; it was then taken back into the West. In Fourth Age 31 the Westmarch was added to the Shire, making the Tower Hills the new western border of the land.

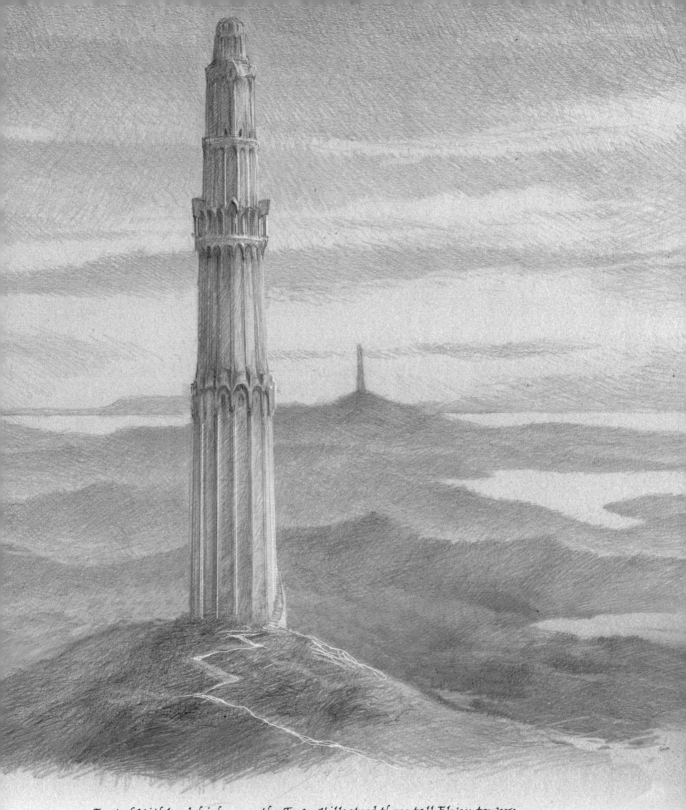

East of Mithlond, high upon the Tower Hills stood three tall Elven towers:
the White Towers. The highest was called Elostirion. It held a Palantír,
in which glimpses of Valinor could be seen.

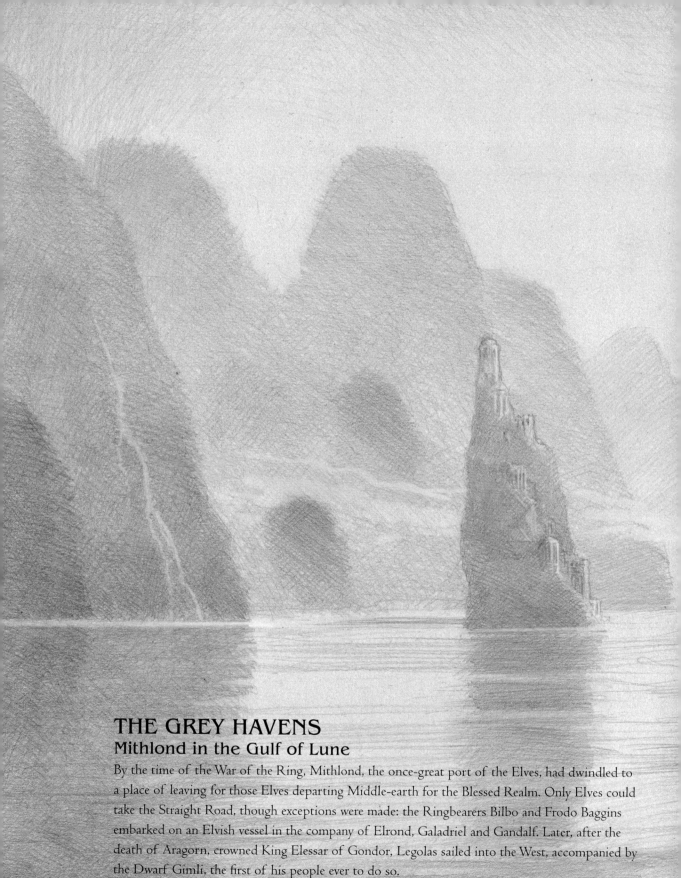

THE GREY HAVENS
Mithlond in the Gulf of Lune

By the time of the War of the Ring, Mithlond, the once-great port of the Elves, had dwindled to a place of leaving for those Elves departing Middle-earth for the Blessed Realm. Only Elves could take the Straight Road, though exceptions were made: the Ringbearers Bilbo and Frodo Baggins embarked on an Elvish vessel in the company of Elrond, Galadriel and Gandalf. Later, after the death of Aragorn, crowned King Elessar of Gondor, Legolas sailed into the West, accompanied by the Dwarf Gimli, the first of his people ever to do so.

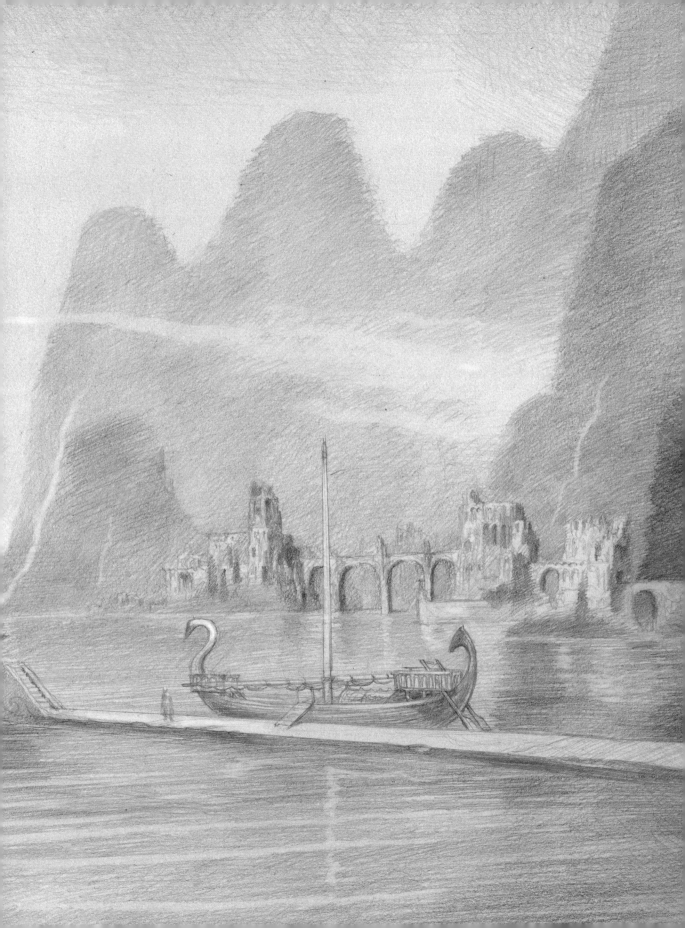

POSTSCRIPT
In Good Company

So many drawings… After literally drawing my way the length and breadth of a world, and equally literally sitting in the midst of a pile of pencil stubs and full sketchbooks, accurately recounting a journey that took place as much in fiction and story as in real life, is nearly impossible.

Illustration is a solitary pursuit, locked away in one's studio; film work is the consummate team effort, requiring split-second reactivity and unlimited creativity, the whole driven by a sense of expectation and urgency. Sharp wits and sharper pencils. And an unlimited supply of sketchbooks. The challenges were of every nature, from daggers to dragons, from humble clay cups to towering sets, the whole part of an incredibly varied but nonetheless hopefully coherent design-as-you-go world. Here are a few glimpses.

Some of the territory was familiar: for *The Lord of the Rings* from previous work, for *The Hobbit* from the preceding trilogy. Going back to Hobbiton was like going home. Working on the *Lord of the Rings* and *Hobbit* trilogies offered the opportunity to explore the whole of Bag End, something I had never dreamed of doing when painting the illustration for the cover of the *Map of the Hobbit* (although I did a view of a bewildered-looking Bilbo, in the midst of a crowd of merrily raucous Dwarves filling his dining room, as a vignette for that same map). I was asked to imagine standing in that hallway, then turn about face and draw the rest of Bilbo's dwelling, and happily worked my way from room to room, even drawing several full floor plans. I designed many rooms that I knew would never reach the screen: bathrooms, spare bedrooms, even a secret passageway and a discreet back door. It is very much the house in which I would enjoy living, though round doors are cumbersome things to open and close.

Smaug's wide wingspan covered many departments at Weta Digital: models, rigging, animation, textures, lighting… digital effects companies are not necessarily structured to accommodate such a vast creature. Rather than leave each department to work in habitual succession, Team Smaug came into being: punctual weekly reunions with an artist from each department, where each person could update the others on progress, and more crucially fill in gaps. Often, a quick sketch could resolve a question, and allowed me to intervene whenever guidance was needed. It was magical to see the modellers at work, transforming simple pencil drawings into 3D renders, to see the enormous acreage of scales, each different, that needed to be created and textured. Finally, Smaug left our building, and went to the animators, before reappearing scene by scene, moving, speaking and breathing fire, fully alive. (We promised ourselves that we would get Team Smaug t-shirts, but somehow never did.)

The Swiss Lake Dwellers were an initial source of inspiration for Lake-town (I live only a few miles from La Tène, the locality on the shores of the Lake of Neuchatel that lent its name to the Late European Iron Age) but the Celtic inspiration was abandoned in favour of something more recent historically and farther to the north and east. Every available book on Russian

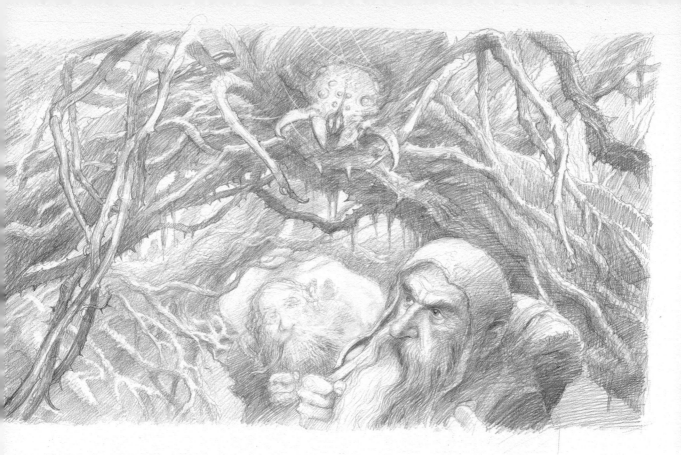

wooden architecture and Norwegian stave churches ended up in the design office. Scrutinizing the building techniques and applying them to the framework of Lake-town was an incredibly enriching experience. With familiarity, an unconscious *vade mecum* of stylistic instinct develops and guides the hand and the eye; a fictional culture can be treated as one would approach a historical drawing, taking into account the tools and materials that the builders might have used, conferring an archaeological credibility even when filtered through fiction.

Of greater difficulty was convincing the carpenters to build Lake-town slightly askew, as if it was slowly subsiding into the waters of the Long Lake. Carpenters are adroit at perfect verticals and horizontals; asking them to actually *build* skew-whiff structures was quite an imposition.

Wandering in the sets was a favourite pastime. Several times I went to Dale before sunrise, to wait for the sun to appear and slowly light the city. I photographed Dale from the heights of Wellington, from across the bay, and never understood how similar images didn't appear on the internet. Sometimes things can be hidden in plain sight. The hill above the Stone Street studios, though, was a favourite haunt of spoiler hunters, and often needed to be patrolled to discourage photographers. The exterior Lake-town set was also a place I loved, best visited in the pouring rain, despite the risk of slipping off a crooked walkway into the water. One day, a late afternoon sun poured through the open door of one of the sound stages and lit Mirkwood. It was magical.

Radagast's house, Rhosgobel, is nowhere mentioned in *The Hobbit*, but coincidence would have it that it was one of the first entirely original sets constructed for the *Hobbit* trilogy. (The preceding sets revisited places covered in *The Lord of the Rings*: Bag End and Rivendell.) Many options were proposed before Peter suddenly had the idea that the wizard's house should be a tree-house of

a most unusual kind: a tree in a house and not a house in a tree. Designing the interior (only one side of the exterior was built) was a free-flowing exercise in cluttering up the drawings with details, imagining the invading roots and branches lifting floor tiles, pushing the fireplace askew, growing through the library.

One day, passing through the studio the day the Rhosgobel interior was scheduled to be shot, I discovered one of the sculptors taking a chainsaw to the tree trunk, Styrofoam sawdust flying everywhere, and great slabs of tree dropping to the ground. Peter had visited the set and estimated that he didn't have quite sufficient elbow room to shoot. It was resculpted, repainted and ready again the next day. Unexpected changes could come up at any moment. I recall asking Peter several times which way the doors of Thranduil's realm opened, since the design of the doors themselves depended on it, and confirming several times that they did indeed open inwards. Wandering through the completed set I once again found chainsaws at work – the doors needed to open outwards. I salvaged as many bits of sculpture as I could and fixed them back in place with room to allow the doors to swing, then quickly rushed off to design a new lintel while the sculptors readjusted the flanking columns.

One of the most memorable episodes involved the grand Lake-town set in "Kong" stage. On the *only* day Alan Lee called in sick in six years on *The Hobbit*, I was summoned to the set at around 4 p.m. As I arrived near the spot where the entire crew was gathered, I heard Peter say "Where's John-and-Alan?" When I turned up alone, explaining Alan was home sick, he replied "Okay, well, you'll have to be John-and-Alan today," and proceeded to explain what he needed. Peter had shot every angle possible, and for the needs of the following sequence a set redesign had to be sketched out to allow the substantial crowd of actors and extras to appear in an entirely different part of Lake-town. At 4:30 I headed back to the office, took a deep breath, and redesigned the set, keeping in mind Peter's requirements and the necessity of turning the whole thing around overnight. At 5:45, I rushed back to Kong stage with a pencil drawing, Peter approved, and it was whisked away to be scanned and distributed to the night crew. Next day, the set was ready.

Unfortunately, I neglected to design a comfortable podium for the Lake-town musicians, so the following day Alan (still very ill, and, I imagined, surely tremendously contagious) myself and two professional musicians found ourselves in wigs and weighty costumes cheek by jowl on a cramped little platform pretending to play the extravagant instruments we had designed. Poor Alan got the heaviest (his fault, he designed it) but nevertheless soldiered on. In between takes we would scurry back

to the office to draw — film design waits for no man. We never came up with a convincing name f
or the band. My career as a musician was mercifully short-lived.

We would often wait on Peter's good graces, tucked away drawing in a corner of a sound stage,
in order to present him with the latest work when he could spare a moment. In the sepulchral
silence of a film set, even the tiniest noises are audible and we soon found that the softer the pencil
the less noise it made sketching. I often toyed with the idea of heading in to the art shop in town
and asking to see their quietest sketchbook. Sound is not necessarily a quality one considers when
choosing paper.

Designing the Dwarves was a challenge that Alan and I kicked off by taking photos of each
other and then exaggerating the features in Photoshop. (He made a far more pleasant-looking and
affable Dwarf than I did; I always looked rather grim.) I repeatedly drew myself as a Dwarf into
concept art, in the hopes that I might somehow subliminally persuade Peter to cast me as an extra,
but he stoically resisted. Somewhere, though, on a hard drive at Weta Digital, there is a 3D scan
of my nose. I have no idea if it actually made it, in whole or in part, into a version of Dáin's face
or not.

At one point, I designed double-ended pole arms for the Elven army and spent several
happy hours in the parking lot with a friend, swinging prototypes about, acquiring bruises and
blisters, until we had developed a fighting style for them. I regretted they never made it into the
film, but they did require a bit of room to manoeuvre. Tauriel's
asymmetrical bow and her elegant *taiaha*-inspired double swords
never made it either. The prototypes sat in my office for years
until I finally gave them away.

Beorn's house went through over half a dozen iterations before

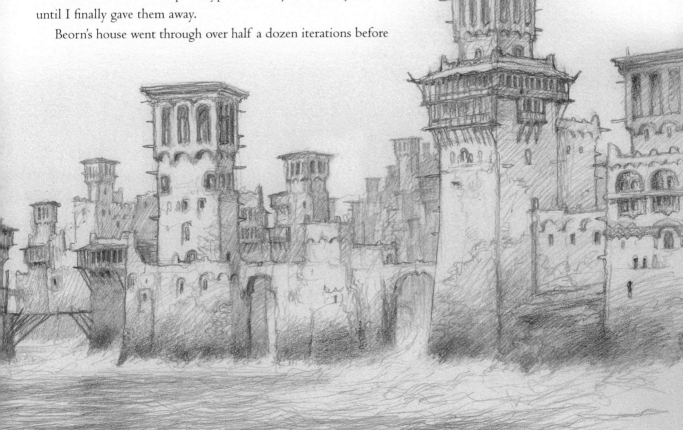

a final design was chosen and portions of the set were put into construction. Then the location changed, and the heavy influence of the landscape demanded a full redesign. I am sure I did nearly a hundred drawings for the carvings (those long winters… unless of course Beorn hibernated like a bear) that cover the entire inside of his house. No two are the same. The sketches were enlarged, printed out, and glued directly to Styrofoam blocks, which were deftly carved by the incredible team of sculptors. Intrigued as to how they could make such fine carvings in such a recalcitrant substance, I asked one of them to show me his tools: two ordinary dollar-store plastic-handled kitchen knives, razor-sharp and half worn way by use. A combination of humble tools and sure-handed skill created the hundreds of square feet of intricate interlace and high relief that characterizes Beorn's culture, into which I managed to slip several Green Men, the World-Tree Yggdrasil, Huginn & Muninn and Jormungandr.

Have sketchbook, will travel. When Peter had taken the main unit on the road, travelling the length and breadth of both islands to shoot on location, we were often obliged to track him down to present new work. Alan and I would board an early morning flight to some tiny airport, pick up a rental car, and head off to track down Peter, and then wait until he had time to see us. Nothing is more precious than time when the light rises in the morning and sets at dusk, and all manner of meteorology can get in the way. On one trip, Peter didn't have time to see us at all — we returned three days later. Another time, when the sun was playing hide and seek, we were ushered in and out of the director's tent with each passing cloud, until it seemed we brought good luck in the form of dependable nebulosity, so we stayed, keeping the sun at bay, though we didn't get to show any work. We wandered through Hobbiton, encountering Hobbits, watching the sun set over the Shire. We always took sketchbooks and pencils (which, happily, require neither batteries, chargers or wi-fi) and, one occasion, I spent a long day on the shores of the Long Lake at the edge of the Lake-town refugee camp, under the shelter of a pine with a canvas groundsheet and makeshift cushions, happily sketching my way through Erebor. This trip also had the benefit of allowing us to take the thousands of photos that stood us in good stead when post-production came around.

Besides the human friends and colleagues on this journey There and Back Again, the New Zealand landscape itself was a constant companion. Location scouts took us to places I never dreamed of seeing. Seeing so much of New Zealand from a helicopter was a unique experience, it filled my imagination and provided me with a solid sense of Middle-earth impossible to acquire from photographs. So many of the fantastical landscapes we painted to replace the green screens were almost directly taken from real landscapes we wandered through. The unique quality of the light, the otherworldly geology and vegetation, seen through the viewing glass of J. R. R. Tolkien's stories, was an extraordinarily enriching experience, very much a Hobbit's-eye view. Hobbits with sketchbooks, drawing the world as they went. There. Back Again. And the journey between, which is of course the best part.